Robert Brownjohn
Sex and Typography

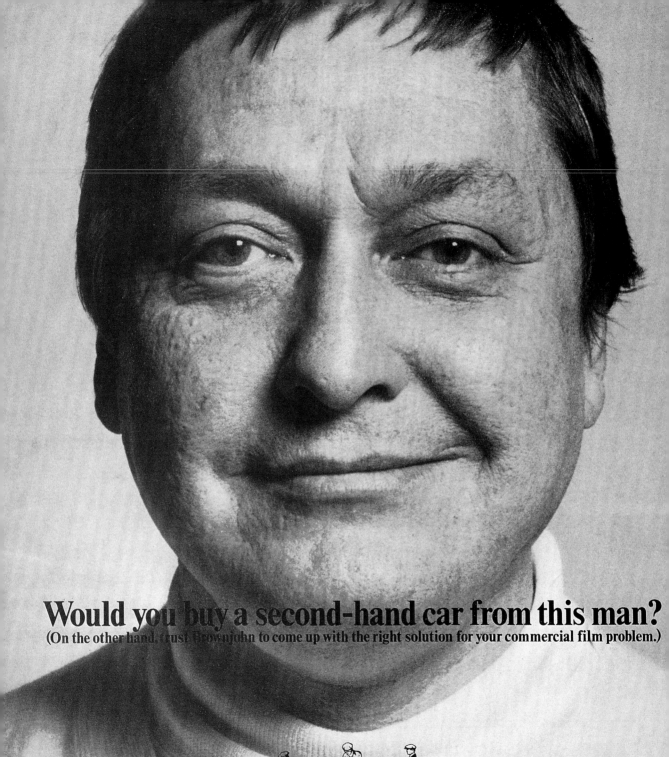

Would you buy a second-hand car from this man?
(On the other hand, trust Brownjohn to come up with the right solution for your commercial film problem.)

Cammell Hudson and Brownjohn Associates Limited
Shawfield House Shawfield St London SW3 FLA 0113

Robert Brownjohn
Sex and Typography

1925–1970
Life and Work

Originated by Eliza Brownjohn

Written by Emily King

Laurence King Publishing

Thanks

In honour of Bj and Donna (whom
he never stopped loving).

I want to thank David and Rachel for
their constant love and support without
which this project would not have been
possible. They are my strength and my
hope – and Bj would have loved them
very much.

To Emily King – because you understood
everything, cherished it and gave the
book life, and to your family who
selflessly made it possible for you to
spend quality time and energy on it;
Quentin Newark – our book designer,
supreme creative sounding board
and all-round great guy;
Alice Rawsthorn – who had
unwavering belief from the start
and made a huge commitment;
Alan Fletcher – the catalyst for
this entire project, who helped
me find the way.

To Jo Lightfoot and all at Laurence King
for their keen interest.

Thank you to Trevor Bond, Piers
Jessop, David Cammell, David Peters,
Dick Fontaine, Hugh Hudson, Derek
Birdsall, Ken Garland, Derek Forsyth,
Marisa and Edgar Bartolucci,
Tom Geismar, Ivan Chermayeff,
Tony Palladino, Sara Chermayeff and
everyone else who has helped me in
the last six years with their involvement
and enthusiasm.

And finally to all my close, personal
friends who have been the best support
system anyone could wish for. You were
always incredibly encouraging and
believed in this project from the very
beginning. You know who you are.

Eliza Brownjohn

Published in 2005 by
Laurence King Publishing Ltd
71 Great Russell Street,
London WC1B 3BP, United Kingdom
T + 44 20 7430 8850 F + 44 20 7430 8880
enquiries@laurenceking.co.uk
www.laurenceking.co.uk

Book originated by Eliza Brownjohn
Designed by Atelier Works

ISBN-13: 978 1 85669 464 3
ISBN-10: 1 85669 464 X

Front cover: Robert Brownjohn
and Margaret Nolan during shoot
for *Goldfinger* title sequence, London
1964. Photograph: Herbert Spencer
Back cover: Material from *Watching
Words Move* booklet, 1959/62. Brownjohn,
Chermayeff & Geismar Associates
Frontispiece: Press advertisement,
1966, Cammell, Hudson and Brownjohn
Associates. Art Director: Bob Gill

Printed in China

LAURENCE KING

Contents

The right man
Alan Fletcher

Bj was the right man, in the right job, in the right place.

There wasn't really a big division between design and advertising in London back then [the early to mid-1960s], but there were several different cultures. There was that gentlemanly English advertising thing, Ashley Havinden and so on, men who probably had lunch at the Reform Club. And there were the younger people who were evangelical about the Swiss school of design, the disciples of Max Bill and Müller-Brockmann. Then there was the American influence. It wasn't just Bj, there was a whole influx that was invigorating the industry: Bob Brooks, Lou Klein, Bob Gill … The advertising agencies were bringing them over. So, in that particular period you had these three cultures going on, and Bj was someone who could bridge them. He appreciated the Swiss school, but was essentially part of the American culture. He was always seeking the essence of the job, the big idea, rather than just a nice-looking layout.

Bj liked his ideas to seem off the cuff. I remember him telling me, 'Oh, I just thought of this idea, what do you think?', and Donna saying, 'Don't be silly, we were working on that last night until 2 am!' He liked to seem lazy, but he could work hard at it. He was being paid what we called megabucks, ten grand a year or something. It was really an enormous amount of money to the rest of us. (These days there are more designers in London than there are watchmakers in Switzerland, but in the early 1960s you used to be able to write all our names down on the back of an envelope.) He lived a glamorous life of money, cars and expensive restaurants, which was out of the pedestrian designer's orbit.

He had a real charisma, more than character. He was a good-looking man, and he was well read in a non-academic way. You always knew he was about five jumps ahead of whatever you were thinking. He was self-taught, or at least he didn't follow the accepted wisdom. He wasn't someone who went unnoticed: his lifestyle was very glamorous and visible, as opposed to most designers, who work hard in, wherever it is now – Clerkenwell or somewhere – and go home to Wembley on the tube.

There is something timeless about Bj's work. He never fell into the trap of doing something that was in the style of the moment, it was just not in his nature. He wasn't worried about the flavour of the moment, never thought of it even. Everything he did took a straight line from what he was thinking, what he wanted to express; any style in his work is absolutely his, it was just him and a piece of paper. You don't find many people who can do that.

Introduction

Robert Brownjohn was singular in both talent and character. During his relatively short career – a working life that lasted little over two decades – he attained a unique position in the worlds of design and advertising. Not only did he effortlessly bridge the fields of still and moving imagery, he also moved easily between abstract visual thought and commonplace graphic idioms. Rather than being governed by rules or formulas, his method of design was grounded in pure intelligence.

Brownjohn moved from New York to London in 1960 and within a few weeks of his arrival he had become one of the scene's defining personalities. His death in August 1970, at the heartbreakingly premature age of forty-four, was mourned as if he were one of the city's own. In truth, however, swinging London was only the last chapter of a multifarious existence. Born in 1925 in New Jersey, the son of an English immigrant bus driver, Brownjohn was encouraged to develop his artistic talents by his high-school art teacher. Deploying a combination of gift and audacity, he took himself to László Moholy-Nagy's Chicago-based Institute of Design in 1944. Once there, he overcame being one of the youngest in the class to make a profound impression on both peers and professors. He became Moholy-Nagy's protégé and later was offered a teaching position by Moholy-Nagy's successor, the architect Serge Chermayeff.

Brownjohn moved from Chicago to New York in 1950, where, after spending several years as a freelance designer, he established the firm Brownjohn, Chermayeff & Geismar Associates (BCG) with Ivan Chermayeff (Serge's son) and Tom Geismar. It was an exciting period, with days spent fusing modernist theories of design with the graphic language of the street, and nights passed listening to jazz or playing poker with Greenwich Village friends. Much of the work produced by BCG during this period appears as fresh now as it did when it was first designed.

In the late 1950s, Brownjohn's drug addiction – a long-term habit that he had brought under control a few years earlier with the help of his new wife Donna – resurfaced with painful consequences. The Brownjohn family decided to move to London, where he could register as an addict and receive medical help. It was a difficult period for all involved, but his transatlantic crossing could not have been better timed. England was just shrugging off the grey blanket of wartime austerity and colourful characters like Brownjohn were being welcomed with open arms. After short spells in the advertising agencies J. Walter Thompson and McCann Erickson, Brownjohn shifted into filmmaking, and in the mid-1960s

he teamed up with the producer/writer David Cammell and the director Hugh Hudson to form the company Cammell, Hudson and Brownjohn Associates. His outstanding title sequences for the Bond films *From Russia with Love* and *Goldfinger* (designed in 1963 and 1964 respectively) became the signature pieces of his career.

Brownjohn's London homes were in Notting Hill and Chelsea and his circle of friends encompassed designers, musicians, artists, authors, filmmakers and actors. All told, the story of his life establishes a bridge between iconic twentieth-century characters as diverse as Buckminster Fuller, Lenny Bruce and Keith Richards. At first glance these connections might seem unlikely, but in the light of the designer's abilities, appetites and enthusiasms they become quite clear. Brownjohn was one of a clutch of extremely distinctive characters who embodied the link between modernism and modern life.

Brownjohn's studio was cleared out shortly after his death by the designer Bob Gill, and much of the work was shown at a memorial event held at the American Embassy in London. Since that event, the portfolio has travelled the world in the company of Brownjohn's widow Donna and his daughter Eliza. Early in 2000, Eliza, inspired by the enthusiasm with which younger designers looked at her father's work, embarked on the research that led to this publication. Then based in Miami, she telephoned or e-mailed many of Brownjohn's friends and former colleagues in pursuit of information and additions to the archive. Moving to London in 2001, her first call was to her father's good friend Alan Fletcher, who provided a short list of names and numbers that blossomed into a network of vital contacts. Eliza assembled the material with love and care, and without her diligence, perseverance and insight this project would have been impossible.

For Brownjohn life and work were one and the same, but for the purposes of this book we have made an attempt to untangle biography from design. Admittedly this is a somewhat artificial exercise, but it is important not to allow the extremities of Brownjohn's story to overwhelm the brilliance of his output. No-one understands the extent to which Brownjohn's habits were related to his genius – maybe his addiction was intimately tied to his abilities, maybe it was a thing apart – but the significance of his talent is beyond dispute. This book is primarily a homage to one of the key designers of the post-war period.

The process of piecing together Brownjohn's story has been fascinating and I am extremely grateful to all those who agreed to be interviewed, especially his New York partners Ivan Chermayeff and Tom Geismar and his London colleagues David Cammell and Hugh Hudson. Edgar Bartolucci provided vital information about Brownjohn's time at the Institute of Design and his early years in New York, and Sara Chermayeff added a warmth to the tale that would have been sorely missed. Stanley Eisenman and David Enock fleshed out the view of life at BCG, and Tony Palladino, Angela Palladino, Dick Davison and Bob Gill offered

invaluable accounts of the man and the work. Willie Landels and David Bernstein told the tale from the employer's point of view, while Trevor Bond and Piers Jessop filled in the picture from the perspective of the employee. Angela Landels, Dick Fontaine and Bobby Gill all offered vivid descriptions of Brownjohn's ability to inspire.

Thanks also to Sam Antupit, Derek Birdsall, Frances Dickens, Richard Filipowski, Derek Forsyth, Ken Garland, Katy Homans, Martin Hurtig, Sanford Lieberson, Jack Masey, Kiki Milne, Bruce St Julian-Bownes and Jean Wadlow.

And, of course, very many thanks to Alan Fletcher, who started the ball rolling and much more besides.

Biographies

Sam Antupit Yale-educated designer Sam Antupit spent a year as a member of the Push Pin Studios in New York before becoming Art Director of *Esquire* magazine in 1964.

Edgar Bartolucci Edgar Bartolucci studied at the Institute of Design for a year in 1943, and subsequently established the firm Bartolucci & Waldheim with fellow Institute student Jack Waldheim. Their designs include the popular BaWa chair. In 1951 he moved to New York where he worked first with Bob Cato as BC Associates and later with Harold Lane as Instore Advertising.

David Bernstein Having studied English at Oxford, David Bernstein entered advertising in the early 1950s and joined McCann Erickson as a copywriter in 1954. Two of his advertisements were shown on the first night of commercial television on 2 September 1955, and after that he rose quickly through the ranks, becoming Creative Director of the company by 1961.

Derek Birdsall After studying at Central School of Arts and Crafts, Derek Birdsall founded the design group BDMW Associates. He designed the first Pirelli calendar in 1964 and later became the Art Director of *Nova* magazine.

Trevor Bond In 1950 sixteen-year-old Trevor Bond began working for the cartoon film studio W.M. Larkins. He stayed there until 1957, when he joined his former Larkins colleague, the celebrated animator Bob Godfrey, at Biographic Studios. He animated the Maurice Binder-designed titles for *Dr. No* and later worked with Brownjohn on the next two Bond titles and the Midland Bank advertisements.

Eliza Brownjohn Born to Robert and Donna in 1956, Eliza Brownjohn moved to England with her family in 1960. From 1963 to 1966, Donna and she divided their time between Ibiza and London. In the late 1960s, she attended various schools in the UK. After her father's death, she moved to New York with her mother and, in the mid-1970s, she worked for the art director Henry Wolf. In the 1980s and 1990s she pursued a successful career in the recording industry and she currently lives in Miami with her husband David and daughter Rachel.

David Cammell After graduating from Cambridge, David Cammell established a photographers' agency and later teamed up with Hugh Hudson to form the film company Cammell Hudson Associates. Joined by Brownjohn in 1966 they became Cammell, Hudson and Brownjohn Associates. In 1968 David acted as Associate Producer on his brother Donald's film *Performance*. The company disbanded because of financial difficulties in 1970.

Bob Cato A contemporary of Brownjohn's at the Institute of Design, Bob Cato went on to form BC Associates with fellow Institute student Edgar Bartolucci. He left the partnership in 1955 to work full-time for the BC client CBS television. He acted as best man at Brownjohn's wedding to Donna Walters.

Ivan Chermayeff Son of celebrated architect Serge, Ivan Chermayeff was born in England, but moved to the United States with his family in 1940 at the age of eight. He was educated at Harvard University, the Illinois Institute of Technology and Yale University, before establishing Brownjohn, Chermayeff & Geismar Associates. After Brownjohn's departure from the firm, he continued to work with Tom Geismar as Chermayeff & Geismar Inc. The company became one of the most successful design consultancies in New York.

Sara Chermayeff Sara Chermayeff married Ivan in 1954, a year before her graduation from Sarah Lawrence College with a BA in creative writing. She has worked as an artist since the 1960s.

Dick Davison Starting work in the back of a printing plant, Dick Davison moved to the front office and eventually acquired his own business, Colorcraft Lithographers. During the 1950s the company earned a reputation for quality print with its work for New York's best design studios and for artists such as Jasper Johns.

Frances Dickens Frances Dickens (née Desnaux) began working at McCann Erickson in 1959 aged eighteen. She spent the next seven years as an assistant in the agency's television department and also ran the McCann film club.

Stanley Eisenman While studying art at Brooklyn College, Stanley Eisenman took a design course with Ivan Chermayeff. On graduation in 1957 he abandoned his ambitions to be a fine artist and joined Brownjohn, Chermayeff & Geismar Associates. He left in 1961, when he formed Eisenman & Enock with fellow employee David Enock.

David Enock David Enock studied advertising and design at New York Community College in the mid-1950s and later worked at several New York agencies. In 1958 he took his portfolio to Brownjohn, Chermayeff & Geismar Associates and was offered a job on the spot. He left in 1961, when he formed Eisenman & Enock with fellow employee Stanley Eisenman.

Richard Filipowski Richard Filipowski studied at the Institute of Design in the mid-1940s and was later offered a teaching position by Serge Chermayeff. He remained in Chicago until 1950, when he moved to the Harvard University School of Architecture.

Alan Fletcher After studying at the Royal College of Art and Yale University, Alan Fletcher established the London-based firm Fletcher/Forbes/Gill with fellow designers Colin Forbes and Bob Gill. In 1965 this firm evolved into Crosby/Fletcher/Forbes and, in 1972, became Pentagram.

Dick Fontaine — After graduating from Cambridge, Dick Fontaine took a job at Granada TV where he worked on the 'World in Action' series, and in 1966 he became a member of a filmmaking co-operative. His films include the 1965 documentary *The Beatles at Shea Stadium*.

Derek Forsyth — Derek Forsyth studied graphic design at Central School of Arts and Crafts and became Art Director at Pirelli in the early 1960s. His best-known legacy is the Pirelli calendar, which he art directed between 1964 and 1974 and between 1998 and 2003.

Ken Garland — After studying at Central School of Arts and Crafts, Ken Garland became the Art Director of the Council of Industrial Design's magazine *Design* in 1956. He left the magazine in 1962 to form his own company Ken Garland Associates.

Tom Geismar — Educated at Brown University and Yale School of Architecture and Design, Tom Geismar spent two years in the exhibitions unit of the United States Army before joining Brownjohn, Chermayeff & Geismar Associates in 1957. After Brownjohn's departure from the firm, he continued to work with Ivan Chermayeff as Chermayeff & Geismar Inc. The company became one of the most successful design consultancies in New York.

Bob Gill — Bob Gill studied at Philadelphia Museum School and then became a freelance designer and illustrator in New York. In 1960 he moved to London, working first for the advertising agency Charles Hobson and later joining fellow designers Alan Fletcher and Colin Forbes to form Fletcher/Forbes/Gill. In 1965 he left F/F/G to work independently. He returned to New York in 1975.

Bobby Gill — Bobby Gill trained as a painter, but later taught graphic design in various schools including East Ham College of Art, the London College of Printing and the Royal College of Art. She married Bob Gill in 1965.

Hugh Hudson — Hugh Hudson went straight from school at Eton to working in a London advertising agency. In the early 1960s, he teamed up with David Cammell to form the film company Cammell Hudson Associates. Joined by Brownjohn in 1966 they became Cammell, Hudson and Brownjohn Associates. After the firm disbanded, he worked on television commercials before directing his first feature *Chariots of Fire* in 1981.

Martin Hurtig — Martin Hurtig studied at the Chicago Institute of Design between 1948 and 1952.

Piers Jessop — Starting his career at the London-based cinema-advertising agency Pearl & Dean in 1961, Piers Jessop later became an editor at World Wide Pictures. He joined Cammell, Hudson and Brownjohn Associates as a supervising editor in 1966.

Angela Landels	Angela Landels began her career at the London advertising agency Coleman, Prentis & Varley at the age of sixteen. She worked her way up the company and, in the late 1950s, moved to J. Walter Thompson as an art director. She spent the 1960s working as a creative director and a freelance fashion illustrator.
Willie Landels	Born and raised in Italy, Willie Landels joined J. Walter Thompson in London in 1950. He first became an art director and later head of the art department. He left in 1965 to edit and design *Harpers & Queen*.
Sanford Lieberson	American agent Sanford Lieberson arrived in London in 1965 to open a branch of the Los Angeles company Creative Management Artists (CMA). He represented, among others, The Rolling Stones. In 1968 he left CMA to produce the film *Performance*, working from an office in Shawfield House.
Jack Masey	In the 1950s and 1960s Jack Masey was an exhibition designer for the US government. He acted as Design Director of the 1959 American National Exhibit in Moscow and worked on the US pavilions for several world's fairs.
Paul May	As a young London-based designer, Paul May heard a lecture by Brownjohn and was inspired to move to New York and seek a job with Chermayeff & Geismar Inc. On his return in the late 1960s he became a designer for Thames Television.
Kiki Milne	Norwegian-born Kiki Milne came to London as a teenager in the mid-1950s. She married Nicky Byrne (later the merchandising manager for The Beatles) and the two of them ran various boutiques in the King's Road area. In 1964 she closed her shops to concentrate on making costumes for film and theatre. She lived with Robert Brownjohn for part of the 1960s.
Angela Palladino	Born and raised in Italy, Angela Palladino married Tony in 1958. She took up painting in the late 1950s and became a respected folk artist.
Tony Palladino	After studying at an Arts High School in East Harlem, Tony Palladino worked his way up through the New York advertising industry. In 1958 he founded Blechman Palladino with R.O. Blechman, and in 1964 he moved to London to establish a branch of the New York agency Papert Koenig Lois. Returning to New York in 1966, he became Creative Director at Van Erunt Advertising.
Bruce St Julian-Bownes	Bruce St Julian-Bownes worked at McCann Erickson as an account handler between 1962 and 1965.
Jean Wadlow	Jean Wadlow began her career as PA to the chairman of the advertising agency Charles Barker. Later she joined the agency's cinema and television department and, aged twenty-two, became head of department. She commissioned the hugely successful series of Midland Bank cinema advertisements.

Life

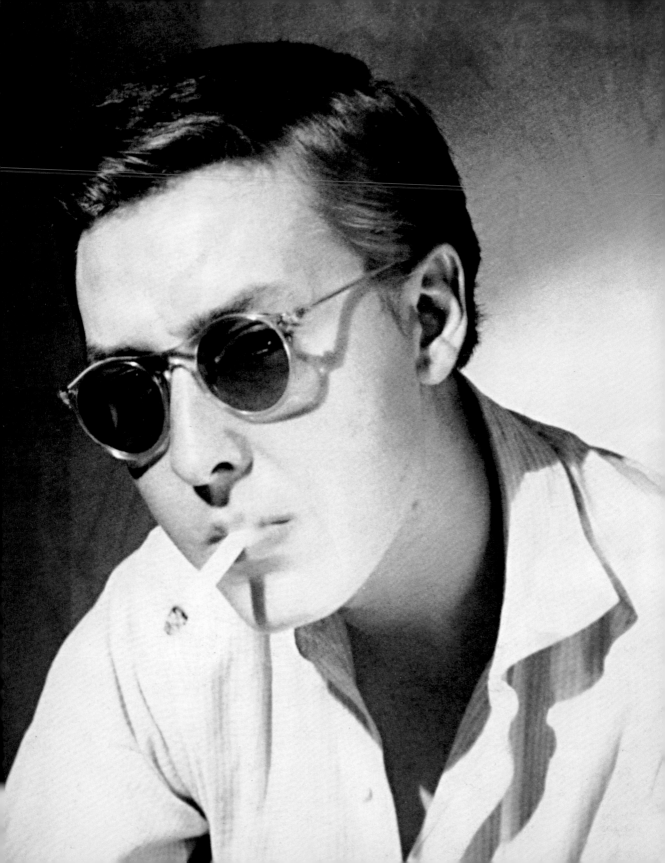

1925–1950 Chicago

8 August 1925 **Born in Newark, New Jersey to Anna and Herbert.**

Eliza Brownjohn This is what I know: He was born in Newark in 1925. [His mother Anna] was already in the States when Herbert came over. He was British, he came from Highgate, but I don't know why he emigrated. He worked as a bus driver and they had three children. Bj was the baby, his sister Elaine was much older, and in the middle was Margaret. Margaret was the only one that Bj got along with, she was on the same level and they could relate to each other. Even so, he was very much the black sheep of the family.

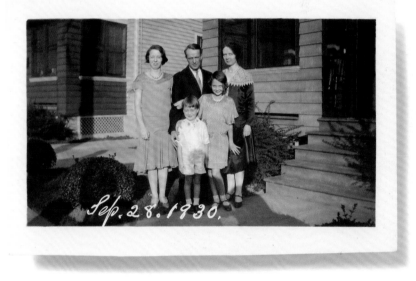

Sep. 28. 1930.

Bj's father died when he was twelve. He was very close to him, and when he died that was it, he no longer had any real connection to his family. They didn't understand him and he felt like an outsider. It really affected him. His mother was unbelievable, she just didn't get it. She was very strict, icy cold and unemotional.

When Bj visited New York in the 1960s, he would bring me over to stay with my Grandma. At that point she was living in New Jersey with my Aunt Elaine, who was a widow, and my cousin Ellen. I can only imagine what it must have been like

for Bj growing up there! It was a really uptight place. She had all the furniture covered in plastic, and I wasn't allowed to wear clothing that showed my skin.

I think Bj put all his efforts into school because there was nothing for him at home. His art teacher really helped him, giving him guidance and encouragement. Had he come from a different kind of family, he might not have taken things on so young. He needed to find freedom from that stifling background.

1939–43 Attends Arts High School, Jersey City.

Eugene M. Ettenberg (writing in *American Artist*, Summer 1959)
… he was born and grew up in Newark, New Jersey. Emulating his older sister, who was a painter and fashion artist, he absorbed all the art that the Arts High School had to offer, encouraged by a teacher, Miss Isabell Stewart. (Looking back, how many of us have a Miss or a Mr. 'Stewart' to thank for steadying us in our first unsure steps!)

Tony Palladino I think he aligned his childhood with the kind of childhood I had. He told me some specifics about his mum and dad, you know, details like his mother wore an apron round the house, but he was very sketchy. Our childhoods were similar because we came from a certain kind of neighbourhood. I came from East Harlem, which is considered bad territory in New York. There were the racketeers of the neighbourhood and Bj always used to like to think of me as a demi-racketeer. But I was never really a tough guy. I was tough because I had to survive, but I always wanted to be an artist.

Bj always liked to think that his old man and my old man were the same kind of guys. They were tough guys who were a pain in the fucking ass, but they really wanted us to make something of ourselves. They were deliberately disciplined with us.

1943 Attends Pratt Institute.

Eugene M. Ettenberg *On graduation in 1944, Brownjohn went on to Pratt Institute, where, in his freshman year, he met Will Burtin. Burtin's teaching and his stories of the wonders of the Bauhaus School fired young Bob into entering the Institute of Design in Chicago, as the nearest approach in America to that German experimental school.*

1944 Arrives at the Chicago Institute of Design.

Edgar Bartolucci I met Brownjohn in Chicago at the Institute of Design. It was during the war and I, like most of the other students, was listed as 4F, which meant we weren't well enough for the army. I had an arm that wasn't working correctly, I don't know what Brownjohn's problem was, but we were all misfits as far as the army was concerned.

At that time there were only about twenty of us and we got to know everybody. Brownjohn came three weeks late, so he was not in the class picture. I remember people saying, 'Hey, this young kid has arrived.' I don't think he had enough money from his family, because he had to freelance. Most of the fellas did odd jobs, working at the silkscreen shop or something.

Richard Filipowski　I first met Brownjohn in 1944. He invited me to his apartment to view his graphic work and I was overwhelmed by his technical mastery, particularly that of illustration. However, when I complimented him, he told me to 'get out!', which struck me as somewhat odd. My general impression was that he was conceited (in my opinion he had every right to be) because of his great talent. He also made fun of people with lesser talent. Once another student had made a sculpture out of clay, and Brownjohn took it, put it on the floor and squatted over it.

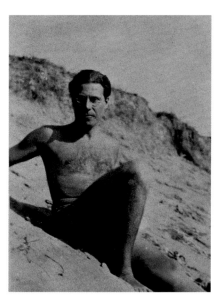

László Moholy-Nagy, 1920s

Edgar Bartolucci　I don't know where he was living the first few months after he arrived, but, pretty soon, he moved in with Bob Cato and Dave Aaron. They were already roommates and Brownjohn didn't have a place, so they said he could stay for a night or two. But after about two months he became an unwanted guest. Cato and Aaron were very neat, and Brownjohn was the opposite, it was like *The Odd Couple*. Eventually they picked up his stuff and put it outside the door.

1944–46 **Taught and befriended by László Moholy-Nagy, the Director of the Institute.**

Richard Filipowski
Moholy appointed me to a teaching position just before he died. I worked alongside invited lecturers such as Jose Loisert and Siegfried Gideon, as well as many others. The courses Brownjohn would have taken were Workshop, Physics, Math and Introduction to Architecture.

Edgar Bartolucci
The Institute was different from other schools in that you could take as many courses as you wanted, paying no more than your original fee. They had a night school too. School started at 9 am, but everybody had made their own key, so most students got in around eight in the morning and they didn't leave until ten at night.

Studio, Institute of Design, mid-1940s

You had a basic workshop and teachers in architecture and graphics, and there were also people lecturing on mathematics and other odds and ends. It was much more enlightened than other art schools. They were like factories that taught technique. At Chicago they didn't teach techniques at all, they opened your eyes to other things.

After you left the Institute, you were interested in everything and anything. Moholy was more child-like than anybody I know. He would see something that others thought was ordinary and make you realize that there was more to it. I remember a student blowing bubbles in a ten-gallon jar. Most of the students said, 'Oh, it's nothing,' but Moholy was crazy about those bubbles. He would

László Moholy-Nagy, Lithograph, 1920s, 45.5 x 60.5 cm (18 x 23 ³/₄ in). Estate of Robert Brownjohn

Chicago

make you look at things differently and students eventually developed that eye, the ability to see things in a new light.

You have got to remember that all the students at the Institute were different. There was an instructor who had also been up at Frank Lloyd Wright's school. He said that the difference between the two was, at the Wright school there was one genius and it was Wright, but, at the Institute of Design, Moholy was only one genius among many. Sometimes people like to tell you that Brownjohn was completely off the wall. But, basically, the Institute of Design students, all of them, were off the wall.

Eugene M. Ettenberg *There for the next three years he worked under Moholy-Nagy. Product design excited him most, and Moholy-Nagy allowed him to work on his favorite Parker Pen account. Shortly thereafter he was made a student instructor in the Foundation Course at the Institute.*

1946 László Moholy-Nagy dies of leukaemia. His book Vision in Motion is published posthumously and includes an illustration of Brownjohn's student work 'Tactile chart in bent plastic'. Moholy-Nagy is succeeded as Director by Serge Chermayeff and Brownjohn soon becomes Chermayeff's assistant and friend. During this period Brownjohn frequents Chicago's jazz clubs, as do Serge Chermayeff and Buckminster Fuller.

Serge Chermayeff (interviewed by Betty Blum for the Chicago Architects Oral History Project, 1986)
I had two excellent assistants, not from faculty, but they were leftover from the best students of Moholy's. Brownjohn was the best.

In our school, you couldn't recognize who did what unless it was very brilliant like Robert Brownjohn. He was so gifted that it was inescapable that he was the best man around the place.

Brownjohn, I'm afraid, became 'hooked'. On heroin, I believe. While it was tremendously expensive here, all the drugs were, [they] were penetrating the schools. I had an awful lot of trouble because the drug police really weren't a big enough force to attend to a relatively small school. We had very little help from them. The drugs penetrated very, very deep.

Richard Filipowski While other students and faculty smoked cigarettes, Brownjohn told me that he was trying marijuana. He frequented the black neighbourhoods where he could easily obtain it. Serge Chermayeff sent Brownjohn to a rehab facility, but that didn't cure him. The tragedy was that this great talent was wiped out by a heroin addiction.

Edgar Bartolucci	Most of us students were pretty erratic in our behaviour, but Bj was different. He had problems that other people didn't have, he got involved with harder drugs than others.
Piers Jessop	He once told me that he started getting in trouble, by which I think he meant heroin abuse, because he was mixing with these gods at the Institute of Design, people like Buckminster Fuller. I remember him saying that he felt very insecure and nervous about it, out of his depth, and I figured that he was talking about the origin of his drug habit.
Sara Chermayeff	Barbara Chermayeff said that when he lived with them in Chicago he was a wonderful tenant. He had all these very strange friends, who were of course Billie Holiday and Charlie Parker and everybody. She said, 'They would all come over and they were so quiet, and then I realized they were all on drugs!'
Ivan Chermayeff	I knew Bj early on when I was still a student. He was at the Institute of Design and my father was very closely involved with him. He used to come stay with us at the house in Wellfleet when he was in college, way back. I guess it must have been in '49.
Richard Filipowski	My last encounter with Brownjohn was probably in 1949 at Chermayeff's house in Wellfleet, in Cape Cod, where we were both staying. He treated us to a supper of mussels, which he had gleaned from various piers in the harbour. It was a very delicious occasion.
Sara Chermayeff	That crowd of Marcel Breuer, and Ivan's father Serge, and Gyorgy Kepes, they were all European bohemians, very different types. My family went to Cape Cod, too, but my father was an Irish man who had only gone to the eighth grade and those intellectual types scared him a bit. He always thought they were a band of gypsies, but I, of course, thought they were wonderful. Serge had flair – he went around barefoot – and they had this wonderful place in Wellfleet.
Ivan Chermayeff	I used to call him Bj the golfer: Bj and I were staying at my parents' place in Cape Cod one summer, and nearby there were these golf places, driving ranges. They never bothered to pick up the balls, and in the middle of the night we were driving once through fields and fields of what looked like mushrooms. We drove up and down and collected hundreds of golf balls and then Bj and I drove them from the top of the hills into the middle of the pond in Wellfleet.
Late 1940s – early 1950s	**Assists Chermayeff in teaching and teaches night classes of his own.**
Sara Chermayeff	I think Brownjohn went into teaching as an assistant or something. They all loved him. He was very funny and very charming. Very, very charming. I can't think of anybody like him really.

Martin Hurtig My student days at the Institute of Design were from '48 to '52 and during that period Brownjohn was a part-time member of the faculty. Our student body was rather small and therefore we were superficially acquainted with most everyone in the school, but my only impression of Brownjohn was that he seemed to be a very private person and somewhat remote.

Freelances as a graphic designer for Coronet and Esquire magazines with fellow students Edgar Bartolucci and Jack Waldheim.

Edgar Bartolucci I was freelancing with another designer from the school called Jack Waldheim. Eventually we got a little studio, calling ourselves Bartolucci & Waldheim, and Bj would do things for us. We had first started working while we were still doing classes at the Institute, and Bj did too. We needed to supplement our incomes. Later on Bj also freelanced at *Esquire* and another magazine called *Coronet*. I think he was doing paste-ups for them.

Eugene M. Ettenberg *On leaving school, Brownjohn spent the years of 1948 and 1949 as an architectural planner with the Chicago Plan Commission, helping to develop the Civic Center for Chicago. He then returned to the Institute of Design as a full-time instructor of product design, only to leave in 1951 to go to work for George Nelson as a designer.*

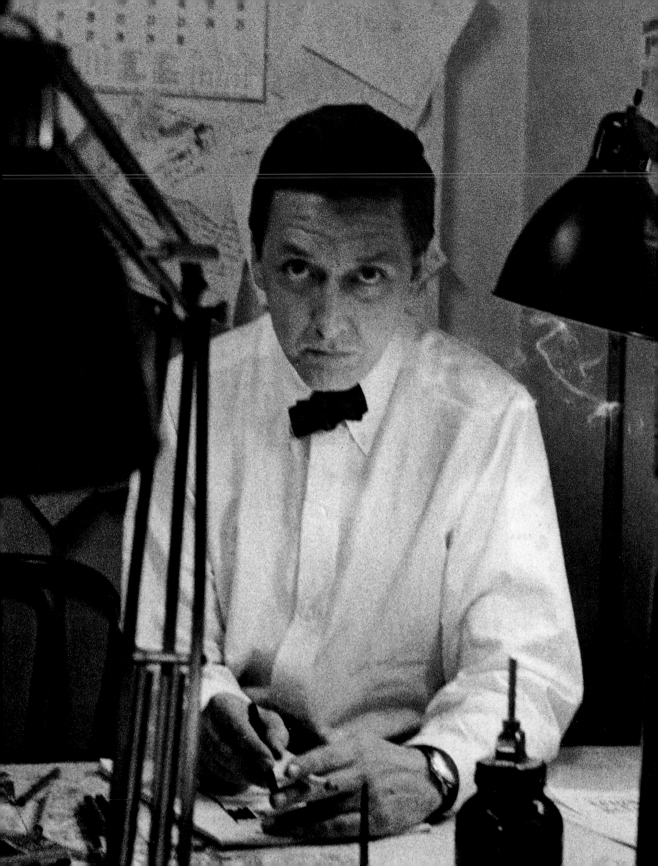

1950–1960 New York

1951 **Leaves Chicago for New York.**

1951–56 **Works as a freelance graphic designer in New York for clients including George Nelson, then the Design Director of Herman Miller, Edgar Bartolucci and Bob Cato.**

Edgar Bartolucci A few years after I left Chicago I started a design business in New York with Bob Cato, a company called BC Associates. Brownjohn had a drug problem and he came out from rehabilitation to see us. He needed a job, so he worked for us on and off. I remember that a cigarette was a permanent fixture in his hand; his drafting paper was always getting burnt.

Bob Cato Bj was belligerent, anti-social … He never wanted you to find anything out about him, he wouldn't give anything away. He had a keen wit and extraordinary sense of humour. We had terrible fights, but he was absolutely wonderful and adorable. He had a keen and available mind, he worked hard not to work.

Edgar Bartolucci Bob Cato started working full time for CBS in 1955 so he left the company and I tied in with a display manufacturer by the name of Lane Displays. Harold Lane and I were partners and we changed the company name to Instore Advertising. Sometimes Brownjohn worked for us steadily for two or three months, but then he would get interested in something else and disappear. He would always come back, eventually. I didn't even know whether he had an apartment, because he would often end up sleeping in the office. We would come in and find him asleep on a drafting table. He would say, 'Well, I worked late and I didn't feel like going.' Truthfully, we didn't know. He had a key to the place. We had nothing that could be stolen, so it wasn't a matter of who you gave the key to.

Early 1950s **Becomes a friend of Charlie Parker, Miles Davis, Stan Getz and others.**

Dick Davison My brother was a jazz musician and so I was involved with jazz musicians most of my life. Bj was attracted to them too. We went to the Half Note, where probably the most loaded jazz musicians in the world were playing. John Coltrane and Miles Davis, guys who were really zonked. We all liked that kind of thing.

Ivan Chermayeff A little before we were in business together, I was spending the summer as a waiter in the first-class carriage of the *Bermuda* [*The Queen of Bermuda*, Furness Bermuda Line]. On my days off, I used to leave the ship and spend time

with Bj. We would meet all kinds of people at all hours of night. I remember spending the evening with Miles Davis – apart from being pretty great at what he did, he was a very interesting guy.

Edgar Bartolucci At night, when he had finished working, he would leave the office and go down to the Village, hang out with all these musicians. And then you wouldn't see him for three or four days.

August 1955 Marries Donna Walters, and in March 1956 their daughter Eliza is born.

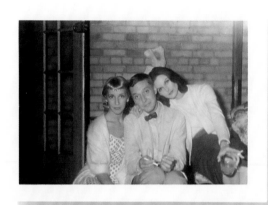

Brownjohn with Donna and Anne St Marie, 1957

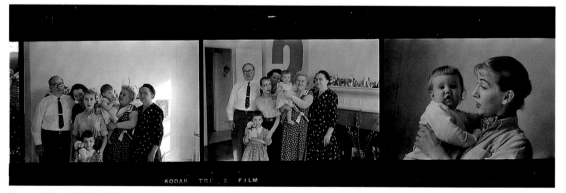

Donna and Eliza with family, 1957

Edgar Bartolucci	It was only after he met Donna that he worked for us steadily for a period of about six months. He was much more stable, much more consistent. Without her he was really lost.
Ivan Chermayeff	I worked with Bj one summer making point-of-sale displays for beer, or whatever. He was working with another Institute of Design person, Edgar Bartolucci – Bart – who designed the BaWa chair. It was a little company right near the Museum of Modern Art on 53rd Street.
Edgar Bartolucci	We were going great guns then. We had this project for CBS. They were going to show their TV sets in the ballroom of the Waldorf Astoria and invite their salesmen from all over the country. We had two or three weeks to put on this show, with all the televisions and the fixtures. We had to dress the ballroom, putting up silkscreen panels with copy. Brownjohn was in charge of getting the graphics together, and in the meantime he had run into Ivan Chermayeff. He needed help, so Chermayeff came to work for us for about three weeks. A few months after that Brownjohn, Chermayeff & Geismar got together.
Ivan Chermayeff	At the same time Bj was working for Cato and Bartolucci, he was freelancing for another guy, someone who produced design for people, annual reports and things like that. All around this guy's office were these big abstract paintings, six or eight of them. Bj really didn't think much of them, he thought they were pretentious. So one night, when the office was empty, we opened the frames of the paintings and added some bits of black tape, he really changed the direction of all these terrible pictures. And the great part of the story was that the guy never noticed. Bj visited the office some time later, and there they were, just as Bj had left them.
Sara Chermayeff	I remember when I first met Brownjohn in 1955. Ivan and I were walking in the Village on Greenwich Avenue and this cab lurched to stop, screeched to a halt, and Bj leaped out of it and recognized Ivan. I had never seen him before. He had in his hand a huge wad of money, a roll of money, which he said he'd found in the cab, but now, knowing Bj, that isn't necessarily so. It was a memorable meeting. It wasn't very long after that that they went into business together. I was a bit jealous of Bj myself. I felt that Serge and Bj were the only people that Ivan respected, he had an animal attraction to them, I saw that. Ivan just thought he was wonderful, he really did.

Either that night or very soon after he took us back to the one-room flat he shared with Donna. I think he was working for I. Miller, a very fancy New York shoe store, at the time. Andy Warhol was doing the illustration and, I think, Bj was involved in that. I remember seeing the Warhol shoes for the first time when I went to his house. |

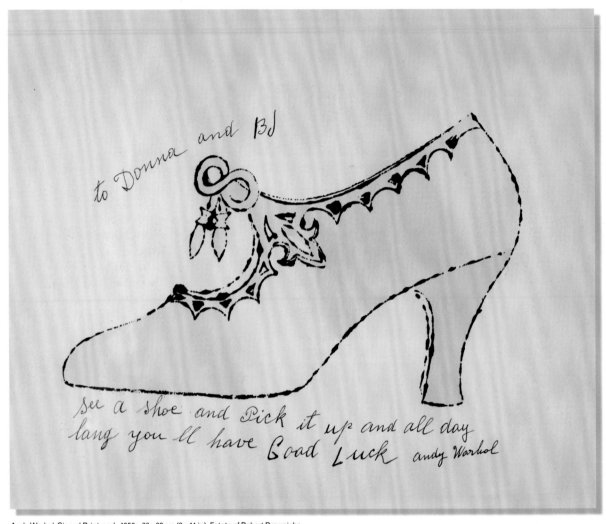

Andy Warhol, Signed Print, early 1950s, 23 x 28 cm (9 x 11 in). Estate of Robert Brownjohn

1956 Starts partnership with Ivan Chermayeff.

Ivan Chermayeff We went into business together because there was something to be done in graphic design and not so many people to do it. It was not that there was no competition, but there was an opportunity. If you took your portfolio to a publishing company, you could get some work, more or less.

Sara Chermayeff Bj and Ivan had a great time together when it was just the two of them at the beginning. It was all jokes and carrying on and lurching here and there, and they started to be really good and get work. He was off drugs at that point, definitely. Donna had locked him up in this little apartment. She was proud of it. She had literally locked him up, he had wanted her to. Bj and Donna's daughter Eliza is a little bit older than my first daughter Catherine. I inherited all her baby equipment, high chairs and the like. Our families spent a lot of time together.

One night we were celebrating our first anniversary, or something like that, and we went to Bj and Donna's place. They had moved to the West Side and they had a really pretty apartment, a big place with marble fireplaces and stuff. It was fancy in the nicest possible way. It was the parlour floor of some grand old house and there was no furniture, it was almost completely empty. Donna, who was a good cook, had made a kind of shrimp dish. But Bj said, 'The big thing is the dessert, I've made the dessert, wait till you see the dessert.' The dessert, the dessert! So we had this delicious dinner and then came the dessert. It was a great big bowl of jello and in it he'd put nickels and dimes, all stirred in. He had worked and worked on it so they were all even. Imagine that!

31

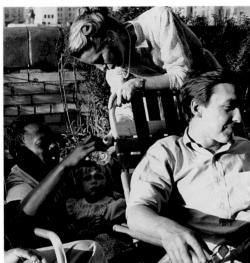

Miles Davis, Amanda Lewis, Laurie Lewis and Brownjohn, 1958
Photographed by Gary Lewis

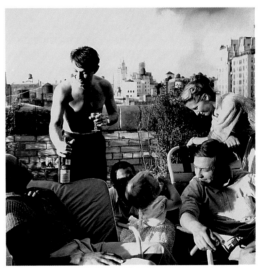

Sara Chermayeff I remember the poker games in our living-room, which included not only Steve McQueen [with whom Donna had a relationship before marrying Brownjohn], but also George Peppard and George Grizzard. How odd that this kid from New Jersey would end up great friends with all of them, and with Miles Davis and Charlie Parker. People would say that it was all to do with drugs, but I remember him and Miles Davis together, and it was not about drugs at all, they loved each other. People loved Bj, it was just that they couldn't always deal with him because of the addiction. It made him unpredictable. But when he wasn't on drugs he was a darling person. He was so sweet with Eliza when she was a baby. I remember him bringing her over and being so careful with her, a little girl all dolled up by Donna, she would come in little organdie dresses.

1957 **Tom Geismar joins, creating Brownjohn, Chermayeff & Geismar Associates (BCG).**

Sara Chermayeff When they went into business together, Ivan wanted to bring in a third person, someone to create a balance, particularly because Bj was that bit older. Ivan had been at Yale with Tom Geismar, so he approached him to come in with them.

Tom Geismar After graduating from Yale in 1955 I was drafted into the army. It was wartime, but at that point the Korean War had wound down and I got accepted into the army exhibition unit. I sent in my portfolio and right at the last minute the orders came through and I avoided getting shipped to Korea. It offered a wealth of experience, there were sculptors in the machine shops and painters making murals, a wonderful bunch of people! Then, in 1957, Ivan contacted me. I had known him at Yale. He said, 'I am really sick of freelancing and I want to start an office. There is this fellow who my father knew who I would like to do it with. Would you join us?'

Stanley Eisenman becomes BCG's first employee.

Stanley Eisenman I went to Brooklyn College, doing fine arts. In my last year I had to take a graphics course. The man who usually taught the course was on sabbatical and in his place was a young guy who looked like a student – it was Ivan! At the end of the year he asked me to work with him.

I remember the first thing they made me do. They had this huge bag of cotton reels – God knows where they found it, this huge bag! And they made me thread them up to create a curtain, a thick curtain of reels that you had to push your way through to get to the studio. That was my first job!

Bj's teeth were all false. He got some dentist to put in little snaps so that they clicked into place. He loved to go through the whole explanation of how the teeth worked, to give demonstrations.

Tom Geismar The office was one big room, a walk-up in a building on the West Side. I think that it was Bj who had the idea that we should somehow divide the room. It had to be Bj who thought of going to the garment district and getting all the spools, the actual spools they used for thread. We picked up thousands and we strung them up to make dividers. There was only one problem with the spools. We had no air-conditioning and in the summer it was terribly hot, I think we had one window that opened up in an alleyway or something, so we bought this one huge rotating fan. As the fan turned the spools would go 'GRRRRRRRR'.

This is a story that typifies Bj: his teeth were in terrible shape and finally he went to a dentist. I'm surprised that he went, but he must have been in pain.

The dentist told him that he would have to pull them out and replace them with false teeth. So Bj insisted that the false teeth be made as brown and as mouldy as the ones they were pulling out. And they did, somehow they managed to make them really look rotten.

Eugene M. Ettenberg (writing in *American Artist*, Summer 1959)
Brownjohn looks more worldly than his thirty-three years would suggest – and tired. But his weariness was easily explained after I learned all he does during the week. He is slim and of medium height, with casually combed sandy hair, and he has a trick of explaining things in short, enthusiastic bursts, while his eyes show suppressed excitement.

Sam Antupit The first time I met Bj was in BCG's 50th Street office. I remember walking in there and going up the stairs. They were so cheap, so impoverished in the office that they didn't have walls! There were beaded curtains instead. It looked like you were walking into a brothel. And it was filled with smoke, totally filled with smoke. Neither Tom nor Ivan smoked, so it was obvious who was responsible. So I walked into this den of iniquity and I hear this growling over in the back, 'Yes, it's done!', 'No, I'm not going to do it!', 'They never understand anything!' Lots of little staccato bursts coming out from behind this cloud in the corner. It was just so bizarre. I was still in the army at that time and I thought, 'Oh boy, work is going to be very different!' So they introduced me and there was Bj with the cigarette welded in between his fingers. And he was drawing, moving things around and cutting, and the cigarette always stayed in his fingers! Ivan said, 'That's Bj over there', as if he was a chained monkey.

Alan Fletcher I visited Brownjohn, Chermayeff & Geismar while I was a student at Yale. It was probably on my first or second trip to New York, they were on my list of people to see so I called them up. It was all very glamorous, they had these nice jobs and a nice office. At that time, I hadn't even been paid for a job! I remember that they had a wall made of corks that I was very impressed with. I applied for a job actually. They said, 'Look we don't have enough work', but we became friends.

Tony Palladino I first met Bj through Ivan, when they had this company, Brownjohn, Chermayeff & Geismar. That's when I connected with Bj, because we seemed to sense each other coming from the same place of survival and wanting to do something really great.

I started my business in New York in 1958. Bj gave me this, it's a period from a shop sign. I was in partnership with a guy named R.O. Blechman, we were called Blechman Palladino. He gave Blechman a comma in the same scale, wrapping them each in a separate package. The period represented my personality and the comma was Blechman. That was very Bj, he had the ability to be definitively elegant.

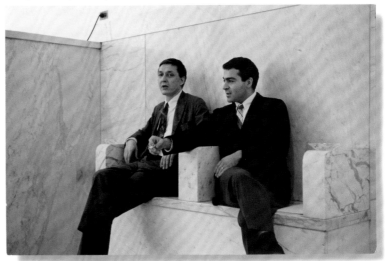

Brownjohn and Tony Palladino, late 1950s

Ivan Chermayeff · We were pretty scratchy when we started out. We would do stuff for anybody and we only had a few little jobs. We mostly did letterheads for people we knew and owed money to – nursery schools, photographers, baby doctors, whoever.

Tom Geismar · Did Ivan tell you about André Surmain? There was a couple living in a brownstone next to our second office and they had a little dog, so we would see them walking it out on the street. We started talking. He was catering for a Mexican airline and he asked if we could do a logo for him. We did an elongated 'E', I think it was called Epicure Kitchens or something. Anyhow, eventually he converted their apartment into a restaurant called Lutèce, which became the fanciest restaurant in New York. Meanwhile his wife had started a travel agency. Nancy Surmain was her name. We did her letterhead too. That was just a chance meeting on the street!

Dick Davison · My business was called Colorcraft, and Brownjohn, Chermayeff & Geismar designed my logo. It was a very small company, but we did work for a lot of artists. BCG influenced me in so many different ways, I can't begin to tell you. At the printing plant we were operating on a shoestring, trying to do the best work we could. We had equipment that we were holding together with Scotch tape and mailing wire, but we made it into a really good place. We painted it and BCG helped us decorate it, and we made it into an interesting space.

I also kept a racing stables as a hobby and Bj designed the letterhead. I invited him down there and he brought his camera and the next thing I know I had a letterhead. I remember the day that he took the photographs out at the farm, he enjoyed that kind of experience, he wasn't used to seeing racehorses.

Mid-1950s **Teaches part-time at Pratt Institute and the Cooper Union.**

Eugene M. Ettenberg *I first came upon Brownjohn's work on the walls of a narrow corridor in the art-school building of Pratt Institute where he teaches advanced advertising design in the evening school. There was a small unpretentious showing of the work of faculty members. He had but two pieces up, as I remember it – a magazine cover and a record-album cover – but they stopped me. They had a lively fancy and a sparkle that made me return later to look at them again and to find out who this colleague of mine might be.*

David Enock joins BCG as an assistant.

David Enock I had gone to what was then called New York Community College and done a two-year advertising and design course. Three or four jobs down the line I heard that BCG were looking for someone, so put my book together and went over there. I didn't know that much about their work, but I knew them as a name.

I arrived and Ivan was on vacation, but Tom and Bj were there. Bj asked me how much I was making, and I told him $100, and he said, 'Oh, I'll give you $95.' That's how I got the job.

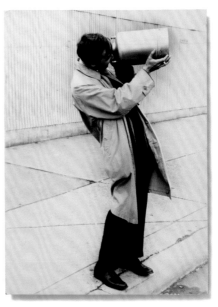

Brownjohn with a Pepsi-Cola syrup canister, late 1950s

I had this black portfolio and it had no cover, so you never knew which was the top. I cut a very thin line, probably a thirty-second of an inch wide and about two inches long of masking tape, and I put it on the front of the book, just at the right-hand corner, so I would know. Later Bj said, 'That's why I hired you.' It must have been around 1957.

BCG was a huge influence on my life. I never even knew about the Bauhaus before! I learnt a lot very quickly, it was very important and exciting to me. It was a wonderful business and a wonderful attitude.

Ivan Chermayeff Bj would find answers anywhere. There was a book jacket he did, the subject had something to do with doodling, and Bj would always scribble while he was on the phone. He took his blotter, or whatever it was underneath the phone, and that became the job. It represented the book perfectly. That was typical of Bj, to pick up on something very fresh and new. He was very good that way.

Sam Antupit When I visited BCG I saw some incredible wide swatches of brilliant colour. I heard Bj say 'Aechh' as he holds up this thing that I had never seen before. It turns out to have been a magic marker. The big fat old ones, they weren't magic markers for artists to use, they were from the hardware store, for marking cartons and stuff like that. I think they came in three colours. It made a new smell in the room, magic marker and smoke! I said, 'That's great, what are those?' 'I don't know, but they're ten cents a piece,' he said. I asked how many colours they came in. He said, 'Only three colours, but that's all you need!' There was black, red and blue. And their work came out all black and orangey red, by necessity.

David Enock I wasn't there long before I designed a couple of book jackets. Anyone had a chance, jobs were up for grabs, whoever had the idea got it done. Before joining BCG, I hadn't been exposed to a place where so much design was being done at one time. They were designing signage for the United Airways terminal, and they were doing book jackets and album covers.

1958 **BCG expands, acquiring clients including Pepsi's in-house magazine Pepsi-Cola World and the American pavilion at the 1958 Brussels World's Fair.**

Tom Geismar Maybe later in '57, or early in '58, we decided we wanted more space so we found another place on the ground floor of a building over on the East Side. It must have been a former apartment. We decided that we didn't all have to be in the same space, so it ended up that Bj and I shared what must have been the bedroom. Our desks were the usual doors from the lumber yard with trestles, and we put them so that they faced each other. That was when I really got to know Bj, because we were together all that time. He was a much older, much more experienced guy than me. I was pretty naïve and I just marvelled at his wit

and his ability to home in on an issue. It was a great education for me. Even if we weren't working on the same thing, which we usually weren't, I learnt so much just sitting right across from him. We were there for a couple of years.

Eugene M. Ettenberg *1957 was a momentous year for Bob, he made the decision to team up with Ivan Chermayeff and Thomas Geismar in a partnership of talents, his own speciality being graphics.*

This happy arrangement, housed on the ground floor of a converted apartment building in the east fifties in Manhattan, is a beehive of creativity. Phones ring, heads pop in and out, and consultations, reminders, and the promises of photos, type proofs, dummies and the layouts for deadlines are made.

The three partners complement one another beautifully, each overlapping the abilities of the others. It is a common thing for all three to have worked on one job, although, somehow, each one's individuality is retained. In looking through a portfolio of their work, it is possible to spot the company mark made by Geismar, the cover by Brownjohn, and the text page layouts by Chermayeff.

David Enock Bj had a really wonderful sense of humour, he was really a devil, but he had a wonderful sense of humour. At one point our offices were in a small townhouse, and there were two adjacent rooms, Tom and Bj sat in one room and Ivan and myself were in the other. One day we glued all of Bj's tools to his desk, stuck his T-square and his pencils exactly where they had been the night before. We were peeking around the corner when he was trying to get them off. He knew what was up very quickly, but he tried a few times. Then he picked the board and turned it over and carried on working on the other side. He did one up!

Dick Davison I met Bj and was able to recommend him to the Pepsi people as a potential designer. Pepsi had gone through some changes. It was originally owned by the Loft Candy Company, but had been taken over by Al Steele, who later married Joan Crawford, and he wanted to change the image of Pepsi completely. The first year Steele took over he changed the design of the annual report, which we printed. The next year he wanted it to be different and even better, so we recommended Brownjohn, Chermayeff & Geismar.

David Enock *Pepsi-Cola World* was coming in every month, and I think it was one of the primary pieces of work through which people came to know BCG. The magazine covers were really outstanding and they won a lot of awards. They were primarily Bj's work. The client was Gary Lewis, the editor of the publication. He and Bj were friends.

Dick Davison A person like Bill Brown [assistant editor on *Pepsi-Cola World*] could question Bj and he would be very responsive, but every once in a while someone else might ask something and Bj would blow his head off, tell the guy he didn't know

what he was talking about. Bj used to design the majority of the covers, he had the creative ideas and they were very clever. The people at Pepsi liked it, but they thought of Bj as being a little outrageous, but then they thought of me and the people who worked for me in the same way.

Ivan Chermayeff I remember I used to call Bj the steel trap, Bj's idea of being really alive and good was to do things as fast as possible. He would hear half of the description of a problem and he would solve it with an answer while it was being discussed. He'd be done, not out loud, but he would be. Bj was funny and he was uninhibited. He was open and free in a way that makes it a lot easier to be fast – fast meaning not just speedy but direct.

David Enock He struggled with things, and he was very moody. He needed to prove himself all the time. It had to be a great job. He could sit for hours – not hours, days – thinking about just one thing: the next Pepsi-Cola cover. When he wasn't coming up with stuff, he was really pissed off. You couldn't talk to him. Then when he got something it was such a relief, to me anyway, I don't know how everyone else felt. It was beautiful to see terrific ideas, fresh thought, a new way of looking at something.

Tom Geismar The company started to get more significant when we began doing the things for Pepsi. That was also when Bj started disappearing, being more mysterious. Earlier on we just laughed together a lot, there was such easy interaction. Actually, I think that his falling back into drugs was because of the guys from Pepsi-Cola: Gary Lewis and he had been friends from before.

Dick Davison We used to go to Bill Brown's house. Bill was a guy who recorded everything, his pleasure was putting conversation on tape. He would pick a topic, you would have a certain amount of time to talk on it, or someone else would talk on it, and Bill would record it all. Then he would put a musical background behind it and play it to the same people some time later at a party or a dinner. Lenny Bruce came to these sessions, and there were a few other people, but the group was very small. Bj used to come whenever he could. That was just a lot of fun.

Tom Geismar We did all kinds of things for Pepsi-Cola. As well as the magazine, we started doing exhibits in their lobby. We would be the curators of design exhibits, putting together some terrific shows: one about toys, one about the American flag, one about theatre in Germany. There was a whole series of them. Pepsi had just moved into that building on Park Avenue. It was a very pure building at that time, with an open lobby (today it is Walt Disney and a bank, or whatever), so we created shows to go in that space.

Sara Chermayeff They made this extraordinary Christmas decoration that was the talk of the city. It was a huge ribbon made out of Christmas tree balls. That was the point that they really started to be 'it' in town and have lots of fun.

David Enock	One piece, I knew it was wonderful but I didn't know why, was the ribbon in the Pepsi-Cola building. It was trouble, the balls were always falling off, every two minutes there was a ball falling off, but it was really fabulous.

Late 1950s **Lives with Donna and Eliza on Barrow Street in Greenwich Village.**

Dick Davison	Bj and Donna lived in a little house on Barrow Street. It was fabulous, like a dollhouse. You went down this alley and it just opened up to a perfect two-storey house. There was nothing in there that he paid more than $50 for. It was full of great things that he had picked up one place or another. It was crammed with stuff, but it was a really comfortable place: bedroom upstairs, kitchen and living-room downstairs, not a hell of a lot to it, but what a building! I spent many a night there.
David Enock	I went home with Bj after working all night. Well, he was having fun all night and I was working. We would go to his house in Barrow Street, I went to sleep and Bj went upstairs. A couple of hours later and I woke up and the house was filled with smoke. When we had come home there were ashes in the fireplace and Bj had taken out the ashes and put them in a plastic basket and they had smouldered and gone through.
Alan Fletcher	Paola and I used to live just round the corner from them in the Village. We used to play poker. I always used to lose, I could never remember the sequence, but Paola would win.

1959 **Stanley Eisenman is drafted into the army.**

DEAR BC+G

 H W ARE Y U ALL, I H PE
Y U HAD A HAPPY H LIDAY. I'VE
BEEN IN HEIDELBERG N W F R
TW WEEKS. IT IS A W NDERFUL
LITTLE T WN, L TS F LD BEER
TAVERNS AND S ME UT F THE
WAY PLACES WHERE THEY⋀G D HAVE
M DERN JAZZ. MY J B IS PRETTY
G D, I HAVE A LT F SPARE TIME
T D WHAT EVER I WANT, H PE
T HEAR FR M Y U S N. GIVE
MY REGARDS T EVERY NE.
 STAN

Stanley Eisenman In 1959 I went away to the army and Bj and I used to correspond. The letters came from the studio, but it was Bj who did all the writing. He saw me as his protégé. Once they sent me a full page of 'wanted ads' from the *New York Times*. I couldn't work out why they had sent it to me, but then I saw a message about two thirds of the way down. It looked just like the others, but it said 'Stanley we want you back.' When I asked Bj about pursuing an art career he said, 'Forget about all that shit.' I think he realized that it would be a very difficult career, but he was always saying nice things about my work.

Late 1950s **BCG designs experimental publications for The Composing Room and exhibits work at Gallery 303.**

Tom Geismar A group of us were asked to do something for The Composing Room, which was a type shop. The guy that ran it used to like putting on exhibitions and making publications as a promotion for the place. We were asked to do something about type and we decided jointly, I don't remember how the idea

came about, to do something that turned into a project called the 'Typographic Eye'. I think there were six of us, Bob Gill, Tony Palladino and George Tscherny, and the three of us. We would walk around New York together taking photographs, finding signs and other things that we thought were interesting.

Ivan Chermayeff We used to spend a lot of time walking around looking at unsophisticated art, because it is fresher and smarter. You can walk around some place like Astoria and see great stuff. It is often much better than the work of professional designers. We were always looking to redefine the language of design.

We produced a little booklet called *Watching Words Move*. It was done in The Composing Room in one day, the whole thing. It was so fun and all sorts of people picked up on those ideas – that kind of mixture of languages, not just the sound, but the spelling and the pluses and minuses and figures and the alphabets. We were putting all these things together in a new way that was pretty lively. We used to spend a lot of time pasting up boards – cutting and pasting and joining and flipping. We were using messages like paint.

Tony Palladino We did nice things like discover New York. We would go to Coney Island and check out interesting elements that we could use in our communications. Coney Island was full of picturesque images and design motifs. On one of those trips I found a sign that said 'OPEN', it was on a shoemaker's shop. It was ripped and I noticed that, in spite of saying 'OP' 'EN', it could be read. I said, 'Some day I am going to do that.' And I used the memory of that image when I designed the book cover for *Psycho*.

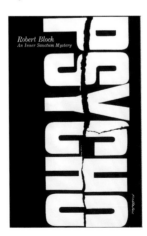

Book cover, 1959, Simon & Schuster
Designer: Tony Palladino

Alan Fletcher What impressed me was that there was a group of them, about eight or ten of them, all the same age, trying to do the same thing. There were designers like that in London, but there were fewer of them and they were less – how can I put this? – well, I found them less interesting.

Ivan Chermayeff It is sort of old-fashioned now to call someone hip, but Bj was really hip. Now you might say cool. He was cool, he was fast, and very street smart. Bj did not operate on some esoteric level, he cut through all of that. Being street smart is not necessarily a good thing, but it sure as hell opens up opportunity.

Tom Geismar I got married in the summer of 1958 and Bj gave Joan and me a collage made out of sandpaper. It was just squares glued down, some with emery that was black, some with tan. It looked like a really geometric thing, but it was all sandpaper. It still hangs in my kitchen today. We once had a robbery and the cops came in and they became completely intrigued with this collage, forgetting all about the robbery.

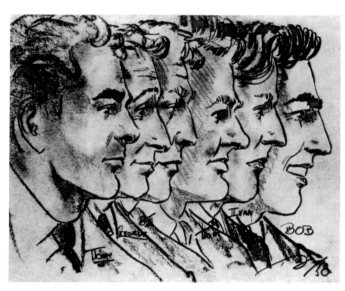

Left to right:
Tony Palladino
George Tscherny
Brownjohn
Tom Geismar
Ivan Chermayeff
Bob Gill

Portrait by an
anonymous street artist,
1958, Coney Island

Stanley Eisenman Another time I went to his house in Greenwich Village. I don't know how he managed to find a house in the Village, it was a great area, but that was Bj! Anyway, he had collected all these rusty pieces from the street, keys and cans and things like that. He left me with a pot of glue and a piece of hardboard and asked me to paste all these things to the board in a certain arrangement. I did it and it was a beautiful thing. BJ really saw the beauty in ordinary objects.

1959 BCG acquires corporate clients, including Chase Manhattan Bank.

Ivan Chermayeff After a while we began to meet more people. Particularly architects, we got to do a lot of work with architects. Bj knew them from the Institute and I knew them through my father. We still had a very modest space, but the work got a little more involved when we started to do things connected to public and corporate architecture. We got to work on the Brussels World's Fair through Bernard Rudofsky, who was an architect of sorts.

David Enock	I was learning a lot about business, that interesting work is hard to come by and that your ideas are not always accepted by the client, they have to be sold to them. I sat alongside Ivan, every day, face to face. I watched him and heard him on the phone with clients and I said to myself, 'That's what I want to be able to do.' He was really wonderful and articulate. He was the outside person, the client contact.
Tom Geismar	At first we were doing all these album covers, a dozen at a time for $75 a piece. It was a time when we were doing all sorts of experimental things and building up a reputation. Jobs like Chase and other bigger projects didn't come until late '59 and early '60.
Dick Davison	Ivan was more after commercial success than Bj. Once the door opened for him, he was more directed. Of course he was still pure in his thinking about design, but he was much more interested in being commercially successful. Bj had very little commercial ambition. He put more into the joys of life on a day-by-day basis and he never looked down the road that much.

1960 Leaves BCG.

Dick Davison	Bj was taking drugs before I met him, he was way down the road by then. But at the earliest stages he was more contained, more in control with it. The out-of-control thing came during the time I knew him and he really lost it badly in the year before he left New York. Seeing him that way was very distressing, he had such a pure talent and was such a remarkable individual.
Tom Geismar	I think he had tried to get away from that life, start a new beginning. And he was very enthusiastic, really working hard. Then after two and a half, three years, suddenly, he really changed.
Stanley Eisenman	I remember one time when he was working on a newspaper ad for a Ionesco play, and the producer starting saying, 'Wouldn't it be better like this and that?', Bj wiped everything from his desk on to the floor, everything went flying.
Ivan Chermayeff	If someone says, 'I'm just going out to get cigarettes, I'll be back in fifteen minutes', and you spend three days fielding telephone calls from his wife, you know there is something wrong. You could be talking to Bj, with all these other people in the room, and Bj would be out like a light on the table. He was pretty far over the edge. Obviously people were much more aware and knowledgeable about the habits than I ever was.
Tom Geismar	He went through times when all he would eat were egg creams and then he would disappear for three hours in the bathroom. We would have a meeting and he wouldn't show up. He became a lot more erratic, but he never said anything. We had no idea what was going on, even then.

Tony Palladino	Ivan had just gotten up to here with Bj. He couldn't stand the condition because he was running a business. Ivan was struggling with the idea of getting rid of Bj. It was very tough for him to do because they were dear friends.
David Enock	The first I knew of it was when he called me to come and help him work on the Pepsi-Cola annual report one Sunday. I came in and he was lying on the floor in the bathroom. I am not sure what happened. He told me to go get to work. I didn't know if he was sick, if he didn't have a fix or if he was just having a good time. There were a couple of times that happened. I was not into drugs at that time, and so I was very naïve about it.
Stanley Eisenman	I never understood why he did it. He had a good business and a family. But I never got into it, it wasn't my place. As for Tom and Ivan, they believed he was hurting the business and they felt it was better if they split.
Ivan Chermayeff	It became perfectly clear that this wasn't going to work, that we were all going to go down with the ship. When somebody isn't holding up their end, when they have other priorities and they say they are going to do something and they don't and we lose a connection to a client or friend or whatever … We had to tell Bj that we couldn't do it. He was in hospital at that time, I don't remember the specific reason.
Tom Geismar	I really had no idea what was going on, which seems really ridiculous at this point, but I didn't. Bj had put himself in a so-called hospital on the Upper East Side, an apartment house. I don't know what you would call it, it was a place where you recuperate. He had been really bad and I guess he realized it too. It wasn't the first time he had done this, but we were just at our wits' end, not knowing what to do. We went up to the hospital, and – I don't think he ever forgave us for this or Donna never did – we said, 'Bj we just can't take this any more, you're never there, you don't show up for meetings.' I don't remember the specifics of his reaction, but it was soon after that he went to London.
Stanley Eisenman	We all went to the boat to send him off. We were standing on the dock cheering when, all of a sudden, Bj remembers that he had come in a rental car. He takes the keys and throws them right off the boat. I don't know where they landed. I don't think the car was ever returned.
Tony Palladino	I remember there was an incident on the boat, David Enock, Stanley Eisenman and I, we got drunk and almost got stuck on board. Then we were at the dock, you can't believe the scene. I was on the dock yelling 'the car keys!' and he threw the keys right into the water, we were laughing like crazy. Always sabotaging the establishment.

1960 Moves to London.

FORUM FOR FIVE:

worst thing you can do is use Futura when everybody is using Futura. On the other hand, if everybody is using News Gothic, maybe the best thing you can do is use Futura. Because of this, any discussion about faces as important considerations is bound to be a discussion of something that is very temporary.

BENNETT: Of course, it's the temporary nature of preferences for faces that creates quite a problem for the man you designers have to work closely with: I mean the typographer. When one designer specifies Standard and another indicates Venus, the typographer is in a dilemma. There's hardly any discernible difference between these two faces. From a practical standpoint, it may be unrealistic economically for him to stock both faces. Well, which one does he put in?

GILL: I know . . . it's a real business problem. As a designer, I'm glad it's not my problem.

BROWNJOHN: Can we go back to the question about progress? The only real advance—let's say in the last 15 years—in advertising typography has been in the use of type not as an adjunct to an illustration or the image but in its use as the image itself.

GIUSTI: In my opinion the progress in typographical design has been achieved by the elimination rather than addition of type faces. Today's designer will employ maybe no more than two faces for an advertisement or booklet. Some years ago he might have used ten or fifteen faces.

BROWNJOHN: I agree. But I attach a different meaning to elimination. When you use the word PRODUCTION in a contemporary manner, reinforcing it

perhaps with an image of production, you are able to eliminate typography of possibly thirty or forty words saying production really means man-with-worker's-glove-on-his-hand-plus-wrench-and-he's-tightening-the-nut-in-the-production-of-America-to-fight-overseas. You are eliminating because you are reinforcing the typographic message or word with an image. By putting them together you are creating a new image which makes the elimination of words easier. You have found that the old image, the old word, doesn't mean enough any more to say what you want it to say. It's too familiar an image. So now you are experimenting with typographic imagery to make a new statement. I think perhaps our modern poets have created the modern typography.

BENNETT: Because they use words as imagery?

BROWNJOHN: How else do you use type?

GILL: So much of the discussion about type is academic to the contemporary designer . . . the discussion of whether Baskerville is inferior or superior to Caslon, or whether Broadway can ever be used again because it's kind of old fashioned. As soon as you make such a statement, some other designer with imagination will use Broadway excitingly. Tools in other fields can become obsolete and their relative merits can be subject to discussion, but this hasn't ever happened and isn't true in typography. Typography essentially is the creation of an image which will stop someone. That image can be old fashioned when all are contemporary—or contemporary when all are old fashioned. This is a very basic thing. Do we agree on that or do we disagree?

BENNETT: I don't think we can disagree, but what you're talking about I pretty much visualize as the headline—the first thing the reader sees. It's the thing that draws you to the page or to the cover. But where does the typographer

8

Type Talks Brochure, 1959, Advertising Typographers Association of America

go from there? This is not the end of the advertiser's message. He wants to sell you a color television set, or a racing car, or a yacht.

GILL: Well, to be specific we have much less body copy today than we had five years ago.

BENNETT: You arrest the reading eye with a typographic headline or image…

GILL: And we can almost hope to do no more.

BENNETT: But you've got to do a little selling somewhere.

BROWNJOHN: I don't think you do. I think you have to sell with the image itself. The only subsidiary copy necessary is simply a bit of cataloging. I personally feel people rarely are sold by what is usually contained in that small paragraph.

BENNETT: People who are spending money on advertising may disagree violently with that point of view.

BROWNJOHN: I am sure of that.

SUTNAR: The designer must go far beyond the limited function of arresting attention. For one thing, there is a vast area of advertising typography which isn't confined to the magazine or newspaper page. I mean typography for catalog pages, informational booklets and other sales pieces which require a lot of body copy. To create an image isn't enough here. These pages demand easy and quick legibility. You need a selective eye for the right type for each job. Today time is very short. Everybody has less and less of it. There's too much information on all sides to absorb conveniently. Naturally this has a bearing on how a designer should select faces. For example, for these reasons I like to use News Gothic Condensed. Even in the smaller sizes it's extremely legible.

BENNETT: But how about other choices when more than one face may do the job equally well?

GIUSTI: I think any type that is well designed is an appropriate type. My personal method of selection is to study the two most difficult letters—g and o. If they are right, it usually follows the whole alphabet is right. On these counts, I would choose the Grotesques instead of Futura, which is too mechanical, too small, too round, not well balanced. The same thing would apply to serif faces: I don't like Bodoni and would prefer, in its place, Whitehall.

GILL: Statements like that make me uneasy. I think they're conditioned by the times. Thirty years ago we would have had just as good reasons to describe the merits of Futura. And who knows but what 20 years from now, if we're back to Broadway or Barnum, we'll have equally wonderful reasons for saying we think they're beautiful. I think we are very style conscious. This can make any face obsolete—temporarily.

GIUSTI: On the contrary, a type that is well designed will never become obsolete.

GILL: Well, how do you account for the fact men like Cassandre—very sensitive men—used faces which today you feel are very ugly?

GIUSTI: I don't think they were very sensitive on those occasions when they used ugly faces.

BENNETT: And maybe they didn't have the choice in the 30's we have today.

Collection Museum of Modern Art, New York

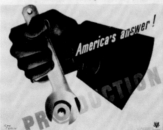

9

1960–1970 London

Eliza Brownjohn	We came on the SS *Liberté* [French Line]. It was August 1960, I was four and a half and I remember everything about it: how the cabin looked, the party they gave for the children. Coming to London was a relief, New York had got unpleasant. Donna was a pillar of strength at that time.

1960 Arrives in London.

Ivan Chermayeff	There were quite a few Americans in London at the time, people like Bob Gill and later on Tony Palladino. There was an openness to American design and advertising in England and Bj certainly became a part of that. But I don't think it had any influence on his decision to move. I would say zero, coincidentally only.
Angela Landels	As I remember it, almost 1 January 1960, there was a fabulous kind of rustle, a murmur that ran through the town, the people, the air, the climate, everything! It was really dazzling, but it was very subtle. It took off, but nobody spoke about it. Suddenly we all felt that we didn't want to be anywhere else. For the first time, we wanted to be exactly where we were, doing the things we were doing.
Dick Davison	He went to England because they had decriminalized drugs. Of course it didn't work in the end. That is how he got into doing combination stuff. The whole idea of going was wrong, but his situation there was pretty good. I think his effect on London was greater than London's effect on him.

Early 1960s Lives in Campden Hill Towers, Notting Hill Gate.

Alan Fletcher	Bj wrote a letter saying, 'I am coming to London and I am looking for any kind of work, can you help me?' I met him off the boat-train at Paddington, he was with Donna and Eliza. I think he had got on the boat with nothing and cold-turkeyed his way over. He looked pretty fucking terrible, in fact they all looked fucking terrible. I don't think they had slept the whole way. I don't know where they went at first, maybe to stay with Donna's parents. Later they moved into the tower in Notting Hill.

We were all there. I think maybe Bamber Gascoigne was the first guy to put his money down and Paola and I were second. It was £9 a week and it was empty. There was a bathroom with nothing in it, you could pick your own bath and basin! It was like a miracle then, all the other places in town were so awful. Bob Gill, Lou Klein, Bamber Gascoigne and I all lived on the top floor. Brownjohn and Derek Forsyth lived in the lower building next door. I remember

Dudley Moore used to play the piano in Bob's apartment and we would all go round and have drinks.

Brownjohn had a nice wall in his flat, crap he'd picked off the streets and arranged to make the alphabet. He was very pleased when he found an 'H' or whatever. And he had a milk crate that he used as a magazine rack, rolling up the magazines and shoving them in. He was very pleased with it. That's part of our generation, making do with what's around, because you couldn't find anything. They lived there until Donna got pissed off with him and threw him out.

Eliza Brownjohn Once we had settled in, Bj was feeling very upbeat and so was Donna. The flat had two floors, with the bedrooms upstairs and a big sitting-room downstairs. I remember the toilet was full of Bj's books, Albert Camus and so on. He was an avid reader, he had every Penguin book there was, and they were all in the toilet because that's where he liked to read.

Bob Gill I was just planning to go on holiday to Britain or France, I hadn't decided. And then a friend called up and said, 'You know there is an ad in the *New York Times*, some English agency is looking for a creative director. They are interviewing at one of the hotels.' I thought it would be interesting to work for a month, rather than have a holiday, so I went along with my portfolio. This was in 1960, and the guy took one look at my work and said, 'We'll hire you,' and I said, 'I only want to stay for a month' – I was on a roll in New York, I was a hot designer – but he said, 'Come anyway!' I knew I was going to stay for a while as soon as I got off the plane. There was something about the chemistry, it was such an adventure, like landing on the moon.

The advertising agency was called Charles Hobson, it was terrible. The guy who hired me was called Nicholas Kay, he was a fifty-five-year-old, very square Englishman with an umbrella and a bowler. He was paying me more than the Prime Minister was making, he thought the sun shone out of my ass! But it was a hack agency and I wasn't interested. Very soon I formed Fletcher/Forbes/Gill, with Alan Fletcher and Colin Forbes. London in 1960 was amateurs-ville, it was like shooting fish in a barrel. We were so obviously number one, there was no question. We ended up doing everything.

In 1960 Bj wrote to me, or called me, asking me to get him a job. And I said, 'You're a great designer, you don't need me. If you can straighten yourself out, you can come here and be a big shot, because you'll be the best art director in the country.'

I saw a lot of Bj in the beginning because we lived in the same block of flats, Campden Hill Towers in Notting Hill. It was a wonderful vignette of London. When the building was nearly finished in 1960, I enquired about a flat at the top.

It was not very high, tenth or fifteenth floor. They said the rent would be £8 or £10 a month. Then I asked about the rent on the lower floors, and they said it would be £15! They had no idea! This was the highest block of flats in England, and they were thinking, 'Who would want to live high up?'

Willie Landels Do you know the story of Bob III? Bj and Bob both lived in Notting Hill and from Bob's flat you could see the balcony of where Bj lived. Bj thought Bob was a hypochondriac, so he made a big card that said 'BOB GILL' and crossed out the 'G'. He put it in his windows and left it there for days.

Bobby Gill Bob and Brownjohn could be like two bulls around each other, either very friendly or very not. They used to sit around trading ideas, topping each other, but also appreciating what each other was coming up with. And they used to ring each other up and say, 'Has this been done?'

1960 Becomes a Creative Director at J. Walter Thompson.

Willie Landels Bj came straight to us. He gave me a magazine, *Typographica* – I still have it – in which there was some of the work he had done with Chermayeff and Geismar. I looked at it and said, 'Great, come work for us.'

J. Walter Thompson was an American firm, but the London branch was very, very English, with eighteenth-century furniture and eighteenth-century manners. It was all very charming and agreeable. George Butler was the head of our department. He was a terribly charming man. He never spoke, he just drummed his fingers on the table and looked out of the window. He looked like a farmer – Harris tweed and rosy cheeks – but he had an amazing past. He had been a pupil at the Bauhaus, behind the exterior he was really very modern. He loved Bj very much, but he was nonplussed by him, everybody was nonplussed by him.

Ken Garland I was art editor on *Design* magazine and Bob [Brownjohn] looked me up. He was very edgy and neurotic, but he was a sweet man. He was at JWT at the time and he talked about advertising, which was interesting for me because graphic designers of my generation tended to keep away from it. American graphic designers were able to ensure that they got what they wanted in advertising, but we in Britain were still apprehensive that our design ideas would be steamrollered. We preferred to find our own outlets, where we could work without the inhibitions of advertising, as we saw them then.

The American graphic designers who came to London, Bob, Bob Gill and Bob Geers, had fled from the pressure cooker of New York. But I think they brought the pressure cooker attitudes with them.

Alan Fletcher He would go in mid-morning, and have a big long lunch, and he probably had a

bit of a doze in the afternoon, because he would be out late in the evening. That was what the world of advertising was like then. Because it was new, it was much more exaggerated. They didn't work very hard, because they made so much money. He didn't do much work, it was more a case of being wheeled in to bludgeon or charm the client.

He was earning megabucks I suspect. If he was earning, say, £8,000, we were earning £2,000. It was like that in the advertising business in that period. Hitting that moment with all those Americans coming over. It was a glamorous thing.

Robert Brownjohn (quoted in the 1965 D&AD [Design & Art Directors] Awards Annual)
Advertising agencies are really like benevolent societies – with their pleasant relaxed atmosphere. I was so lazy.

Willie Landels When Bj joined JWT, we shared an office that overlooked Berkeley Square and was full of Regency furniture. We became very good friends. He was rather special because he came from America and was a graphic designer. He would intervene in situations where we believed he could be beneficial. If he thought a campaign was no good, he would do some work on it.

He recorded everything. It was terribly funny. Suddenly he would stop working, take out a camera, and say, 'I am a genius, a fantastic genius, this is geeenius!' And he would photograph it.

There was a famous, awkward episode. My wife was an art director too, at Coleman, Prentis & Varley [CPV], and she was doing an advertisement for Yardley Lipsticks. Bj said to her, 'It should be a gun with the lipsticks in the gunbelt', and Angela did it. Bj claimed it as his, which in a matter of fact it was. It was his idea, but Angela solved it very well. She told everyone that Bj gave her the idea, but he was annoyed because she won a big prize. Anyhow, it was a gold lipstick – no use for Bj!

Angela Landels When I think about it, my input on that extraordinary poster was very little. I was at home one evening working on layouts for the campaign and Brownjohn, as was fairly frequent in those days, was lying on the sofa, sounding off about how brilliant he was. He asked me what I was doing, and when I said, 'Something for lipsticks', he said, 'Oh, I've got this great idea.' Then he told me this marvellous idea of the gun holster with the lipsticks as bullets. I would not have thought of it in a million years – I had an absolute abhorrence of guns, and to me the whole notion of equating them with anything was repugnant – but I could see it was a brilliant advertising image. He gave me the headline too, 'A woman's ammunition'. It was perfect. The Bond films were just coming out, they were this incredibly popular new genre, so the imagery of guns was in the zeitgeist.

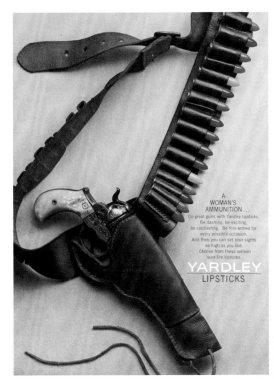

Press Advertisement, 1962,
Yardley Lipsticks, Creative Group
Leader: Angela Landels
Art Director: John Castle

Of course I said, 'I can't possibly use that idea. You work in another agency and have a cosmetics account. What would they think?!' And he said, 'Oh please, I don't want any credit. I just want to see it in print. I don't want it wasted.' When he left the house Willie said, 'Don't touch it, leave it alone, never think of it again.' The next day I gave the account executive my layouts. I got on well with her, so I told her about the idea, saying that we couldn't use it, of course. But as I described it, I saw this look pass over her face. She went to Yardley with my layouts, and said, 'Don't bother with these, this is what we are going to do.' When she told me I protested, but she said, 'Too late, they've bought it.' So then I worked it out with the art director John Castle, who got the photograph done and found the pistol, a beautiful little pearl-handled pistol.

Embarrassingly enough it won every award going, London Transport poster of the year and so on. And Yardley's lipsticks went from fifth in the market to second, which was amazing. They gave me a little lipstick case made of solid gold. Initially Brownjohn was very pleased, but the more publicity it got, the more he resented it. I don't blame him. Then the journalist Anthony Hayden-Guest interviewed him for the Sunday papers and Brownjohn told him that he was the author of the poster. Next day I was hauled into the director's office at CPV and they said, 'Where did this come from?' Of course I had told them at the time, but there was such a fuss.

Donna sweet:

Can you bring me paperback penguin of E.M. Forsters — "a Passage To India" — and Norman Mailers "Barbary Shore"? Also "I Claudius" by Robert Graves — and if they have them at Smiths get me Albert Camus' "The Plague" and also "The Fall". Published in Penguin soft covers — I beleive. Also — if you can manage it — a new pair of corduroy trousers — same size and color as last ones — to bring to hospital along with white-button down shirt and black tie. Bring with you Friday in case you go away for weekend. Also some three penny stamps for local mail I write + half dozen 6 pence aerogram — self sealing letters — you know the kind I mean — with stamp printed on outside. In top right and kitchen cabinet — closest to living room is a tube of butane gas for my cig, lighter as well as some flints in small plastic package. (Just remembered — I took lighter gas to Michels and left it there — so perhaps you can pick up another at tobbaconists (Just ask for Dunhill Butane gas lighter fuel. And some hard candy to suck on — raspberry flavored or something.

Also could you bring a few reprints of BCG article in Herbert Spencers mag. "Typographica 2" — This is the English mag — not the german, which I don't want! Also a nice resent photo of you and Eliza — from the batch I sent from N.Y. Also a copy of Sens' the "Hard-Easy Book" with Eliza in it.

(over)

Letters from Brownjohn to Donna and Eliza, sent from hospital, 1961

My Dear Donna (and Eliza of course)!

I have determined that I shall no longer be an addict. I have also determined that this woman – this psychiatrist can help me. She seems to have a wisdom that struck me very strongly – when you have read the article reprint from "Lancet" perhaps you will agree. I need help. I need crutches – a wheelchair might be more appropriate. I remember the first years of our marriage and the first years of my being able to do work – work that came easily and was good. It was not exactly Romeo and Juliet but a lot of it was good. With your help and Eliza's help I was able to prove to myself for the first time in my life that I could do it if I was willing to work hard enough for it. I was willing – but somehow I still get the idea that I did it for you and Liza – and to a lesser degree I suppose – for a lot of other people. I'm not sure I did it for myself. Similarly I'm not sure I gave up drugs for 4 years for myself. I didn't want to – I had to! I remember very well how for 4 years I felt just as good off of drugs – as on! The taking of drugs is in a sense a social thing – a ritual – a pattern – a very exciting one – The buying – the cheating – the lying – the risks – the how much more can I get away with before mommy spanks me stuff. If you remove that excitement – i.e. by making it legal – you reduce it quickly to a function much more similar to that of brushing one's teeth – rather than the game of cops & robbers or cowboys & indians that I often live. I think perhaps one stops in such a case through sheer boredom. I want to stop forever – not for a year and a day.

I think you have many virtues – and few faults. You know me very well – but sometimes even you don't understand me – and sometimes I think you misunderstand yourself as well. I like being pleasant – I like to make people laugh like I did you and Barry last night and ⟶

Dear Donna & Eliza:

How are you. You have not written for a while and I worry about you. Did you get the bicycle all right. I also sent a Thanksgiving card and some color shots I took at London airport. I am writing this on a proof of an xmas issue cover of Advertiser's weekly — I thought you might like to see it. A snow-flake made of television antenna — in case you don't get it. This is really a birthday letter for Donna. A very happy birthday to you — I hope someone gives a nice party for you. I am sending a gift but it may get there late. I will also send a cable in case this doesn't get there in time. I may go to Ethiopia at the end of Feb. or March all expenses paid — by Prince Merid — a friend of mine — to design the interiors of his new house. If I do I can stop off on the way back to see you for a week. The weather is very cold here again — a bit of a drag. Work is going well — which helps. Love to you both.

And HAPPY BIRTHDAY !

XXX XXXXX
XXXXXXXX.

Letters from Brownjohn to Donna and Eliza, sent to Ibiza, 1962

M^cCANN-ERICKSON Advertising Limited

Incorporated in Canada

M^cCANN-ERICKSON HOUSE · NEW FETTER LANE · LONDON EC4 · FLEET STREET 6543 · CABLEGRAMS: MACADCO LONDON EC4

Dear Donna,

Sorry not to write – I have been incredibly busy for a change. Designing some excellent packaging that is actually being printed. I'll send you a slide of it. For <u>vitamins</u> – you remember. Also all the Sebbix shampoo stuff is going ahead. My Yardley ad won the Layton color trophy award – the highest award for graphics in England. I don't get credit of course – but everyone knows I did it. I lectured at ~~the~~ Ealing Art School last week and they have asked if they can award the ROBERT BROWNJOHN DIPLOMA IN GRAPHIC DESIGN next semester. They actually name the years diploma after me – and I do the judging. They said they felt it would then become the most meaningful design diploma in England. Very sweet of them – so I accepted. I saw the page proofs of the word game

S. BARRON · C. E. BERNSTEIN · H. A. BRAID · F. T. BRICKMAN · P. R. J. GILBERT · P. V. LORNE · P. W. NEEDHAM · L. W. RODGER · T. N. TREEN · S. L. WEAVER JNR. (U.S.A.) · E. C. WILLIAMS

1961 **Designs a maquette for Player's Bachelor Cigarettes.**

Alan Fletcher He got fired from the Bachelor Cigarette account. When he had presented it to the client, they had thought it was a fantastic idea, but Bj was so pleased with himself, he told everyone in town about it. He certainly showed it to me and I think he showed it to several other people. Somehow the client found out and made the agency fire him.

Willie Landels He did packaging for cigarettes, Bachelor cigarettes. He was very naughty. Once he got a packet of cigarettes and filled it with Tampax and offered it around. Of course the client was very upset.

David Cammell I'll never forget meeting Bj for the first time. I went over to have dinner with the Landels, Willie and Angela, and he was in the next room. Suddenly the door opened, and out he came. He had this marvellous, youthful crew-crop hair and jeans and a t-shirt. And he came bouncing into the room with this irresistible grin. He made a big impression on me. He had a slow, wry voice and a terrific sense of humour. There was an electricity about him, he was very exotic.

Angela Landels Willie's mother referred to Brownjohn as a fallen angel. I thought that was a rather perceptive observation. He did have a lovely look, the look of a man who had once been an angel, but had gone wrong somewhere in his life.

Willie Landels Bj was always mysterious. I didn't know about drugs, nobody knew, but he would disappear into the lavatory for long hours and often he would ask me to drive him to some mysterious places, obviously to buy stuff. I was very naïve.

Angela Landels I was in a taxi with him going somewhere to get a fix. I don't know why I was with him, I think he really was quite ill. He was telling me about drugs, saying, 'You just can't imagine how wonderful it is,' and I said, 'You just can't imagine what a terrible advertisement for addiction you are.'

Willie Landels Eventually it got much worse. I remember he came to dinner at our house once and he was very unwell. Of course I knew by then.

Angela Landels There was a very gifted Swiss photographer, Hans Feurer, who worshipped the idea of Brownjohn – he was very keen on design and fashion. He said, 'Can I meet him, will you introduce me?' We told him to come round one evening, but warned him what it might be like. Unfortunately it was one of Brownjohn's really bad days. He was lying on the sofa, very ill, but Hans was hanging on his every word and rushing to do things for him. He just worshipped him.

Willie Landels I introduced Bj to Bill Free, a great friend of mine who was the number two boss at McCann, and Bill stole him. That was my intention. Bj was becoming an embarrassment and I wanted to get rid of him, but I wanted him to go

somewhere he got more money. He was very egocentric. I liked him very much, but he needed so much of your time, he sucked you dry.

Alan Fletcher We set him up with a doctor, a friend of ours called Richard Bell. He looked after Bj for years, I think he saw him just before he died. I don't know if Bj was using drugs in London, he may have been on and off. He took to drinking a lot of beer. At first he was thin and then he got much heavier.

I knew he was in trouble. He used to listen at the door, waiting until I turned the water off so he knew that I was in the bath, and then he would knock on the door and say, 'Paola, can I have a one pound? I have a taxi waiting.'

Eliza Brownjohn Behind the flats in Notting Hill was the doctor, Dr Bell. Bj went there for his daily injection. They were always very honest with me.

Early 1960s **Visits New York.**

David Enock The first time Bj came to visit, after he had been in England about a year, he asked Stanley and me to come and see him at the Plaza Hotel. We went to his room and were there for two and a half, three hours, not saying a word to him. Stanley and I were whispering to each other and he was just smoking, smoking, smoking. That was something you really couldn't do, just start small talk with Bj.

Stanley Eisenman We sat for an hour watching him like that. I think he missed New York and all the people.

1962 **Quits J. Walter Thompson for McCann Erickson.**

David Bernstein I became Creative Director at McCann in London in '61 or '62, and around that time the American agency sent over a guy called Bill Free. With the help of Free, I hired two deputy creative directors, Desmond Skirrow and Bj. Both of them earned about twice as much as I did.

Our offices were in New Fetter Lane, near Fleet Street. At one stage Bj shared an office with Desmond, which was useful because Desmond would help if there were difficult moments. They got on well, but you cannot imagine two more different people. Bj always had a feeling that there must be a better way of doing things and Desmond was more of a craftsman. It was interesting to see them working, it was almost like a battle. You would pay money to watch, because they were quality minds at work.

We got on very well, but I found him unusual. The thing about Bj was, well, where do you begin? He was very bright, but he was also asleep a lot of the time because he was on drugs. He would be in a meeting and have a Gauloise in his mouth, and his head would be dropping and ash would fall everywhere. You

Drawing by
Alan Fletcher of
Brownjohn with
the London circle
of designers, 1960s

Back row
1. Bob Brooks
2. Colin Forbes
3. Germano Facetti
4. Peter Wildbur
5. Theo Crosby
6. F.H.K. Henrion
7. Barry Trengove
8. David Collins
9. Alan Fletcher
10. Abram Games

11. Ray Hawkey
12. George Daulby
13. Peter Paul Piech
14. George Mayhew
15. Ken Garland
16. Robert Brownjohn
17. Herbert Spencer
18. Frank Camardella
19. Colin Millward

Front row
20. Sidney King
21. Eric Ayres
22. Romek Marber
23. Mark Boxer
24. Lou Klein
25. Derek Birdsall
26. John Sewell
27. Ian Bradbury
28. Gordon Moore
29. Dennis Bailey
30. Bob Gill
31. Malcolm Hart

would wake him up just before his lips burnt. Often you wouldn't know if he was coming in to work at all. He was usually quite late. He was also very unpredictable. He could be docile, like a little lamb, or very aggressive.

Our daughter Jane was born on 8 August, Bj's birthday. He turned up to the clinic smoking Gauloise with a present for the baby. He was so pleased she had his birthday! He also shared a birthday with Gladys the tea lady. If only she were alive today, she would tell you about Brownjohn. They were an item in a way, he ribbed her, she ribbed him. She wasn't allowing anyone to tell her what to do, but there was lots of love.

Frances Dickens I remember the first time I saw Bj. It is an amazing memory, like a photograph. I was standing by the lift at McCann Erickson and this gentleman came along wearing a Sherlock Holmes deerstalker and a cape, the sort of thing you imagine Toad of Toad Hall wearing. He turned his face around toward me, and I remember this so vividly, it was so pockmarked and his eyes were slightly froggy too. He was a very strange individual. He was earning a vast amount. I might have got this wrong, but I think it was £8,000 a year. That was a lot of money then. I ran the film club and Bj introduced this film *The Connection* (1962). It was shot like a drama documentary, hand-held video camera, black and white. It was about a bunch of people waiting for their fix.

Bruce St Julian-Bownes I met him at a lecture he gave in the McCann film theatre. He wouldn't start the talk until he had a can of beer in his hand, which I thought was quite cool. He presented an alphabet that was made out of bits of garbage, a whole font formed from rubbish! He also showed a pack of cigarettes that looked as if it were transparent, as if you could see the cigarettes, but they were actually printed on the side. He underplayed everything, he was very low key, but everyone realized that he was one of the stars of the industry. We felt very privileged to be there.

John Brimacombe I was Bj's aid at McCann Erickson: I helped him with research, I brought up his sandwiches, fed him pills, put him in cabs, lent him money. In return he taught me that concept was number one.

John Gorham ('The Brownjohn Tales', *Designer*, November 1979)
Andy Arghyrou had only just come out of art school when he started working for McCann Erickson and was put in the packaging unit under Robert Brownjohn. BJ was rarely there, so even after Andy had been there three months BJ would come in and say: 'Who the fucking hell are you?' Andy was terrified of him, and thought that perhaps every big man in a big agency behaved like that. It got to be quite a routine.
'What are you doing in my fucking office?'
'I work here.'
'Get out.'

So Andy found another spot to work.
Two days later.
'What are you doing out here? You work for me.' And back he'd go.
In the end the agency bowed to the inevitable and gave Andy two desks.

David Bernstein I was a director on the board and I had to defend Bj from my fellow directors. There were people who resented him in the creative department. They knew he was getting a lot of money and not turning up, or, when he did turn up, he was asleep. But a creative department can always afford one maverick, in fact it needs a maverick.

Bj had an intermittent genius. Occasionally he would talk rubbish, absolute rubbish, but often I had no idea if it was rubbish or not.

Bob Gill I'll tell you about a few of Bj's jobs that don't exist, because they were never done. One is an anti-smoking commercial: there is a black screen, then a crack of light, and a door opens. A beautiful little girl comes in. It is obviously her father's study, all brown leather. She looks around, knowing she is doing something naughty. Then she comes in, sits at his big desk and opens a drawer. There is no talk or anything. She takes a pack of cigarettes, she puts one in her mouth and starts smoking. This pure English rose smoking! That scene takes thirty seconds and then there is a voiceover saying, 'Now isn't that stupid to allow your children to see you smoking.' The agency found it too shocking, they didn't buy it! Another one was for the greenbelt. Bj was going to advertise for a blonde model with hair down to her shoulders and pay her to shave her head completely. The commercial was going to consist of her hair falling away, with a voiceover about the insanity of destroying the glories of nature. Again, he was too far ahead of his time.

Derek Birdsall Bj and I were on the first or second D&AD jury. There were twelve or fifteen of us and we were paired off, me and Bj together. We were looking through all the work on the table, and he picked out a cover and said, 'This is Swiss design you know, we've got to encourage these young people!'

Eliza Brownjohn In 1962 we [Eliza and Donna] went to Ibiza for the first time, for a holiday, and then we moved there. It was a great life. It had been a very hard situation for Donna, and it had gone on for a long time. She loved him with all her heart, but she couldn't live with him.

1963 **Moves to a flat on Sloane Court West with the fashion designer Kiki Milne.**

Sara Chermayeff Kiki was like a cross between Jeanne Moreau and an Eskimo. She was very attractive and feisty and very, very chic. I had never seen anybody with such a great dress sense. When we visited London she took me to Vidal Sassoon and I got a terrific haircut. I came out and Ivan didn't recognize me. She had this

black bob and a very flat face. She was very tiny and very thin. I think that they had terrible fights and threw things at each other in restaurants. He wouldn't have done that with Donna, she was very pretty and very sweet. Donna was a nice woman, a very nice woman, a mothering type, but maybe Bj liked someone who threw a pie in his face.

Kiki Milne (second from left) with Brownjohn, mid-1960s

Bobby Gill She was a real match for Brownjohn. They were a funny couple to look at, she was so tiny with her black fashion bob and her huge eyes and enormous high shoes. And she had a deep voice, just like Brownjohn's. It was very tempestuous, one minute they were together and the next minute they would break up with great rows. I remember going to their flat once. Their bedroom was all black, I mean all black: black curtains, black walls, black satin sheets. Apparently it was because both of them were insomniacs, but I think that would make me insomniac. It was a real statement.

Alan Fletcher I remember I was in a cab with him and Kiki and they were fighting. It was like being caged with two wild animals. The driver wouldn't stop because he was so scared. Kiki was a small lady, but she was tough too.

1963 **Freelances from McCann Erickson to design titles for From Russia with Love.**

Alan Fletcher He said, 'I've just sold this fantastic idea.' And he did the whole presentation for me again: 'So, I put the slides on, and I walked into this room and I took my shirt off … ' He had that performance thing, how he presented work and ideas, and himself.

Trevor Bond Bj came to me through Harry Saltzman, he called me up and said, 'Harry Saltzman tells me that you will take care of me.' I first met him in a coffee

bar opposite Biographic Films in Dean Street. He was bright yellow, he wasn't too well. He was working for McCann Erickson and had never done any film. He told me his idea for *From Russia with Love*. It was going to be an animated chessboard, with bullet holes and all that stuff. We never got round to doing a proper storyboard and a couple of weeks later he rang me and said, 'I've got a brilliant idea. I want to do the credits on a dancing girl, and it's going to be live action.' Of course, I'd never done live action, but I didn't tell him.

We went to a nightclub called the Omar Khayyman to audition dervish dancers. We got one to come to the studio to do tests, and we stood her on a chair and said, 'Can we just lift up your skirt, so we can project on your legs?' She thought we were making a porn movie, so she stormed off disgusted. But she did dance a sequence for us before she left. We used it as a cutting point, when we went to the 'wines and spirits', which is what we called the small credits.

Then a friend of mine said, 'I know who you want, you want Julie Mendes.' She was a snake dancer and she could handle the lettering brilliantly. She was perfect, but she wasn't very attractive, so we had to get another girl for the face shots. We tried not to hurt Julie's feelings too much, but I guess when she saw the film she knew it wasn't her. We got a beautiful Persian model. She had terrible teeth, so she never smiles in the titles, but she had nice boobs, so we projected '007' on those. It took three weekends and I think we charged £850.

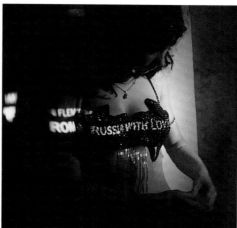

Sara Chermayeff	There are things Bj did that were just great. After one of his successes in England he went to Paris, to the Ritz for the weekend. He decided he was flush and he ordered up caviar and champagne. So, in they come, and they have a great silver dish with ice and this tin of caviar and the champagne. He is alone and he'd never seen so much caviar in his life, but he'd paid for it and there it was. So he ate until he felt sick. When the waiters came back, they looked at the tin and said 'Sir!' And he realized that, at the Ritz, they bring the whole thing in, weighing it before they bring it in and weighing it again when you've finished, and you only pay for what you've eaten! So he paid thousands. That was very typical of him, both to do it and to tell the story.

1964 **Leaves McCann Erickson and designs the titles for Goldfinger.**

Trevor Bond	I think *Goldfinger* were the only titles that ever went to the censor. We were going to project objects on her body, but that was too difficult, it was hard to make them stand out. It was Bj's idea to project scenes from the film. The golf ball down the cleavage is pure Bj. It was brilliant.
	They were very expensive to make. We quoted £5,000 and they cost £5,000. You never made a profit with Bj, because he always went over the top and used all the budget. We used to work very late, until the early hours, and he would be with you all the time, hands on. I was learning a lot, but, to tell you the truth, he was terrifying. I was glad when he had gone home, because working with him was so tiring.
Robert Brownjohn	(quoted in the 1965 D&AD Awards Annual)
	There are a lot of designers in New York or London who could have done this job as well as I could. But it takes a lot of time wheeling and dealing for an idea to see the light of day. I'm lucky with Harry and Cubby (Harry Saltzman and Albert Broccoli, the 007 producers) because they let me get on with it, leave me alone and don't ask questions. But you need a little luck – the luck incident – being in the right place at the right time, to get ahead in this business.
Dick Davison	I remember visiting Bj when he threw a dinner party for the guy who brought him in on the James Bond movies, the producer or whoever it was. This guy was Bj's exact opposite, a great salesperson type. Bj chose an Indian restaurant that this guy had been going to for a while and, we didn't know this at the time, he had gone in earlier in the day and paid the staff a certain amount of money to totally ignore the Bond guy, no matter what. So there he was, and he had told everyone that he knew the restaurant, and they knew him, he had been there so many times … It was a riot. In one way it was a mean thing, but Brownjohn was just trying to get the guy to take it easy and shut up a little.
Trevor Bond	*Goldfinger* was so successful and Saltzman said, 'I am going to set you two up', and I was thinking, 'Please.' But Bj said, 'I don't need you', and turned him down.

I don't know why he did it, there was a big confrontation of some kind. And of course Harry Saltzman didn't need Bj, but Bj did need Harry Saltzman. So Saltzman went back to Maurice Binder [the designer of the titles of the first Bond film, *Dr. No*].

1963 **Tony and Angela Palladino move to London.**

Tony Palladino I came to London in around '63 or '64. I was opening up a branch for a hot New York agency. London was fertile territory at that time. I designed the local offices and became Creative Director.

I met up with Brownjohn and he was looking very happy and healthy, he was great looking. There was something about Bj and London. Because he was able to discard what had happened in the States, the scrubbing that he went through, it enabled him to be free. He was wearing his ribbons!

Once we were both in England and working as consultants to advertising agencies, we would sit down and enjoy the fruits of our positions. We were heavy, salaried guys and we would talk about that, poking fun at the old neighbourhoods and at the guys who wouldn't understand a word we said. Very vain, but stuff like that. We were just a couple of dudes who came out of shit and managed to make something of ourselves.

Angela Landels He once said to me, 'To think that I was a bus driver's son!'

Angela Palladino Bj came to be a very good friend of mine. When we lived in London, he used to pass by every day for a drink and we would cook him dinner. We were very close. Kiki Byrne really cared for him, she did a lot for him, she was very tough. They were always fighting and then they would make up like kids, they would come over to our house and we would have to resolve it. They fought about everything and nothing. You know, she liked singing and he hated her singing.

George Perry (writing in the 1965 D&AD Awards Annual)
He lives in Chelsea, claims that he has lunched at the Terrazza at least twice a week for five years, and has a nine-year-old daughter. His flat is full of typically inspired improvisations – a seatless bentwood chair painted white and hung over the fireplace to look like a stunning piece of modern sculpture, a big gilded letter 'R' studded with lights (it must have been a circus sign) suspended over the dinner table like a chandelier.

Jack Masey I spent one night in London and, on the recommendation of Ivan and Tom, I tracked Brownjohn down. He was with this Norwegian woman and we three had dinner one night. He was literally larger than life, he was big! I was captivated by this guy, there was something grandiose about him. I remember him sitting there, with this bombshell adoring him and hanging on his every

Meet the man who gets the Bond films off to a sizzling start

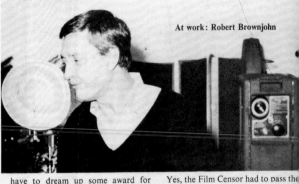

At work: Robert Brownjohn

The what? Oh, come now! You know what I mean. That long, sprawling, apparently endless list at the start of a film, naming all the talents involved; the list that gives credit where credit's due.

Credits used to be a bore; in many films they still are.

"The interminable before the unbearable," as one star put it to me.

In recent years, though, they have suddenly been revolutionised. Fresh brains have moved in (following the lead of America's Saul Bass) and swept away the dull, old-fashioned style. Now the often-abused titles have an exciting, vivid life of their own. Brightened and tightened, they add new impetus to a film.

I mean, who can forget last year's smash-hit credit-titles in *From Russia With Love*? Remember all those writhing names, shimmering around and on the undulating body of a gorgeous belly-dancer.

This was the work of American designer Robert Brownjohn, a Londoner by adoption, after four years here. His were the first titles ever to be given an O.K. by the Censor.

Brownjohn's unique design won cries of delight from the public, plaudits from the critics and high praise from his fellow-designers. That's all. No award. Nothing from the British Film Academy.

It's my feeling they will jolly well have to dream up some award for titles soon. For if, like everyone else, the Academy thought the *From Russia With Love* credits were good, then wait, just wait, till they see Brownjohn's creation for the new James Bond film. *Goldfinger*. It's sensational!

Very saucy indeed

WHERE, BEFORE, BROWNJOHN HAD THE CREDITS DRIFTING AROUND THE GIRL'S SHAPELY TORSO, THIS TIME HE USES FILM-SCENES. THE NAMES OF THE STARS, TECHNICIANS AND OTHERS ARE SET QUITE FLAT AND STILL—WHILE EPISODES FROM ALL THREE 007 FILMS FLASH AROUND AND OVER THE FANTASTIC STATISTICS (41-23-37) OF STARLET MARGARET NOLAN.

She appears on the screen, wearing just a 30-guinea bikini, made of gold leather, and covered in gold-paint elsewhere. And what Sean Connery, in his Bond exploits, gets up to over her anatomy is very saucy indeed.

Yes, the Film Censor had to pass the titles, too!

"I'm not worried by our Censor, Brownjohn told me. "It's the other countries that present problems. I have doubts about Italy and Spain with this last credits—you know how they feel about belly-dancers. This time America may be the big problem."

To meet this man, who is doing so much for British credit-titles, you have to go to a vast building near Fleet Street. Brownjohn works on the sixth floor as design director for the huge McCann-Erickson advertising agency —work which does, by the way, win him awards!

He is known by one and all as "B.J." ("For Big Jerk, I guess") and jubilantly proud of his success films—but easily annoyed by British credit-titles.

"The trouble here is simple," he said. "Producers always leave the titles to the last minute. They see what cash, if any, they've got left and then decide on the cheapest way to tackle the job!

Katrina and the Stars

ARIES
22nd March to 20th April
Your personal magnetism is high during October, and you can use popularity to promote something of lasting importance. The rainbow hues of progressive thought will make you doubly appealing.

TAURUS
21st April to 21st May
Cool detachment is needed if you're not to get involved with the emotional problems of your friends. Give sympathy by all means, but let it rest there.

GEMINI
22nd May to 21st June
The coming month calls for extreme caution in money affairs. A high-sounding scheme involving risk will inevitably lead to heavy losses. Play safe.

CANCER
22nd June to 23rd July
You stand to gain in your present field of employment in an unexpected way, and you can put the results in your pocketbook or bank while Saturn favours your chart.

LEO
24th July to 23rd August
A certain recklessness and feeling of discontent may undo much of your success of the past. Put on the brakes. Give your mind free rein in formulating new policies.

VIRGO
24th August to 23rd September
Be on the lookout for a person in your immediate circle whose ambitions are wholly selfish. There is no sense in supplying assistance to an inconsiderate materialist.

LIBRA
24th September to 23rd October
Splendid month for business and social progress. What you know inwardly can be made into a reality. The cosmic cornucopia of plenty is really spilling out in your direction during October.

SCORPIO
24th October to 22nd November
Nebulous Neptune is at work—so beware all you starry-eyed people! This planet has the uncanny effect of making everyone look twice as good as they really are, so make allowances for a rude awakening!

SAGITTARIUS
23rd November to 22nd December
Others tend to look to you for encouragement and sympathy when their spirits are on the low side. This is all very well, but you may need a bit of encouragement yourself.

CAPRICORN
23rd December to 20th January
Watch expenses which will tend to rise alarmingly throughout the coming month. This applies especially to those who concentrating mainly on having a good time.

AQUARIUS
21st January to 19th February
A romantic dream could well bloom into a thrilling experience, but don't let this delightful surprise upset your emotional balance.

PISCES
20th February to 21st March
Saturnine rays which encourage negative thoughts are prominent in your solar chart during October. The best way to combat this tendency is to dig yourself out of the rut.

How to order Showtime
You can get a copy of Showtime each month for a year by filling in the form below and sending it with a 16s. Postal Order—to cover cost and postage—to:
**Showtime, Circulation Department,
11, Belgrave Road, London, S.W.1.**

BLOCK CAPITALS PLEASE

Name

Address

22

Showtime Magazine, 1964

'GOOD TITLES ARE EXPEN-
VE. SINCE *FROM RUSSIA WITH
VE* I HAVE HAD MANY
FERS. BUT FEW WILL MEET
Y PRICE; AND THAT'S ONLY
,000. NOT MUCH WHEN YOU
ALISE I PAY MY TEAM OUT
THAT.
"This kind of operation can never
a one-man job," he continued.
d be lost without my crew—Trevor
nd (no relation to 007) is my
oduction manager; David Watkins
my lighting-cameraman; and Hugh
ggett is my editor.
"I also have to get the equipment
d hire a studio—in this case
vickenham, for seven days at £70
day. Then there's my model, make-
woman, and all the usual tech-
cians. I'm lucky if I make £1,000.
"Now in the States, Saul Bass gets
7,000 a movie."
BJ agrees that Bass is the uncrowned
ng of the credit-title designers. It
as Bass who started the revolution.
st known among his 24 designs is
work for Otto Preminger; he
kled all Otto's films, from *The Man
ith The Golden Arm* to *The Cardinal.*
was also responsible for the famous
credits at the beginning of *Walk
The Wild Side*—which won better
views than the film!

The Bass Influence

So far Bass is one step ahead of
ownjohn. He has broken into the
ecial consultant field and master-
nded the horrific stabbing scene in
ycho. . . the gladiatorial battles in
artacus . . . and the opening aerial
ots of New York in *West Side Story.*
Naturally, BJ is influenced by Bass;
knew him well in New York.
"Not so much influenced by his
as, as the way he changed this whole
stem," he pointed out.
Bass's philosophy on their work is
s: "For the average audience, the
edits tell them there's only three
nutes left to eat popcorn. I take this
ead' period and try to do more than
ply get rid of names that filmgoers
n't interested in. I aim to set up
audience for what's coming;
ke them expectant."
BJ does the same thing—brilliantly.
"It's just like a super book-jacket,"
said over lunch.
It wasn't on our Italian menu, but
ck soup was often mentioned in
's conversation. It was, I discovered,
w York slang for "easy".
"When I first had my idea for this
d of work, colour-film was not
t enough. It would have been duck
p in stills. But I wanted movement.
"IT STARTED SIX YEARS AGO.
AS TEACHING TYPOGRAPHY
TH A SLIDE-PROJECTOR AT

SCHOOL. ONE STUDENT CAME
IN LATE. HE WALKED IN FRONT
OF THE PROJECTOR'S BEAM.
IMMEDIATELY THE TYPE IN
THE SLIDE SHOT ON TO HIS
SHIRT. OF COURSE THE SHIRT
WASN'T FLAT LIKE A SCREEN,
SO THE TYPE CHANGED SIZES.
IT LOOKED GREAT!"
BJ knew the Bond producers
through a mutual friend. When they
called him in to do the *From Russia
With Love* titles, they mentioned they
had a belly-dancer in the film.
Immediately the old idea came to
BJ's mind and, borrowing a projector
and removing his jacket, he gave the
producers an on-the-spot demonstra-
tion of what he wanted to do.
"In *From Russia With Love* we
used three girls," explained Brown-
john. "I used a 3,000-watt slide-
projector. There was no depth of
focus, of course, so the belly-dancer
had to undulate in a very controlled
manner in order to keep within the
correct distance."
It sounds very technical, I know.
But try out one of your own holiday-
movies or slides, put Mum in front of
the beam, and you'll see how these
exciting titles were born. If Mum has a
gold dress, all the better. But watch
your lighting.
DURING ONE OF BJ'S TESTS,
MARGARET NOLAN'S GOLD-
PAINTED BODY LOOKED
SILVER. AND THAT WOULD
NEVER DO. NOT FOR A FILM
CALLED *GOLDFINGER.*
TONY CRAWLEY

Over the page, Mr Connery!

Now meet the girl behind the gold-
paint in the credit-titles—MARGARET
NOLAN.
"It was hard work," she said. "It took
an hour twice a day to get all that gold
on, then I had to stand and lie on a hard
platform for hours with the projector
flickering in my face. Still, the result
made it all worth-while."
Margaret has a small role in the
film. She can also be seen in *The
Beauty Jungle* and *A Hard Day's Night.*

23

word. He was having a good time, yet I saw this sadness permeating the excitement. The dinner went on for a long time, and there were moments when he didn't say much, just drifted off.

Dick Davison If you were registered as an addict, you would only get a certain amount, so he worked out ways of getting more. He would have other people register and pay them for the drugs, and when that wasn't enough he would go out and get some cocaine and mix it with heroin to make speedballs. The whole concept of what they were trying to do with drugs in England was wrong.

I went over to visit him in London a couple of times, but one time I went over specifically because he had asked me to help him clean up. Sometimes he would just use quitting as a way of cutting down on his need, but this time he wanted to get off drugs entirely. I kept him locked up for three or four days. It was very difficult, his need was overwhelming. He was truly, seriously addicted. It is an area that is very complicated, but he was as badly addicted as it is possible to be.

We got him through the worst part of the period, but he was fragile and he really needed a support group, people who had been where he was and had changed and were leading completely different lives. Everyone he knew was an abuser of some form or another. Even if they used less or were using something different, they were reinforcers.

Eliza Brownjohn He was in hospital a few times, in St George's, which is now The Lanesborough on Hyde Park Corner. I remember once when he was very ill, so unwell, and he was in there for several weeks. That must have been around '66.

Tony Palladino I got into an accident when I was in London. I was in a fight at the agency and I went into the hospital. I was back in my house the next day, but I had a pretty big cut. Bj came in the morning and he got in bed with me. He figured that, the kind of guy I was and where I came from, I was going to get money for this happening to me. He wanted to save our friendship with his charm, love and humour, hoping I would give him a cut of the take. But there was a lot of love in it. It was very Bj.

After that I wanted to get back to the States. I had had enough of London. The experience of the fight wasn't good and I really wanted to get back to New York. I wanted to get back into some real competition.

1965 Works with **David Cammell** and **Hugh Hudson.**

David Cammell I left university not knowing what to do. Obviously I had interviews and offers of all sorts of good jobs – I had been editing a political magazine at Cambridge – so I had considered all the respectable careers. But then I was introduced to the

American photographer Claude Virgin. He was a pioneer in his day. He had been brought over by English *Vogue* and had a completely different eye to the English photographers. He was working in the *Vogue* studios and his assistant was David Bailey, so there was a lot bubbling on there. I became his agent. I was introduced to him by Angela Landels, who was an art director and a very good artist, and I became her agent too. Later, through my brother Donald, I met Helmut Newton, a young Australian photographer who had settled in Paris. I pointed out that he needed an agent – I had quite a good thing going, really.

There were some really bright people in advertising then, but obviously I didn't want to hawk other people's work around agencies all my life. I had met a chap called Hugh Hudson, Hugh Donaldson Hudson as he was then called. He was very glamorous, he dressed beautifully and had a smart motorcar. He was the representative of a French advertising filmmakers and I used to bump into him around town. He was very keen to make movies and at some point I said, 'What's all this business about working for other people? Why don't we start our own company?' So we started Cammell Hudson Associates. We financed the company with the money we made from the agency. We didn't have any capital, but we had a very good turnover. And we set up our office in the basement of Hugh's parents' house in Chelsea, so our overheads were minimal.

Hugh Hudson	Our first film was about egg boxes.
David Cammell	Egg boxes, yes, that was an absolute coup, that was what got us started. I met a man in the pub and he said, 'What do you do?', and I said, 'We make films', and he said, 'Oh good, because my boss says we have got to make an advertising film.' We went down to visit the factory and they gave us the job!
Hugh Hudson	Later we made a film called *A is for Apple* for the Apple and Pear Council. We got that job through Robert Carrier, the American chef, the first TV chef.
David Cammell	I had met Brownjohn by that point and realized that he was an exceptional talent. I asked him, 'Have you got any ideas for this film we are going to make about apples?' And he just said, 'A is for Apple.' That is virtually all he said. So I said, 'You mean like a children's book?', and he said, 'Yeah.' He also made animated titles for the film, which were very fashionable then. It won the Screenwriters Guild award for the best film script.
	That was the thrill of working with Bj, all he had to say were a few words and it clicked, you could see the whole thing. He had a great gift as a teacher. He was able to bring the best out of you and give you confidence. Earlier on some of his ideas were nutty, but once I got confident, I could distinguish the good ones from the less good ones.

1966 Designs titles for The Tortoise and the Hare.

Hugh Hudson	He also did the titles for the Pirelli film, *The Tortoise and the Hare*.
Derek Forsyth	I was head of graphic design and art direction for Pirelli and I met Hugh at a party. I remarked that he didn't sound very happy, and he said, 'No, I'm not because BP [British Petroleum] have turned down this idea and I really thought it was for them.' And I said, 'Why?', and he explained the film to me. And I said, 'Hugh, I'll do it!' It cost about £40,000, which was a fortune in those days. The film is very dated, but it is quite good. Bob Freeman was the cameraman, the Beatles photographer.
Promotional brochure	*Pirelli have presented films before, but never one like this, which was sparked off by the clash of two flint-keen enterprises. The earliest document ever filed in the archives of Cammell, Hudson and Brownjohn Associates is a two-page, dog-eared typescript marked* The Tortoise and the Hare: An Idea *... This was a film the associates had always wanted to make.*
Derek Forsyth	We had a rough storyboard, a shooting script, and we went off with Hugh and a small crew to shoot the film in Italy. It took about three months in all. The story was based on the Aesop's fable. A girl is leaving the south of Italy to drive home – she is in a white E-type Jaguar, which was my car – and there is a lorry alongside her. And she stops to have lunch, or to look at the scenery, but the lorry carries on. There is a bit of innuendo, the driver stops by the side of the road to shave and she passes him and gives him a wave, and so on. At the end of the film she puts herself and her car on a train, and, as the train enters a tunnel, the lorry passes her for the last time and the driver waves. The girl was played by Liz Allsop, who was a bit of a star, a Chelsea name.

We were cutting the film in Shawfield Street, and Brownjohn was around, so he was the obvious person to do the titles. He saw the film and he had the idea of putting the credits on moving trucks. It was such a clever spontaneous idea. There wasn't any kind of presentation, no storyboards or any of that crap, he just had the idea and I found the money. Then we had to get hold of a lot of trucks and rent an airfield. Hugh directed it. It was the hardest thing because the titles kept falling off the trucks! |
| David Cammell | Of course the first thing Bj did for us was our letterhead. He didn't design it as such, he just said, 'Engraved. Typewriter face. On Bible paper.' So I trailed around trying to find Bible paper and then it turned out you couldn't engrave on it. We had to carry out endless experiments with thermoplastic printing. |
| Hugh Hudson | And then, when it arrived, it was totally impractical. The typewriter ripped it up immediately. His second letterhead was brilliant though. The page was punched with holes, not sprocket holes, just holes. It was an inspired idea for a film company. |

1966 **Joins David Cammell and Hugh Hudson to form Cammell, Hudson and Brownjohn Associates (CHB).**

David Cammell After *The Tortoise and the Hare* I suggested to Hugh that we take Bj on as a partner. He was older – he was in his late thirties and we were in our mid-twenties – and much more experienced. And his graphic work just knocked us out!

Hugh Hudson When we first asked Bj to join us he said he would if he could have our blotter. We shared a grand rosewood partners' desk. We used to take turns sitting in the chair and on the desk was a pad that we both doodled on while we were on the phone. Bj said, 'Yes, if I can take that.'

David Cammell I felt tremendously privileged, and I do to this day, that he agreed to work with us. He was far more impressive than we were. It was a marvellous gift that he was available, but he wouldn't have been had he not had this flaw.

Bob Gill When Bj started this production company with Cammell and Hudson, he came to me and said, 'Would you do all our ads and our identity programme?' He used to call himself the second best designer in England, it was one of the nicest compliments I ever got.

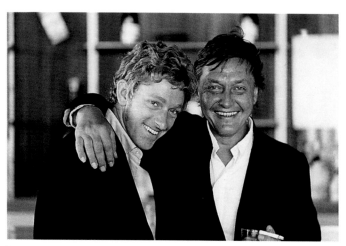

Hugh Hudson and Brownjohn, late 1960s

Bobby Gill It amused me that Brownjohn wanted someone to do the identity other than himself. I always thought that was a bit odd. From then on we saw a lot of Brownjohn, and Cammell and Hudson as well.

1966 **CHB moves to Shawfield House, just off the King's Road.**

David Cammell	Shawfield House was rather eccentric. Hugh and I had our own offices, we had to be on the spot much more than Bj. We hired a rather fancy designer, a partner of Conran called Oliver Gregory. He built this huge conference table that you had to stand up at. Bj used it as his desk. Everything was a bit impractical, my office was wrapped in tinfoil.
Hugh Hudson	I had a table made of poured concrete, it was very awkward when we had to move out. Brownjohn was erratic and unreliable, he couldn't work in a big organization, but it was alright with people like us, we were a bit more relaxed. Of course it was all total chaos, his office had this huge table and there were papers and books everywhere. He couldn't find anything.
Piers Jessop	A producer I was working with said, 'I hear you're going to go to Cammell, Hudson and Brownjohn? You are going to have a hard time: I guarantee you that the first words that Bj will say to you are "You're fired."' And I turned up on Monday morning and, some hours later, who should appear in his fur coat but Brownjohn. He looked at me and said, 'Who the hell are you?', and I said, 'I'm Piers Jessop and I am the new supervising editor.' So he said, 'I'm Robert Brownjohn, and I do the hiring and firing around here, and you're fired,' and he walked off. Of course this was exactly what had been predicted, but three hours later we were in the Chelsea Potter drinking, and he was telling me about Charlie Parker, and we just clicked. He nicknamed me 'Jockstrap', which is not very attractive. He used to say, 'Hey, Jockstrap!'
	Shawfield House had a wonderful courtyard in these pale Mediterranean colours, which Bj was always getting repainted. I remember going there to meet the rest of the editing staff for the first time, walking through a lovely door into the cutting room and seeing four suspiciously glassy-eyed young men. 'Hi', they said, 'Good to meet you, I'm working with you, man, and it's going to be cool.' They were all out of their boxes, and I was from the very straight part of the industry. But I loved it, they were all hippies and they were sweet.
Paul May	When I was a young designer working in London I went to hear a lecture that Brownjohn gave at the Society of Typography Designers. He talked about ideas, and hearing him was one of the things that encouraged me to go to the United States. I worked for Chermayeff & Geismar in New York for a while and then came back to London. I ran into Brownjohn and later gave him a call. We did a job together, designing stationery for the Robert Fraser Gallery. It was a crazy thing, because he wanted every character to be in a different typeface. It was a nightmare, we had to find a nice, co-operative printer. I remember going into Cammell, Hudson and Brownjohn to talk to Bj about work, and this woman, Anita Pallenberg, was draped over this sofa with vast lengths of leg!
Bobby Gill	When Bob was working at Shawfield House, I used to go along for the ride. The people who worked there, Piers Jessop and Marty Fulford, they were a lot

of fun. I was very interested in Brownjohn's work, especially the film, I used to look over his shoulder while he was editing on the Steinbeck. He loved showing things, he didn't care if you were a designer or not, he included everybody.

Once, over dinner, I told him about teaching graphic design students. I was describing one of my classes where I was getting students to look at familiar surroundings and find something different to say about them. He said, 'Oh!', and got out all his photographs, the pictures that were published in *Typographica*, taken when he first came to London. He gave me a great wodge of prints and all his slides to show the students. They were amazed, because they hadn't seen anything like that. I carried on showing them for years.

Once he even came out to lecture my students himself, in East Ham of all places! He came in his '60s fur coat, with his great growly voice. They had never seen anything like it – it was a vocational graphics course – they were gobsmacked!

Piers Jessop You know the piece by Bj in the *Vision in Motion* book? I didn't know about it before somebody lent me the book to read. The next morning I went into Cammell and Hudson and I said, 'I've been reading a book called *Vision in Motion* … ' and Bj said, 'Page 77', and staggered into his room. I had had no idea that he had known Moholy-Nagy. I remember going to the ICA with Bj to see Buckminster Fuller, and he came over and said hello!

1966 Visits New York.

Sara Chermayeff Bj would come from London periodically and stay with us. Once he looked fine and once he was impossible. He was really so overbearing.

Tom Geismar After he went to London he would come back occasionally, then he had really become outrageous. Once my father had come to visit me in the studio and Bj arrived unannounced, it was at the time he was really heavy. He said, 'Mr Geismar, let's go out, let's have a drink!' My father hardly drank, but Bj convinced him to go out for hours and hours. There was I wondering what they were doing. Later my father said, 'Oh, it was very nice meeting your colleague.' That's all I heard.

Edgar Bartolucci Cato ran into him in New York every once in a while. To give you an idea what it was like, Bj runs into Cato in a hotel lobby and they start talking. One thing leads to another, and then Brownjohn says to Cato, 'Hey, can you lend me $20? I have to take a cab.' Even when he was working for a fancy advertising agency, he was broke! And he would never take the bus or the subway. If you gave him $5 he would take a cab. I remember Cato telling me that story and saying, 'He's exactly the same, he hasn't changed!'

1965 –70 Creates the 'Money Talks' cinema advertising series for Midland Bank.

David Cammell	We did a lot of work for the advertising agency Charles Barker and they approached us and asked if we had any ideas for Midland Bank. I had seen this little booklet that Bj had done while he was in the States, it was called *Watching Words Move* and it was purely type. It was such a neat idea. So I borrowed the booklet from Bj, took it to Jean Wadlow at Charles Barker and said, 'Here's the idea for your series.' And they bought it! The first one we made was called 'Money Talks'. It won first prize at Cannes.
	They wanted us to make another one each year after that. The format was set, so I simply wrote the others and showed them to Bj, and he would say 'Yeah.' I remember after the fourth one saying, 'Come on, let's do something else!' The formula was absolutely rigid, but they were such a success. Believe it or not, I have been in the cinema on two or three occasions when the entire audience rose to its feet and applauded them. Of course, I would be sitting there with my girlfriend saying, 'I did that.'
Jean Wadlow	I had seen *From Russia with Love* and I loved those titles. I thought, 'What an imagination!' So I tracked Bj down. I just picked up the phone and found out where Robert Brownjohn worked and gave him a call. He came to Charles Barker and said, 'I wanna see Jean Wadlow.' The MD came down and thought he had come to decorate the reception, he was dressed like he was going to paint a wall. They had never seen anyone like him! Charles Barker was known as the gentlemen's agency.
	I sat him down in our cinema conference area and gave him a cup of coffee and said, 'Look, I have a problem. I need a creative idea that's going to knock everyone sideways. It's for Midland Bank and I think it should be graphic because Barclay's have cartoons.' And he said, 'Interesting.' The brief was to get young people to join Midland Bank using cinema advertising. I asked him about writers. We had copywriters at Charles Barker's, but no one in Bj's league – that's what I told him anyway, men love to be flattered – so we used David Cammell to write the ads.
	The animator Trevor Bond created a storyboard to sell the idea to the bank and I presented it to the top bankers. I had told the account director that I believed that the idea would transform both the bank and the agency and, to his credit, he backed me. The rest is history. They won everything, we were the talk of the Venice Film Festival. We did about seven ads in the series.
Piers Jessop	Bj was terrified because he thought the ideas were drying up, that he had had it. People kept wanting him to do what he had done before, like the Midland Bank commercials. Of course he had used those ideas years before in a book, but Midland wanted them, so he did them again, and they were very successful. And it went on and on. He thought the creative thing had gone.

He used to come in and say, 'Hey Jockstrap, I've got this idea. What do you think?', and I'd say, 'Fucking brilliant Bj, fucking brilliant.' Then, ten minutes later, he would be back saying, 'Hey Jockstrap, I've got this idea', and I would say, 'You told me Bj.' And he would say, 'Not that idea, that's a shitty idea. Why didn't you tell me it's a shitty idea?'

Late 1960s **Becomes part of the King's Road scene.**

Eliza Brownjohn It was a big party and I went everywhere. The *modus operandi* on Saturday was everyone met up at the Chelsea Potter, and then we would move on to Alvaro's for lunch, and then we would move on to someone's house for a drink. Everyone would drink and talk all evening.

Bj used to get me into Tramps and Aretusa, no problem. I was very used to being with adults, so I didn't stand out. The only place I wasn't allowed into was the Chelsea Potter, so the kids would have to stand outside, there was usually another kid there. Sometimes I would go upstairs and play with the owner's daughter.

But we had real quality time when he took me to lunch or to the park, or to London Zoo – he loved the monkeys and rhinoceroses – and he would pour out his soul to me.

Piers Jessop I can remember seeing Kiki running down the King's Road from the Chelsea Potter pursued by Bj with forty Gauloise in one hand and three lagers in the other. Drunk, after some row in the Potter. They were always having rows, but they also had nice times, he was very fond of her. He adored Eliza too, he used to take her to play on that bit of open ground, near St Leonard's Terrace. He was very proud of her.

Hugh Hudson Bj liked the King's Road and that scene. I don't think he went much further than Sloane Court West and Shawfield Street.

David Cammell And Alvaro's and the Chelsea Potter, the pub across the road. Bj often slipped across for a pint.

Hugh Hudson I don't think he ever learnt to drive.

David Cammell At one point he did talk about us providing him with the latest American Corvette, or something. He did feel that his role as director required a motorcar.

Hugh Hudson Because we both had cars.

Robert Brownjohn

Experimenter, innovator, several strides ahead of everyone else in his field, Robert Brownjohn is concerned with the age's current artistic obsession: visual communication. "There are few boundaries to my work, I design anything from letterheads to movies." Architecture, photography, all printed matter, exhibitions, advertising, books, magazines—they are all involved. A member of a successful design partnership in New York, Brownjohn came over on a visit and says he was "captivated by London," so set himself up to work over here. "I was tired of doing nothing but work in New York, nothing but the normal run of graphics. New York is stimulating for a designer, but in London you have to stimulate yourself, and if you want to do something you are the only one who can make sure that it's done." Brownjohn certainly found the necessary inner stimulation in London, immediately became immensely successful, broke into several new fields and is now receiving commissions from the States: "I am convinced they don't know I'm an American—drop out for a while and you are forgotten—which just shows that America is beginning to look across the Atlantic for design ideas." Brownjohn collects prizes, gold medals and awards like other people collect the groceries. Among his notable work has been the American Streetscape section of the American pavilion at the Brussels World Fair and the credit titles for two James Bond films, *From Russia with Love* in which the words wrapped themselves around a belly dancer, and *Goldfinger* ("Those titles alone cost £2,500"). It was not until he arrived in England that Brownjohn managed to get into films: he has just completed a highly experimental advertising film for the Midland Bank which consists entirely of words, moving and jumping and acting out their function (for example the 'o' in golf comes winging in as if clubbed to rattle into place) and is currently working on nine other films—both advertising and documentary. Brownjohn has seen a decisive increase in the general public's acceptance of his type of work: "The change in the past five years has been fantastic. This Midland Bank film is an amazing phenomenon, being just words. I could show you some 200 rejected slides that were once considered too far out." Even so he will always meet censorship until the public (or the client) catches up with him; even the poster he designed for *Goldfinger* was rejected: "And in the film world you have to contend with actors who have it in their contracts that their names must be a certain size, which kills a design." He teaches at the Chelsea College of Art, and his innovations in graphic design have led to the creation of much of the imaginative and enticing work one sees around.

Alvaro Maccione with Eliza Brownjohn, early 1960s, London

A list of the select group of Londoners holding the number of the Alvaro restaurant, compiled by the journalist Jon Bradshaw for *Queen Magazine*, 1966

Mr. A's Ex-Directory Society

Brownjohn
Lionel Blair
Lauro Resta
Harry Saltzman
'Cubby' Broccoli
Doug Hayward
Joseph Janni
Vidal Sassoon
Herbert Kretzmer
Mr and Mrs Bobby Lewis
Mims Scaler
Willie Landels
Alfred Pieroni
Mr and Mrs Ken Adam
Roman Polanski
David Chasman
Maurice Binder
Henry Mancini
Sean Connery
Duke of Bedford
George and Claud Ciancimino
David Bailey
Mary Quant
Alexander Plunkett Green
Leslie Caron
Len Deighton
Jean Shrimpton
Michael Caine

Elizabeth D'Arcy
Brian Duffy
Alan Ladd Junior
G. Gutosky
William W. Graf
Peter Hunt
Charles Kasher
Leonard Lewis
Al Mancini
David Mlinaric
Michael Medwin
Gerald McCann
Ronan O'Rahilly
Edna O'Brien
Maurice Pascal
David Salinger
Marta Sampson
Mike Sarne
Tony Newley
Joan Collins
Arnold Wesker
Billy Hamilton
Leslie Linder
Bob Freeman
Adrian Flowers
Michael Erleigh
Jack De Lane Lee
John Donaldson
Roy Pegram
Michael Cooper
David Cammell

Cliff Adams
Antonioni
Mick Jagger
Brian Jones
Princess Margaret
Lord Snowdon
Samantha Eggar
Tom Stern
John Barry
Pietro Annigoni
Helen Hyman
Jennifer Tudor
John Irwin
Harry Baird
Dudley Moore
David Frost
Terence Stamp
Eric Swayne
Johnny Gilbert
Thom Keyes
Peter Katz
Richard Wattis
Peter Cook
David Puttnam
James Garrett
George Dixon
Robert Edward
Tara Brown
Gerard McCarten

David Cammell — But of course then we would have had to provide a driver. We did have an unofficial driver called Con. He had a minicab and used to drive us around, and then he became a permanent feature, a sort of chauffeur.

Hugh Hudson — Con was always driving Bj around, taking him from one place to another.

Mid- to late 1960s — Frequents London's iconic Italian restaurants: the Terrazza, Alvaro's and the Aretusa.

Hugh Hudson — There were hardly any restaurants until 1961 or '62, it was staggering.

David Cammell — The Terrazza [on Wardour Street] was a huge innovation, there had always been Italian restaurants before the war, but they were full of Chianti bottles with dripping candles. The Terrazza was very cool, very noisy and very cool.

Hugh Hudson — In 1966 Alvaro and Mimo Disci opened Alvaro's on the King's Road. They were two lads who had been waiters at the Terrazza. And later they opened the club the Aretusa, which was a key place when it was going.

Jon Bradshaw — (describing Alvaro's opening night in *Queen Magazine*, April 1966)
The be-sweatered, be-minied mob began to arrive shortly after seven. By eight there was chaos; by ten the police were making provisional gestures to temper the tide outside in the King's Road. Inside the smoke-filled room, it was possible to see the shaggy bunched faces of the photographers and models, the stars and the

starlets, nodding and languidly wagging, undulating like balloons on the great waves of smoke. The lank-limbed fashion model, a man on either arm, had retreated to a corner and spoke delicately of forcing her way to the bar. Everyone knew everyone else.

Willie Landels — Alvaro had a restaurant on the King's Road called Alvaro's. When it opened, Joseph Losey was filming *The Servant* opposite and so everyone went there. Enzo Apicella suggested to Alvaro that they have an unlisted number, only 200 people would have the telephone number in order to book. It made the place a scene from the day it opened.

Jon Bradshaw — *Maccione Alvaro: 'It is the people who make my restaurant, not simply the design. I take bookings only on the day they intend to come. If I do not know the person I say, sorry, sir, we are fully booked. I can tell the moment a person walks in the door if I want him or not. It is something in my blood that tells me that. Not the face so much, not the dress, it's the way they walk into a restaurant, their pose, the way they handle themselves, I can tell … I don't have customers, I have friends.'*

Alan Fletcher — He practically killed me once. I met him walking down the King's Road, I think I was going to see Zeev Aram's little furniture shop down there. The fashionable restaurant then was Alvaro's on the King's Road, so Bj said, 'Oh let's have lunch in Alvaro's!' As we were walking towards the restaurant, he asked all these people he half knew to come with us. By the time we got there it seemed like we were fifty people, it was certainly thirty. Then he disappeared after the lunch and I got stuck with the bill. It cost me something like, in today's terms, £2,000. He did it as a joke, but it was a substantial thing for me.

Dick Davison — Do you know about the time when he threw a plate of spaghetti at someone in a restaurant in Chelsea? He had his moments of acting out that were really outrageous.

David Cammell — We all used to go and eat at Alvaro's pretty regularly. I remember one day Bj went there for lunch on his own – he must have been in a bad mood. He was sitting eating and two guys on the far side of the room kept glancing over at him, talking about him. He finished his pasta and got up – he had to meet some clients at Shawfield House. On his way out, he picked up a plate of pasta, said, 'Don't talk about me behind my back', and dumped it on one of their heads. When he came back we were waiting for the clients and, who should come in, but the two men, one of them covered with pasta! To give them their due, I think we got the job.

Sara Chermayeff — I remember being with him in a London restaurant once when he leapt up and talked to Orson Welles, and he seemed to be an old friend. Orson Welles was as big as a house, and Bj was huge too, both so excessive.

David Cammell	One morning he came in and he said, 'David, I saw Orson Welles last night!' He had been at some restaurant somewhere. He said, 'Orson Welles came in, and he made me look like Twiggy!'
Alan Fletcher	I doubt he ever had a meal at home when he was in London. He was out being wined and dined, or wining and dining. La Terrazza two nights a week, Alvaro's a third, somewhere else on the other nights. Going to the pub afterwards. He was always in the social swim.
Bobby Gill	Brownjohn was very charismatic. He looked like Orson Welles for a start. And that voice, like a bear! He cultivated a wonderful deep voice. And he wore crazy things, big fur coats and crazy big hats. It was an image, part of the times, the swinging '60s. He seemed to be well known and to mix with pop stars.
Piers Jessop	Bj was always picking up girls in the Aretusa and offering them jobs. Young girls used to arrive, beautiful dolly birds, to use the expression of the time, in these little miniskirts. They would arrive on Monday morning and say, 'Where do I sit?'
Eliza Brownjohn	He used to come and visit me at boarding school and take the whole class out for a Chinese meal. The school was vegetarian, so we were all desperate, and the only restaurant in town apart from a Wimpy was the Chinese. Once he landed on the sports field in a helicopter wearing a white suit. The kids went crazy.

1967 **Designs letterhead for the photographer Michael Cooper.**

Bobby Gill	It was very much the style then to have a witty letterhead. Brownjohn designed one for this guy Michael Cooper, who was somebody who hung around, but didn't have much personality. The only interesting thing this guy did was to ask Brownjohn to design his letterhead, so Brownjohn used half the page, making it all about himself.
Bob Gill	This is the greatest free job ever done by a designer. What does he want to say? 'I did this for nothing.' Isn't that great?

December 1967 **CHB throws a party.**

Hugh Hudson	We had a wonderful party, I think it was a Christmas party or a New Year's party, or just a party to celebrate our vast success. People still talk about it to this day.
Piers Jessop	It was a party to attract business, but I think they only invited one client. Bob Gill designed the invitation. It was a film tin, half open with nicely wrapped sweets bubbling out of it.

inside london life

Edited by ROSS BE

Actors Terence Stamp and Michael Caine intent in manner and deep in conversation at the Cammel, Hudson, Brownjohn

4

Look of London magazine, 1967

Other guests at the party included Chrissie Shrimpton

. . . . and David Bailey, with Penny Knorsles.

Beautiful Chelsea

I have always had a rather sneaking admiration for the Chelsea set. Young, well-dressed and quite beautiful. They're not really Kings Road, even though a lot of them do live nearby; they're older and more established and they all have smart cars (or at least the use of one) and expensive clothes from Blades and Dandy Fashion.

The Chelsea set have their heroes, but these are usually people of their own creation. Like Twiggy and Jimi Hendrix. And Terence Stamp and Michael Caine. I went to a party recently, held in celebration of the opening of Cammel, Hudson and Brownjohn's studio extension.

There was a discothèque and group. And lots of liquor, followed down with spare ribs and Chinese dumplings. And lots of people including Terence Stamp and Michael Caine.

These two images of the English screen stood in a corner and talked. They used to share a flat together in Harley Street, and obviously had more in common with each other than the rest of the crowd. Not meaning to detract from the worth of the others, of course.

5

David Cammell	We had a light show and Russian balalaika band that Hugh had used for a whisky commercial (we had made a film for Cutty Sark whisky about Russians trying to steal their secret). We put some trees in the courtyard, turning it into a forest.
Hugh Hudson	And we made a tape of birdsong and jungle noises that played on a loop. At the end of the loop there came screaming out of the night sky, the sound of a MiG jet fighter, which would machine gun everything. Then there would be complete silence until, slowly, the twittering sound built up again. On the evening of the party it snowed and so we put braziers in the garden and the fir trees were covered in snow.
David Cammell	Rather amazingly and completely idiotically we got the Hilton Hotel to supply the food. They had a very smart restaurant up there, it must have cost a fortune! We ran out and they were sending limousines with more.

1968 Plays a cameo part in the film Otley.

Tom Geismar	He became more of a character, a personality, in London. He played it up. What was the movie where he was a heavy?
Piers Jessop	It was only one line, one very short line. He would come in and say 'Jockstrap, how's this: "Where is Otley?"', and I would say, 'It's great Bj, brilliant.' 'But, what do you think Jockstrap? Should I say: "Where IS Otley?"'

Brownjohn and Tom Courtenay, still from *Otley*, 1968

1968 Designs the cover for The Rolling Stones album Let It Bleed.

Sara Chermayeff	The four of us, Bj, Kiki, Ivan and I, went in a limo to someplace where the Rolling Stones were doing this recording. Imagine going and seeing the Stones at that

time! And there they all were, and there was Bj, it was incredible! It wasn't a concert, but they were doing a recording in a studio somewhere outside London. Kiki was smoking away in the back of this limo. I mean, people didn't use limos then, Bj was always way ahead of his time.

Tony Palladino He was doing a cover for the Rolling Stones and we sat down to think about it. We would have a beer and just sit around and think about it, or not think about it. You know the Rolling Stones cover, *Let It Bleed*? With the cake? Put that altogether and destroy it. Fuck it up, you know, fuck it up. I think it shows the anger that he felt at that point in time. It is an interesting image, and destruction was part of that kind of music, but it didn't have the sensitivity that the music contained. I think you could argue with Bj about that particular piece.

Dick Fontaine I remember him doing the Rolling Stones cover, using me as a bit of a sounding board, he was obviously doing that with everybody on the King's Road. He talked about the things he was going to put in it. I think his life was very messy at the time and it was a fair representation of where he was.

Sanford Lieberson When I first came to London in 1963 I couldn't wait to get back to Los Angeles, but when I came back in 1965 just about everything had changed. The music, the way people looked and dressed, lots of Americans living here intermingling, it was all different. It was a gathering city for artists and writers, a focal point of Europe, like Paris had been in the '50s. I was living on the Embankment in Chelsea and I met Brownjohn quite soon after I arrived, he was so much larger than life! I got to know him better in 1968 when I rented office space at Cammell, Hudson and Brownjohn to produce *Performance* [David Cammell was associate producer, and his brother Donald wrote and co-produced]. It was a very lively place. They were one of the top independent advertising agencies.

I spent a fair amount of time there during pre-production and post-production – it was my first film and I didn't know anything about producing movies! Brownjohn was interested in the film, everybody was interested. They couldn't work out what the hell we were doing, and they felt Donald was a debutante. Not so much Brownjohn, he took everything on face value. We talked about a lot of things with Brownjohn, he was such a volatile and voluble person. He was great to be around most of the time. Not all of the time, though. I remember a few occasions when the plates went flying.

1969 Plays a cameo part in Dick Fontaine's film Double Pisces, Scorpio Rising.

Dick Fontaine I think I first met Bj at the ICA, all my painter friends used to hang out there, people like Eduardo Paolozzi, Lawrence Alloway and the Smithsons. I was younger than Bj, but we could make a connection. We came from a 1950s intellectual environment and we both loved jazz. All those velvet-suited people,

people like Robert Fraser or Michael Cooper, they didn't give a shit about jazz. Although I was their age, I was much more akin to Bj.

I talked to Bj a number of times about making a film about his nightmares, his dreams and nightmares. Unfortunately I don't remember them now, but they were absolutely fascinating.

In the end we made a very low budget film in which Bj plays a bullying producer. It was shot in an abattoir and Bj saw it as an ironic metaphor for commercials. He was very drunk and he got very nervous. Very, very nervous, which was surprising to me. He is not playing himself, but there is a sense in which he is, it is his personality. It was shown at the New York Film Festival in August or September 1970. I am sure that I didn't know he had died. I can't have found out until I came back to England, which was around Christmas.

1969 CHB disbands.

Alan Fletcher Bj used to break into Richard Bell's surgery to get into his drugs cupboard. They had to call the police.

David Cammell There had been some terribly embarrassing scenes with him not showing up at important meetings. Once there was an important client meeting, and he didn't show up, and about half an hour before the meeting the police rang. He was in the cells somewhere near London Airport, having broken into a chemist's shop. That was the final straw. There had been a series of incidents, and eventually Hugh and I asked him to leave. It must have been about '68 or '69. He accepted it with good grace. I think he understood we couldn't carry on working with him.

Trevor Bond He'd always be clutching a can of beer to get him through the day, but he would have moments when he was very lucid and working perfectly. That was the tragedy of it. I remember once he came in with his hands bandaged. He had damaged himself trying to break through some glass somewhere, I don't know what he was doing.

1969 Forms Nagata & Brownjohn with David Nagata.

David Cammell He teamed up with a Japanese-American director called David Nagata, they started a company together, but they used all our facilities and we remained friends. We were actually very glad to have them using our facilities, because at that point we were in financial trouble. We weren't getting enough work.

1969 Kiki Milne leaves Brownjohn.

Sara Chermayeff I remember when she left, Bj said to me, 'Kiki has run off with a free-fall flyer. What is a free-fall flyer?' I just remember him saying that.

"Bon soir, BJ," could well be the title for this post-crepuscule drama played, presumably, nightly in the Carlyle-square, SW3, bedroom of designer Robert Brownjohn. BJ, as he is known even to those who know him not, is much respected for the originality and purity of his professional efforts not excluding some stunning titles for films in the James Bond series. With a Turnbull & Asser robe draped across that Jasper Johnish bedspread BJ, in cream and brown-trimmed pyjamas by Hardy Amies, is either in reverent communication with the usual dieties or else is seeking appropriate guidance from his namesake, LBJ.

David Cammell	We had never had a bust-up, but in the last nine months, after he moved out from Kiki's and was living on his own, I didn't see him so much anymore.

1970 Designs the Peace poster for Dick Davison.

Dick Davison	We asked seven artists to design a flag/poster in recognition of the political consciousness of the era. Bj's was far and away the best. He thought that the biggest problem in the United States was the race problem, so he designed a flag with an Ace of Spades on it. I think it was the last thing he did.

1970 Visits New York for the last time.

Piers Jessop	When he left Cammell Hudson and started working with David Nagata, that's when things went wrong. We were all pretty certain that he wasn't fixing when we were at Cammell Hudson. He certainly would smoke a joint and he always had three or four beers in his hand, but he wasn't fixing. I heard that when he went to New York to pick up the prize for the Peace poster, he met a few old bums. He hung out with them and got back on smack, and six months later he was dead. That's the story I heard.
Tony Palladino	I remember we were here in the States and he was visiting. I was living on 63rd Street, and I saw him really relaxed and I thought, 'No shit, he's bought something.' I was living on the 27th floor, and we were sitting at the table looking out the window toward LaGuardia airport, watching the planes taking off. We were just sitting there enjoying each other, like the way my pop and my pop's brothers used to sit around, and he said, 'Isn't life beautiful.' I knew that something was different, because I had never heard him say anything that sincere. I knew that he was in the click.
Sara Chermayeff	The last time I saw him he was very fat and he was wearing a green velvet jacket and a white t-shirt with his stomach sticking out of both, his nude stomach in the winter! I knew he was in terrible shape, I don't know how close it was before he died. I didn't see him in London again. I was scared of Bj at the end of his life, but then he always scared me a little. You could never tell what he would do next, and that always scared me.
David Enock	Bj, Stanley and I were sitting on the terrace of an apartment I used to live in on First Avenue. It was Bj's last visit to the States. He started playing the Bee Gees 'I Started A Joke' over and over again. Tony was there too, and afterwards Tony said, 'I think he was trying to tell us something.' He was playing that song over and over.
Dick Davison	The last time he came to the States was very difficult because he was really far gone. I can't remember what he came for, but he teamed up with some people and ended up in Harlem getting stoned. He never really recovered from that.

1970 **Bj lives alone in west London.**

Eliza Brownjohn After he broke up with Kiki, he fell in love with a girl called Angie. She was very young and super lovely, and she adored Bj. They were living in the mews house where Bj had an office with Nagata, in Albion Mews. But it didn't work out, her parents didn't approve, and after that he went into a deep depression.

He moved back in with Donna and me, but we were going to Ibiza. That's when he went into the bedsit scenario. It was this really sad place: a basement bedsit in Holland Park, just one room, with the ugliest furniture. He was supposed to be coming on holiday with Donna and me soon after.

Bobby Gill We were going up Holland Park Avenue in a car and we saw him stagger across the road in front of us. Whether he was staggering because he was drunk, or he was tired or unwell, I don't know, but he looked terrible. We didn't want him to see us in the car and come over, because we would have had to invite him back and it would be another long night. So we both hoped that he wouldn't spot us. That must have been a couple of days before he died and we felt so bad.

Eliza Brownjohn I saw him just before we went to Ibiza. We had dinner at the Tratoo. He was very emotional, telling me lots of stuff and talking about how tired he was. He hated what he had got involved in, he felt very sad. He wanted so much not to do it, for my sake. He died on his own in his sleep, he had a massive heart attack and his body just gave way.

1 August 1970 **Dies in London.**

Angela Palladino One night he called, it was early evening, about 7 pm. He called from London, but Tony was at a friend's house, so I said, 'I'll give him a message.' He started talking to our daughter Kate – she was about two years old at the time – and he said goodbye. I didn't understand why, but the day after we found out that he had died.

Tony Palladino And we all had received goodbye notes, myself, David Enock, Ivan, just one line formalizing his exit: 'It's really been nice to know you, I cherish our friendship, goodbye, I love you.' I think that was it.

Television Mail (article on Brownjohn's death, 7 August 1970)
It is with the deepest regret that we have to report the death, on the night of Friday July 31 | Saturday August 1, of Robert Brownjohn, the graphic designer, film maker and creative advertising specialist.

BJ's graphic imagination was unbounded, and there can be no doubt that he was a major influence on the shape of graphic design – and television commercial design – during the sixties. His transition from design for print to design for

television, undertaken substantially after he left Brownjohn Chermayeff, was seemingly effortless. And it had appeared from his recent work that in the seventies as in the sixties, BJ's creativity was still consistently ahead of its time.

David Cammell [...] said on Tuesday 'I don't know what to say. I am just terribly stunned. He seemed to be indestructible. He was an impossible character to work with in many ways, but everybody loved him.'

Jean Wadlow, head of television at Charles Barker and Sons, who has worked consistently with BJ for the past seven years, since the first discussions in 1963 for 'Money Talks,' said 'I don't think I shall ever meet a man quite like him. He was so talented and so much larger than life.'

BJ was one of the real characters of the London advertising scene. His style of working was quite unique, but his elusiveness and the individuality of his approach to business never obscured the value of his creativity.

BJ would be rightfully contemptuous of any traditional form of obituary to him. And the traditional form comes hard, anyway, because it's still impossible to believe that he won't be around the business any more. He was a giant figure in the industry, and no-one who ever dealt with him on a business or social level – and you can't really separate the two in our industry – can ever think of him without affection. Quite apart from the contribution he made to advertising over the past decade, we're going to miss having BJ around. It's just not going to be so much fun, or so interesting, without him. He was a rare person, and we couldn't help but love him.

Autumn 1970 Memorial service at the American Embassy.

Bob Gill When he died, my first thought was I had to do a book. I went to his studio and it was unbelievable, there were half-eaten sandwiches and dirty socks, it was just awful. But I said to myself, 'I don't care how zapped he was, he was ready to show his portfolio to the studio in heaven. So somewhere in this mess there is a very clean portfolio of every job, all ready.'

Bobby Gill It was just a small room with a desk, all in a mess, everything piled up. Lots of stuff we didn't know what to do with, photographs, bits and pieces.

Bob Gill So I looked, and I turned the place upside-down. At first I couldn't find it, but then I went back the next day, and – I couldn't believe it – I found it! I went to the American Embassy, and I said, 'A very important American artist has died' – they didn't know so, of course, I exaggerated. So they laid on an auditorium and food, and we had an evening for Bj where people spoke and we showed work.

xxx

Designer who was a docker dies at 44

ROBERT BROWNJOHN, an American who was one of British advertising's most colourful personalities, died suddenly at his home in London last Friday night. He was 44.

Brownjohn, known as BJ or Beej, was among other things a docker and a lumberjack before making his mark as a designer in America in the fifties. He came to London nine years ago as associate creative director of McCann-Erickson, where he stayed four years.

Subsequently he worked for J. Walter Thompson, then set up the film production company Cammell Hudson and Brownjohn. After this split up he started Nagata and Brownjohn with David Nagata. The company won a gold lion at Cannes this year for one of its Midland Bank commercials.

According to fellow designer Bob Gill, Brownjohn "had a great deal to do with the shake-up in graphic design in England in the early sixties." He won particular attention with his title sequences for James Bond films.

As a sideline Brownjohn became something of an actor. He played the "heavy", a role for which his build fitted him, in Dick Clement's film *Otley*.

He leaves a widow and a teenage daughter.

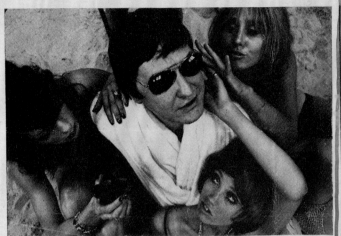

Brownjohn as actor . . . in BP documentary

Eulogies

Eliza Brownjohn I don't think I ever knew anyone who had such a kind heart. He cried when he saw a sad movie or heard a sad song. He was very emotional, very sensitive. That gruff exterior was just protection, it was a shield. In spite of all the craziness, he was just the best father you could ever have had.

Ivan Chermayeff He was a very receptive person, open to all sorts of stuff, not just what he was doing, but sophisticated architecture, art and music. He would have been a very good artist – of course, he was a good artist! Bj had very good taste, that's important, because taste is what allows you to reject crap. Very fast people also come up with an incredible amount of rubbish, but Bj knew what to throw away.

Tom Geismar Bj instilled in me the notion that the idea was all-important. I just marvelled at his wit and his ability to home in on an issue.

Stanley Eisenman He was always going after the winner. He could spend three weeks chasing a great idea. Then, when he got one, he would jump up and down about how terrific it was. He never just settled. He got a real kick out of solving the problem in a unique way.

David Enock He could be very moody, but his work was always great. It was beautiful to see terrific ideas, fresh thought, a new way of looking at something. It worked and it was right.

I tell you something Bj told me. Bob Blechman, the satirical cartoonist – he's a great artist, a little weird, but in a nice way – was over in London for about a month. Bj and he were getting together a lot, and Bj said to me, 'You know that Blechman, he is on the moon.' And I always thought it was Bj who was on the moon! So it turns out that we all think that we're okay.

Sara Chermayeff I was always a bit jealous of Bj. I felt that Serge and Bj were the only people that Ivan respected. He was in awe of them, I saw that. Ivan thought Bj was wonderful, he really did.

Tony Palladino He was street savvy, and to have savvy and be intelligent and charming, those are three important elements. He wove them together to create a powerful wire of self that he presented to the world.

Edgar Bartolucci He was interested in doing something different: choosing a different medium and doing it differently. He was always trying for a new approach.

Dick Davison	He was an individual. He had a clear concept of what he was doing and it was not what was generally accepted at the time. He was not just a leader, he was an innovator in a way that made a difference and affected many people. But he couldn't make small talk, and he had no time for people who were shallow, or weren't truthful, so he could be difficult in a social sense.
Bob Gill	What a personality! He was so much bigger than life, there has never been a graphic designer like him!
Alan Fletcher	He made design into a glamorous thing, rather than a boring pedestrian thing. He always projected an aura of total confidence in what he did, but he was probably as insecure as the rest of us.
Derek Forsyth	We were all a bit arrogant, it was the time, we were like graphic football hooligans. But his ideas were so clever and spontaneous.
Bobby Gill	He wouldn't temper his ideas. People came to him because he was outrageous, and then he was often too outrageous. He was a forerunner.
Derek Birdsall	Bj was partly an inventor, an innovator, and partly a product of his time. Designers like him and Bob Gill were stars for many reasons, their reputations preceded them. They were like football players today! They gave the whole profession a boost.
Willie Landels	He was very quick, wonderfully fast, he could do things immediately. He was brilliant. He was a bit ahead of his time for England, he must have found it frustrating.
Angela Landels	Brownjohn was so gifted. His solutions to problems were so clever. What I loved was the way that he would simplify, and simplify, and simplify, until he had the absolute distillation of an answer.
David Bernstein	Bj would look at something and see it new. I'll always remember a gag he made, I can't do it justice, but there was a lot of rebuilding going on in New York, and there was a sign that said, 'Dig we must for Growing New York!' Bj said it should have been, 'Grow we must for Digging New York!' I will always remember that, it is typical Bj. He would look at something and give it a twist.
Kiki Milne	I learnt an enormous amount from Bj. I was very young and innocent when I met him and he was a wonderful teacher. Most importantly, he taught me how to think. And his work was so brilliant, it was always an inspiration to me.
Trevor Bond	He didn't decorate, he always had a clear, simple idea. Later on in life, when I had a problem, I always said, 'What would Bj have done?' I would try and look at things his way.

David Cammell	He was terribly generous, he brought the best out of other people. He would sow a seed and it would germinate in other people. I am very proud that I spotted him and that we took him on. We were so fortunate. He was obviously a terribly difficult person to deal with, but he was worth every effort.
Hugh Hudson	His standards were incredibly high, I was slightly in awe of that. It would make me a bit nervous. You were frightened that your idea wouldn't meet his standards. I was very influenced by what I learnt from Brownjohn, particularly in my work for advertising, but also in my films.
Piers Jessop	Bj loved paradox, he could associate ideas and images in a wonderfully unique way. His solutions had to communicate afresh, and they had to make you think differently about both sides of the paradox.
Sanford Lieberson	Brownjohn was super-intelligent. That's one of the things that made him so interesting. He was so intelligent and so interested in everything. He must have been very frustrated that he never fulfilled his potential, like so many people of that time.
Dick Fontaine	My sense of his work was that he was running an ironic commentary on the world. He was a brilliantly talented, but deeply flawed, outsider. I suppose, if I am honest, I wanted something of that to rub off on me.
Brian Tattersfield	(quoted by John Gorham in 'The Brownjohn Tales', *Designer*, November 1979) *Some of us at the RCA were among the founder members of the Graphic Workshop, long before D&AD became involved in it, and when it was run by Bob Gill in an agency basement in Conduit Street. One of BJ's first appointments on his arrival in London was to come to the Graphic Workshop to talk about and show his work. Needless to say we were all absolutely staggered by it – so much so that one friend was moved to tears, knowing he would never be able to equal it. That's how involved we were in those days.*

My second story runs on very much from the first, with a gap of two or three years. It again happened at the Graphic Workshop, which I was now helping to run, and where BJ was once again an honoured guest. By now unfortunately he was going downhill, not as a designer, but physically. I remember him arriving an hour late, looking ill and more or less asleep standing up. Alan Fletcher took him to the back of the class to revive him a bit while I tried to keep people occupied. When he came round he talked as lucidly as ever about design, and had the class completely entranced. Out of some kind of hysteria, a student (I believe he was an architect) stood up and quite seriously asked BJ the question: 'What is graphic design?' Brownjohn, just as seriously, but beginning to fall asleep (and still in his raincoat) replied: 'I am.' And he was, God rest his soul. |

Work

Tactile Chart in Bent Plastic

Vision in Motion was László Moholy-Nagy's follow-up to his 1930 treatise *The New Vision*. Where the first book outlines the educational methods of the Dessau Bauhaus, where he taught between 1923 and 1928, the second explores the curriculum of the Institute of Design in Chicago (ID). Central to both publications is the belief in 'the interrelatedness of art and life'. Moholy-Nagy died of leukaemia in 1946, and his book was published a year later by his wife Sibyl, on what would have been the couple's tenth anniversary in the United States.

The Moholy-Nagys moved from England to Chicago in 1937 when László was appointed director of the New Bauhaus. That institution closed only a year later, but he went on to found his own School of Design, the precursor to the ID, in 1939. Although all these institutions were reliant on funding from local industrialists, Moholy-Nagy's American mission was to wrest modern design from the hands of commerce and restore it to its rightful place as the servant of humanity. In spite of the nature of his sponsors, he believed that design should meet biological and social needs before those of business and profit.

Vision in Motion

László Moholy-Nagy
1947, Paul Theobald, Chicago

Vision in Motion is liberally illustrated with photographs of work created by the author, his faculty and his students. Significantly these illustrations accompany the relevant text, a marked departure from the convention of reproducing illustrations as plates in only one part of a book. Among them, published in Chapter III, 'New Education – Organic Approach', is a sculptural piece, *Tactile chart in bent plastic*, made by Brownjohn in 1944. It must have been a novice project, set in Brownjohn's first year at the Institute, and its inclusion is testimony to his favoured status. It was an achievement of which he was immensely proud. Much later, in around 1967, Brownjohn's colleague Piers Jessop came across the picture by chance. Bounding in to work to confront Brownjohn with his discovery, Jessop only had to utter the words 'Vision in motion' before he was met with the riposte 'Page 77'. Brownjohn then ambled back to his room, playing it cool, but his glee at Jessop's find was unmistakable.

The reproduction of Brownjohn's piece is fairly large, possibly even full-scale, which would make the object itself about the size and width of a standard ruler. It is made of a strip of plexiglass, bent into a swooping curve with various materials including leather, wire and some kind of furry fabric riveted to its surface. It is lit to cast a clear shadow, a technique that creates a precise impression of its underside. 'Tactile charts' are described in *Vision in Motion* as exercises in form and texture and, in the caption to Brownjohn's work, Moholy-Nagy suggests that they could have 'practical applications such as the design of better steering wheels, handles for refrigerators or telephones'.

Vision in Motion

László Moholy-Nagy
1947, Paul Theobald, Chicago

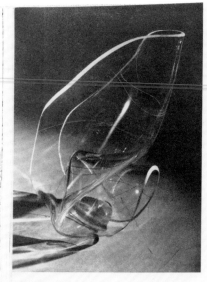

Fig. 61. © L. Moholy-Nagy, 1940
Convex-concave
Circular disk of transparent material, twisted and warped to demonstrate greater resistance against pressure

Surface treatment exercise and bending and warping planes can be the introduction to the understanding of the basic elements of modeling, of the relationships of the concave and convex and compound curvatures penetrating different spatial directions and extending to various levels.
Pre-exercises are made by line drawings (Fig. 59) which can easily be translated into thermo-plastic sheets.

weight sculptures[*]

Weight sculptures enlarge the sphere of observation and experimentation p by hand-sculptures. They teach that we have to deal not only with visual b with tactile illusion. In this instance, the student designs objects for *both* They must appear as equivalents in weight though their actual weights may be ent. They may take on various forms and structures—static or kinetic.

There are various types of hand and weight sculptures:

1. the "fruit" shape (modeled) to catch in the palm
2. tricks for the fingers (to feel holes, and thickness)
3. spring effects (through pressure)
4. motion actions (by inclusion of the joints of the wrist)
5. twisting (by turning parts)
6. changes by motion of parts

tactile structures

Tactile charts and structures represent a refinement of the exercises for the They are devised for finger manipulation of the different qualities of the s touch like pricking, pressure, temperature, vibration.[**]

[*] *Introduced by Andi Schiltz.*
[**] *Many of these exercises are more thoroughly described in "Von Material zu tektur," (Albert Langen, Munich, 1928) and in "The New Vision," (Putnam. & Co., N.Y. 1930; W. W. Norton & Co., N.Y. 1938; George Wittenborn & Co. 1946) both by L. Moholy-Nagy. These exercises can also be used for the rehabil of the blind.*

76

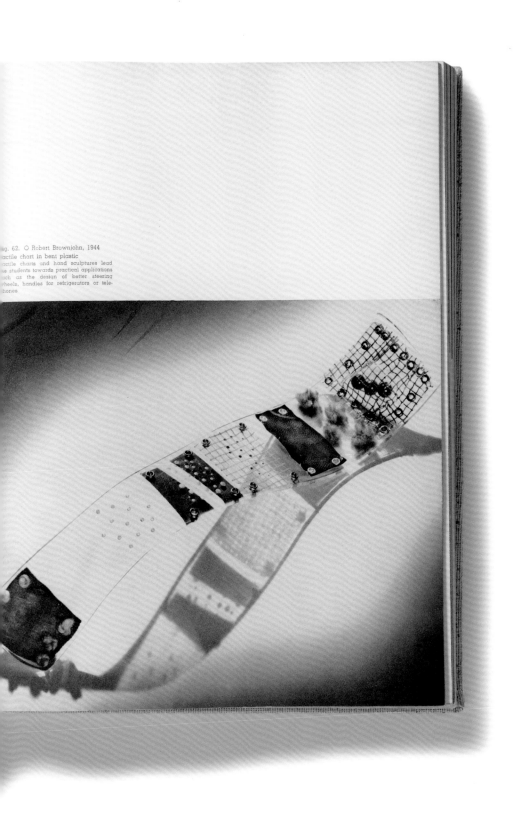

Fig. 62. © Robert Brownjohn, 1944
Tactile chart in bent plastic
Tactile charts and hand sculptures lead
the students towards practical applications
such as the design of better steering
wheels, handles for refrigerators or tele-
phones.

American design reformers had been drawn to the Bauhaus model because of its emphasis on craft skills as the basis for industrial production, but many found the abstract and often rough-hewn objects that emerged from Moholy-Nagy's workshops somewhat incomprehensible.[1] Along with Brownjohn's chart, these included expressive forms made from wood, metal, fabric and clay, a host of which appear in *Vision in Motion*. Essentially they are pieces of sculpture that relate to the body and the senses, but have no straightforward function.

Moholy-Nagy's foundation course and product design workshop formed the core of the Institute's curriculum, but they were supplemented by an array of other activities. Drafting part-time lecturers from the University of Chicago, he ensured that his students had a grounding in subjects as broad as mathematics, physics, philosophy and literature. According to Institute alumnus, artist Harry M. Callahan, Moholy-Nagy himself 'could call the school together and in a half hour give a beautiful lecture – on anything, practically'.[2] The effect on Brownjohn of this catholic education was evident throughout his life. He was an insatiable reader, demanding that novels be brought to his bedside even when he was in the direst health, he loved music of all kinds and had a keen interest in film. In searching for design solutions, he never restricted himself to the territory usually associated with graphics. In particular, he had an unfailing knack to discover the extraordinary in the everyday, a trait he owed exclusively to Moholy-Nagy.

The influence of Brownjohn's education on his commercial work was not always straightforward, but in the late 1950s he did revisit his 'tactile chart' on a grand scale. Commissioned to make a Christmas decoration for the lobby of the Pepsi-Cola building on Park Avenue, he and his colleagues Ivan Chermayeff and Tom Geismar discovered that Christmas tree baubles could be lodged snugly in the weave of chicken wire. Taking this neat fit as a starting point, he created a sweeping wire armature and crusted it with decorations. In photographs, Pepsi's Christmas ribbon appears to be about forty feet long, bent in two swooping 360-degree curves and propped on several pairs of slim metal legs. The baubles covering the surface are in a closely packed grid, melding into one another to create a uniform, reflective texture. Within the parameters of the purely decorative, it was a perfect match between form and function. Created with economical means, it was richly satisfying to the senses. (Although BCG assistant David Enock does remember the baubles coming loose on a regular basis and falling to the ground with a pop.) According to Chermayeff's then wife, Sara, it was the 'talk of the city', the object that cemented BCG's reputation.

Brownjohn shared his pride in having been associated with the ID with most of his former classmates. The student body was very small during the war years and a high proportion of its members had been rejected by the US Army, so they shared a unique sense of identity through disestablishment. In many cases

this feeling survived to the ends of their careers and beyond. Also common to the Chicago alumni was the habit of referring back, in ways that were both straightforward and oblique, to the lessons learnt at the Institute. As Brownjohn's near contemporary Edgar Bartolucci noted, 'Moholy-Nagy did not instruct students in technique, he taught them how to think.' And while techniques quickly become redundant, thinking never does.

Moholy-Nagy was succeeded by the architect Serge Chermayeff. This appointment was made by the Institute's major benefactor and Moholy-Nagy's close friend, the industrialist Walter Paepcke, and was in fulfilment of the founding director's wishes. Chermayeff's most significant ambition for the school involved shifting the curriculum more towards architecture, basing the teaching on the design of accommodation. He also formalized its degree structure, bringing it in line with other institutions in a bid to ensure its survival. In 1949 the ID merged with the nearby Illinois Institute of Technology (IIT). Prompted by necessity, this move brought increased financial pressures that eventually caused Chermayeff to resign. His departure in 1951 marked the end of an era, and the period of radical pedagogy that had so benefited Brownjohn and his classmates drew to a close.

1. For an account of László Moholy-Nagy's years in Chicago see the chapter 'Design for Business or Design for Life? Moholy-Nagy 1937–1946' in Victor Margolin, *The Struggle for Utopia: Rodchenko Lissitzky Moholy-Nagy 1917–1946*, University of Chicago Press 1997.

2. Harry M. Callahan interviewed for the Archives of American Art, 13 February 1975.

Stationery

Late 1950s
Brownjohn, Chermayeff
& Geismar Associates

STATEMENT

DATE

DATE

PARK NURSERY
SCHOOL INC
318 2ND AVE
NYC 3 OR 4 2 8 5 3

HAMPSHIRE HAMPSHIRE
PRESS, INC PRESS, INC
93-97 ONGLEY STREET
ROCKVILLE CENTRE, NY
TELEPHONE RO 6-0157

HAMPSHIRE HAMPSHIRE
PRESS, INC PRESS, INC
93-97 ONGLEY STREET
ROCKVILLE CENTRE, NY
TELEPHONE RO 6-0157

BROWNTOWN

Martin Kooper
666 5th Ave
New York 19 NY
Tel CI 5 2 3 0 0

DESTINATION

TRAVEL

NANCY SURMAIN
TRAVEL CONSULTANT

DAGASSO TRAVEL BUREAU
220 W. 42 St., N.Y. 36, N.Y.

LO 4 7580

Colorcraft Lithographers Incorporated / 175 Varick Street, New York 14, New York / cable Colitho NY / telephone Chelsea 3-2100

color
craft

50
KING
ST
NEW
YORK
14
NY

Bertrand Russell
Unpopular Essays

12 Adventures in Argument by the
Winner of the 1950 Nobel Prize for Literature

DESIGN / BROWNJOHN, CHERMAYEFF & GEISMAR

Simon and Schuster $1.00

THE ART
OF
DECISION
MAKING
JOSEPH D. COOPER

A practical guide for
executives—how to
improve personal effec-
tiveness in decision
making. Techniques for
analyzing the forces that
shape decisions;
predicting how others
will react; bringing
decisions to a head; and
limiting the risks.

Passing Time
Michel Butor

Wednesday, August 6

Thursday, August 7

Friday, August 8

The Open Mind
J. Robert Oppenheimer

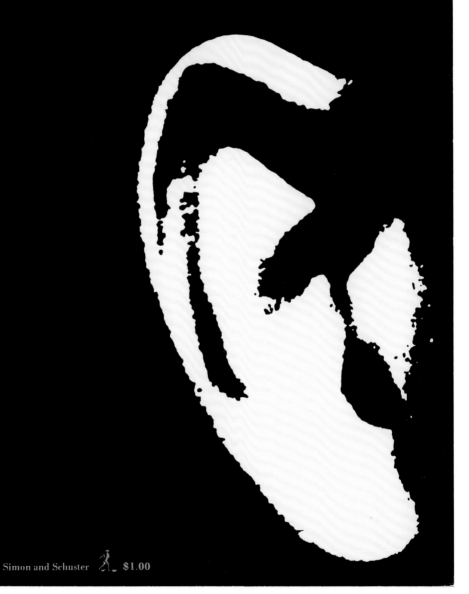

Design: Brownjohn, Chermayeff & Geismar

Simon and Schuster $1.00

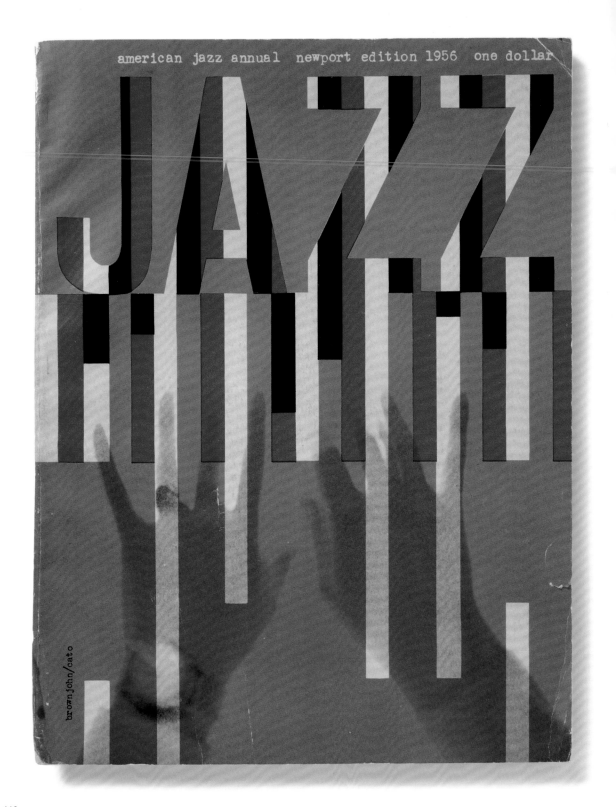

american jazz annual newport edition 1956 one dollar

JAZZ

brownjohn/cato

112

American Jazz Annual	**Wood-Type Collage**	**Dial JJ5**
1956, International Jazz Associates/American Jazz Festival, Newport Robert Brownjohn and Bob Cato *Previous spread, left*	Late 1950s The Philadelphia Orchestra Brownjohn, Chermayeff & Geismar Associates *Previous spread, right*	Album Cover 1957, J J Johnson Quintet/Columbia Brownjohn, Chermayeff & Geismar Associates

CL 1084

J J JOHNSON quintet Dial JJ5

COLUMBIA

PHOTO: DIRONE

Si-Si, No-No

Album Cover
1957, Machito &
His Orchestra/Tico
Brownjohn, Chermayeff
& Geismar Associates

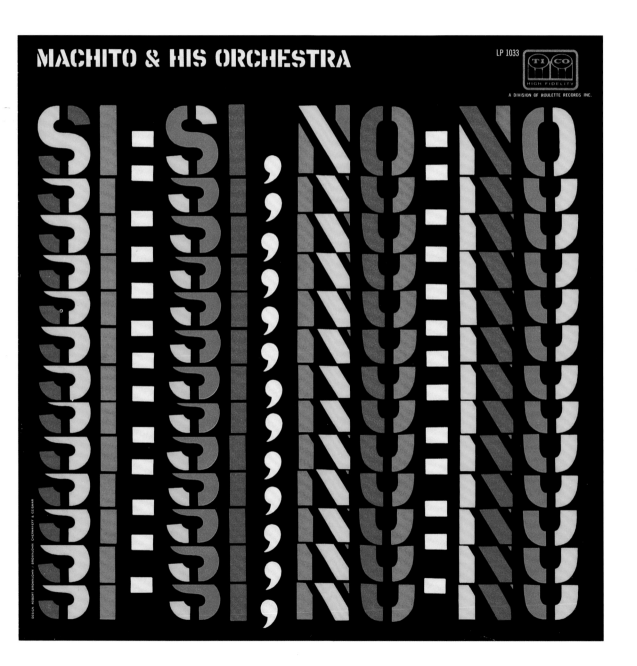

Streetscape

American Pavilion
1958, Brussels World's Fair
Brownjohn, Chermayeff
& Geismar Associates

BCG described their
'Streetscape' as
'an abstraction of typical
American street and store
signs'. A reflection of their
love affair with the urban
vernacular, the design offered
visitors to the Brussels
World's Fair a glimpse of
the typographic environment
of the New York street.

GRISHMAN-RYCE DUO

The Pepsi-Cola World Covers

The magazine *Pepsi-Cola World* was one of Brownjohn, Chermayeff & Geismar's first regular clients. Between 1957 and 1959, the designers art-directed a series of witty, attention-grabbing covers and neat, business-like interiors for the monthly magazine. These days the graphic puns on the *Pepsi-Cola World* covers have a familiar ring, but, at the time, their slightly skewed vision of the everyday was fresh and surprising, particularly in such a corporate context. In the early months the job earned the most significant chunk of the company's income, money that allowed them to move into larger premises and employ more staff. It also won numerous design awards and, in doing so, brought BCG's work to the attention of the corporate world.

Pepsi-Cola World was an in-house magazine, distributed across the United States to the hundreds of franchised Pepsi bottling plants. Its role was to promote consistency, spread the corporate message and inspire company loyalty. As late as the 1930s, Pepsi had been distributed in some regions in recycled beer bottles pasted with makeshift labels, but from the war years onward the company became increasingly style conscious. The drive behind Pepsi's 1950s marketing efforts came from the company's President, Al Steele, a man who took up the reins in a time of declining fortunes. Between 1950, when Steele took over, and his death in 1959, Pepsi's profits had tripled. His strategy was to enter local markets, region by region, and advertise aggressively. Steele was a colourful man who was rumoured to have once run a circus and, in 1955, he married the movie star Joan Crawford. As such, it is hardly surprising that he was more in tune with promotional activity than any of his predecessors. Crucially, he recognized that a fizzy drink is nothing but sugar and water until you create an image.

The gimmick behind each of the *Pepsi-Cola World* covers is the combination of the company identity and a particularly seasonal event: in February a Pepsi logo appears at the heart of a lacy Valentine; in April Pepsi caps rain down on an open umbrella; in June a golf ball decorated with the Pepsi colours hovers on a putting green; and in October eleven Pepsi caps line up for the start of an American football game. The company's strap-line at the time was 'Be Sociable. Have a Pepsi.', and these covers depict normal American activities of the kind associated with a thoroughly integrated, family-centred social life. Through the magazine, the company was aiming to instil a set of common concerns and ordinary assumptions in every member of their far-flung network of bottlers.

Pepsi-Cola World

Magazine Cover
1958, Pepsi-Cola Company
Brownjohn, Chermayeff
& Geismar Associates

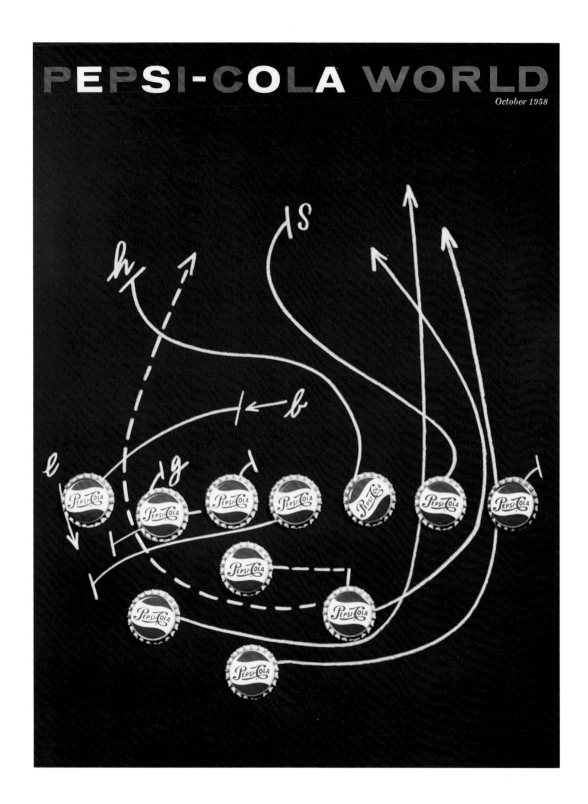

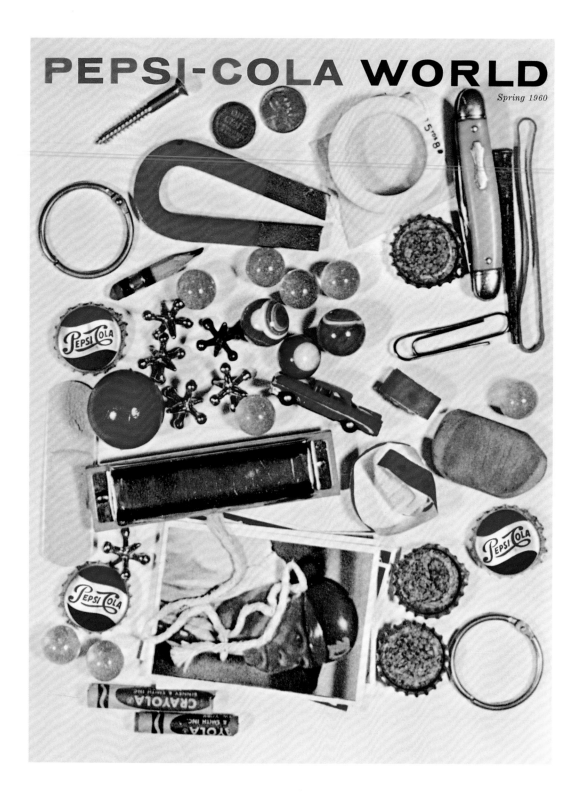

PEPSI-COLA WORLD

Spring 1960

The initial contact with Pepsi had come through the printer Dick Davison, the owner of the company Colorcraft. Davison knew Brownjohn both socially and professionally, and had a similar relationship with the editor of the magazine, Gary Lewis, and his assistant, Bill Brown. Forging the connection between the designer and the client elevated Davison's status vis-à-vis both parties, and it was introductions of this sort that enabled him to transform his company from a jobbing print shop into the printer of choice for New York artists and designers. The connections between Davison, Lewis, Brown and Brownjohn were not, however, entirely above board. They were all jazz enthusiasts and came across each other in the clubs of New York during the mid-1950s. Equally, it seems likely that each of them indulged in drugs to a greater or lesser extent. By the late 1950s, Davison had kicked the habit, but Lewis was more entrenched, to the degree that he was hospitalized in the early 1960s. Likewise, Tom Geismar remembers Brownjohn becoming less reliable in the period he was involved with Pepsi as a client. Late in 1958 he began disappearing from the office, ostensibly to buy a packet of cigarettes, only to reappear days later. The Pepsi covers may be comforting and domestic, but the likelihood is that much of the discussion behind them took place in circumstances that were anything but.

The *Pepsi-Cola World* covers carry the collective BCG credit, but there is a consensus that the majority of them were derived from Brownjohn's ideas. (Davison and Enock both distinctly remember his central role in creating most of the images.) On first glance, these compositions appear to be prime examples of 'big idea' design, a strand of graphics that emerged in post-war America and survives to this day. Among the best-known exponents of the 'big idea' is Brownjohn's near contemporary Bob Gill, a man who has founded his career on the graphic wisecrack. Brownjohn admired Gill very much and was certainly attracted to his way of thinking. From their first meeting in New York to their later association in London, the two of them were perpetually engaged in a sort of competition. They would take part in quick-fire exchanges of graphic puns over dinner and call each other on the phone to check if a particular idea had already been 'taken'. But Brownjohn's discussions with his fellow creatives did not always conform to this pattern and, specifically, it seems likely that he talked to the Pepsi people, Lewis and Brown, in a very different manner. Brown in particular was known for taping his friends as they talked on chosen topics, making free-flowing monologues that lasted for hours. Having distinct overtones of the autonomistic practices of the Surrealists, the ideas that emerged from this kind of speech are likely to have been dreamy, hallucinatory even.

With this background in mind, it is worth reviewing the apparent wholesomeness of the Pepsi covers. Possibly the cosy graphic jokes that entertained Pepsi's American employees belie another train of thought. There is a touch of surrealism in such images as the shower of bottle caps raining down on an umbrella. The brightness of the brolly and the neatness of the hair

Pepsi-Cola World

Magazine Covers
1958–60, Pepsi-Cola Company
Brownjohn, Chermayeff
& Geismar Associates

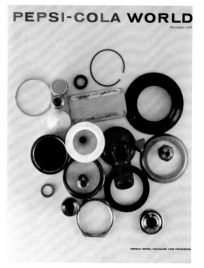

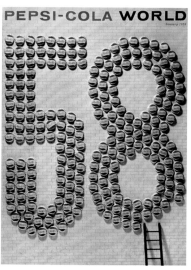

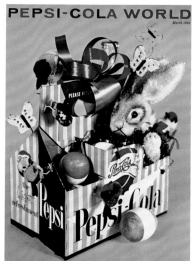

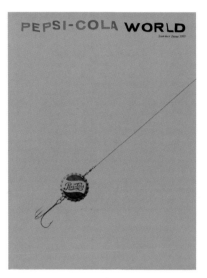

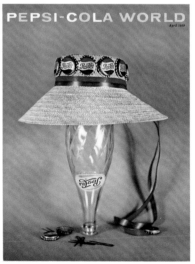

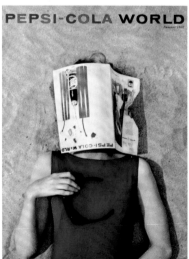

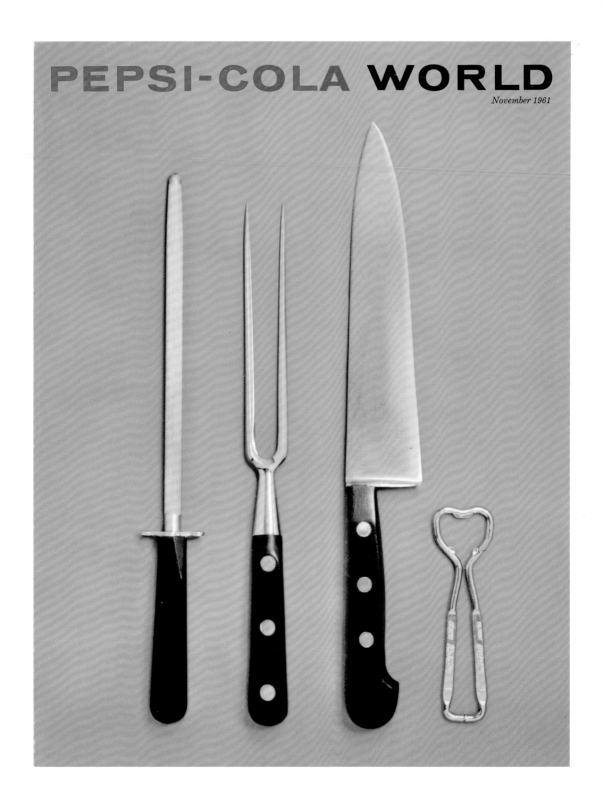

beneath cannot completely expunge the sense of threat. When the Surrealists recast familiar objects into unlikely roles, they cracked open the surface of everyday life to reveal vertiginous depths of uncertainty. On the Pepsi covers this danger is overwhelmed by persistent, commercially branded ordinariness, but, all the same, the faintest residue of queasy surreality remains.

In an essay titled 'Dream Kitsch' Walter Benjamin discussed the manner in which objects from popular culture enter the subconscious mind. He believed that the sphere of dreams was tarnished by its interaction with the rational world, the world that gave rise to industrialism and consumerism. Like Benjamin, Brownjohn was interested in the realm of subconscious, irrational thought and its melding with the everyday, but his profession prompted him to cast this relationship in a more positive light. His close friend, Tony Palladino, remembers the pair of them being particularly struck by the conjunction of two chairs and a sewing machine in Brownjohn's living room, a tableau that took on the appearance of a peculiar rendezvous. Unsurprisingly they were drunk at the time, but the way in which they invested these inanimate, consumer objects with personalities suggests a more complex reading of their graphic ideas. Rather than simply producing puns for the audience simply to 'get', they were creating images that they hoped would reach out and 'get' their audience.

The ability of a graphic idea to engage its audience in something deeper, and maybe darker, than its surface suggests depends, of course, on that audience's willingness to play along. Surrealism impinged on American consciousness in the 1940s and '50s through the work of artists such as Dalí and Magritte and, in a more popular vein, through the films of Alfred Hitchcock. By the early 1960s people began to believe that these ideas might apply to the workings of their own minds and some pioneering individuals turned to therapy. Ivan Chermayeff's wife Sara was one of these, first visiting a psychoanalyst in around 1963. She recalls Brownjohn being intensely interested in her experiences.

Brownjohn's particular concern was with the dream-like moment when what is most familiar is recast as something strange, and this was an interest that became more widespread over the course of his career. Mainstream culture began to catch him up. Perhaps, if he had continued to design the Pepsi covers into the 1960s, they would have ventured into more obviously surreal territory. This was not to be, however, and soon after Brownjohn's departure the account was taken up by BCG's former assistants, Stanley Eisenman and David Enock, who continued to turn out cute puns on a monthly basis. In effect, the Pepsi publication that had once been the financial spine of BCG became the enabler for the breakaway design firm Eisenman & Enock.

Moreover, in the face of this meandering into the subconscious, it is important to remember that the magazine primarily functioned as a business tool and it was extremely successful in that capacity. Over the period of his presidency, Steele hugely increased Pepsi's fortunes and turned it into a company that could withstand celebrity endorsement from Joan Crawford (taking a place on the Pepsi board after her husband's death, she associated herself with the product as closely as possible, slurping it from a straw on many a public appearance, until she was forced into retirement by the other board members in 1972). In February 1959, *Pepsi-Cola World* carried a cover that is less a graphic pun than a simple reflection of the firm's accumulating assets. It was the month that the company moved into new headquarters at 500 Park Avenue in New York and the image shows the Park Avenue Sign at East 59th Street with the standard 'P' replaced by that of the Pepsi logo. The message is utterly singular: Pepsi has arrived!

PEPSI-COLA COMPANY **ANNUAL REPORT 1959**

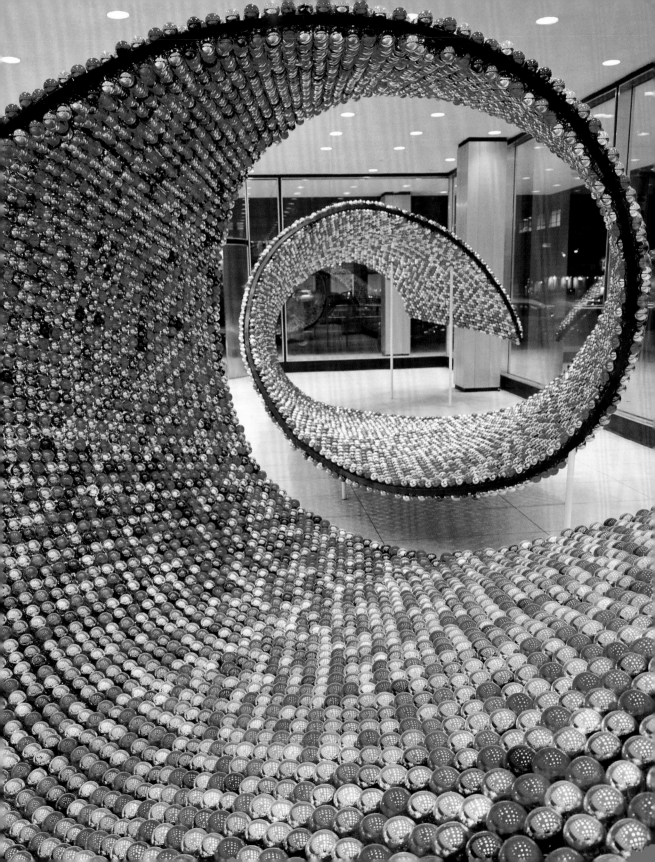

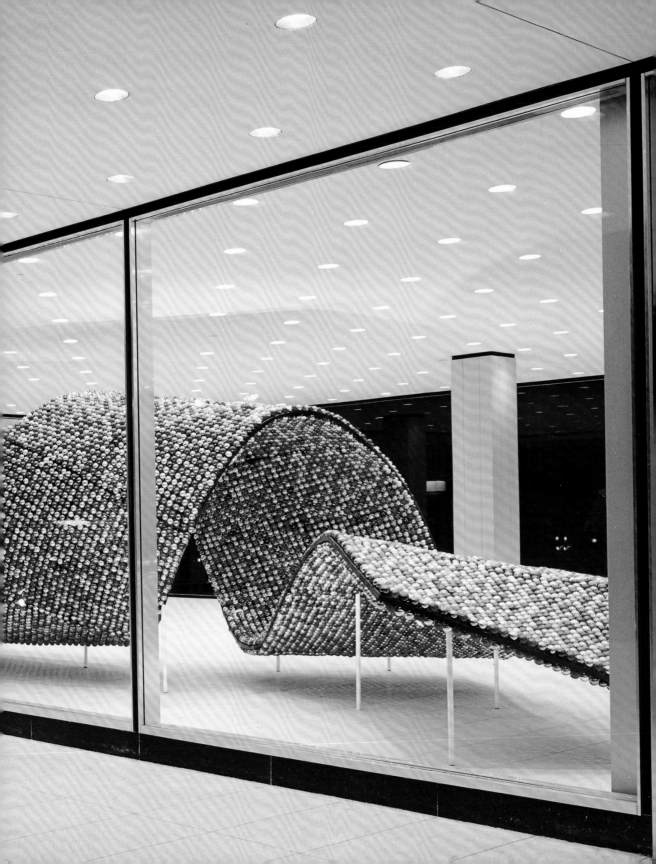

The Composing Room Poster

During the first couple of years of their partnership, Brownjohn, Chermayeff & Geismar tore out and saved the address labels from their incoming mail. Given their striking and unusual collection of surnames, it is not surprising that many of the labels were misspelled. This poster was designed to advertise an exhibition of BCG's work late in 1959. By arranging the carelessly torn scraps of paper in the neatest possible grid, the designers created a witty and seductive image that teeters on the border between the artless and the contrived. The random mistakes of the hapless correspondents are drawn together into an overall scheme of misaddress; and, in the same way, the rough-edged fragments are marshalled into a single, elegant composition.

When this poster was reproduced in *Typographica 2* (December 1960) it was prefaced with an introduction written by BCG's fellow New York designer Gene Federico: 'The aware designer's intuitive and acquired knowledge invests in him a more reliable sense of his times and the needs of the people. Sensing these, he is able to "talk" directly. He *knows* intuitively the language of his day.' In the case of this poster, the dialect spoken is that of the office, and it reflects how powerful the motif of white-collar work had become in 1950s America (think of Jack Lemmon's Bud Baxter and his insurance office in Billy Wilder's 1960 film *The Apartment*). By exposing the minor errors that define bureaucratic existence, BCG manufactured an image with enormous popular appeal. However, more than merely speaking the language of its day, the poster still stands up half a century later. This is due to its combination of immediate accessibility with lasting beauty. Taken together, the various typographic styles, the textures and the carefully torn edges of each fragment create an image that is complex enough to hold your interest long after you get the joke.

Gallery 303 was a space maintained by the New York typesetting firm The Composing Room, Inc. From its launch in 1927, the company was determined to be New York's highest-quality typesetter and this ambition prompted them to support more adventurous graphic styles and experimental projects. In particular, the company's founders Sol Cantor and Dr Robert L. Leslie promoted the generation of émigré designers who came into the United States in the 1930s by showing their work in their gallery (at that time called the A-D Gallery) and publishing it in their magazine *PM*. Although the motives for The Composing Room's cultural programme were essentially philanthropic – with Leslie in particular being dedicated to the education and improvement of graphic designers and printers – they also made sound business sense. In the 1930s and 1940s a number of prestigious European graphic designers received

their first American exposure through the firm's exhibitions, talks and publications and, as a result, they brought important business to the firm. The big names featured in the company archives included M.F. Agha, Herbert Bayer, Herbert Matter and Ladislav Sutnar. The invitation to BCG to exhibit in Gallery 303 was extended in the same spirit. Leslie and his (then) Director of Design and Typography Aaron Burns not only recognized the exciting, experimental nature of the designers' work, but also made a fairly safe bet on their future success.

As well as offering exhibition space, The Composing Room also presented BCG with the opportunity to create some of their most unconstrained, avant-garde design pieces. In the late 1950s the company published a series of sixteen-page promotional booklets, all with their own theme and each the work of a different designer. Herb Lubalin covered jazz, Lester Beall created a meditation on cars and Brownjohn, Chermayeff & Geismar were given the brief to explore New York City. Written in a free-form meditative style by Percy Seitlin (the co-editor of *PM* and *AD*), BCG's brochure combines experimental typography and photography in a loose, rhythmic manner, creating something akin to the graphic equivalent of Miles Davis's trumpet playing. Burns collaborated closely with the designers during the making of the brochure and would encourage them to use new typefaces and work in unusual styles. The relationship was very far from the typical interaction between designer and typesetter. In 1970 Burns went on to co-found the International Typeface Corporation (ITC) with fellow typographer Lubalin. Still in business today, the company's long-term success was established on Burns's forward-looking, uninhibited approach to typography.

The Composing Room poster tells a number of different stories. The small credit on the right-hand side – 'Printing: Colorcraft Lithographers Inc. Composition: The Composing Room, Inc. Paper: Schlosser Paper Corporation' – describes the network of high-end print shops, paper suppliers and typesetting firms behind BCG's professional efforts. The varying typographic styles of the envelopes hint at the company's mix of corporate and independent clients. But, above all, the designers' three names and their clients' and suppliers' apparent inability to get them right tells a story about immigration and assimilation.

Many of the mistakes are simple spelling errors, with Ivan Chermayeff being by far the most common victim: Chermateff, Chermayoff, Chermoy Off. But others demonstrate the extraordinary lengths that people will pursue to recast something they don't understand into material that is more familiar: Chermayeff G. Brownjohn; Brown, John, Chermayeff & Geismar; Brown, John Chermayeff; Chermayeff & Geismar Brownjohn; John Brown-Chermayeff-Geismar; C. Brownjohn & Geismar.

A Return Exhibition of Graphic Design by Brownjohn, Chermayeff & Geismar at Gallery 303, The Composing Room, Inc., 130 West 46 Street, October 19 through November 20. Mondays through Fridays 12 Noon to 6 P. M.

BROWN JOHN CHERMAYEFF
& GEISMAR
235 E 50 ST
NEW YORK 22 NY

Brownpohn (8859)

Brownjohn,
235 East 5
New York 2

Brownjohn Chermayoff & Geisman
235 East 50 Street
New York City, NY

Mr. Brownjohn
Brownjohn Chermayess & Geisme
235 East 50 St.
NYC 22

Brown John Chermayeff & Geismar

235 East 50th Street

New York 22, N. Y.

BROWNJOHN, SHERNOYOSS
AND GEISMAR
235 EAST 50TH STREET
NEW YORK CITY

ATT: MR. ROBERT BROWNJOHN

Brownjohn, Chermayess & Geismar

235 East 50th Street

New York, 22, N.Y.

Mc Geismar

C. Brownjohn &
235 E. 50th St.
N. Y. City

That the three designers should come from such far-flung backgrounds (Brownjohn is a surname of British derivation; Geismar has German origins; Chermayeff spoke of family roots in Chechnya) is typical of the era and the profession. New York's creative industries have always been something of a melting pot, and in the middle of the century new European émigrés were playing an increasingly significant role. It is as if those addressing the envelopes had a desire for a stable normality that flew in the face of reality.

The Composing Room poster is the outcome of a systematic exploration of random elements. It treads the line between pattern and chaos, a boundary that fascinated Brownjohn throughout his career. In New York the designer would scour the streets for metal junk, being drawn to certain pieces of discarded hardware because of the particular quality of their erosion and surface texture. Sometimes he would arrange these collections of waste material into compositions, nailing them into place on pieces of hardboard. Chermayeff still has one of these works on his living-room wall, and its combination of abstract beauty and ordinariness remains utterly compelling (although these days the 1950s scrap has a nostalgic quality, adding a layer of meaning that, presumably, Brownjohn did not intend). In a similar vein, Brownjohn created a gift for Tom Geismar's wedding to Joan in 1958, using different textures of sandpaper. Attaching these to hardboard in a grid, he exploited the various grades of emery to create a piece of subtle and unexpected loveliness.

Brownjohn's sensitivity to the extraordinary qualities of everyday materials can be traced back to the period he spent under Moholy-Nagy at the Chicago Institute of Design. By the time that Brownjohn first met him in 1944, Moholy had already spent a couple of decades photographing chance patterns such as footprints in the sand, tracks in the snow or the shadows of leaves as they fall on a body. Moholy's interest was in accidental systems of reproduction and the inadvertent creation of pattern. Of his extensive series of beach photographs he said, 'my photographs are not the result of chance ...This beach picture is the result of method.'[1] Moholy-Nagy had a 'beachcomber mentality' and he bequeathed this way of thinking to Brownjohn.[2]

But of course an interest in the appearance of happenstance was not confined to Moholy-Nagy and Brownjohn. Particularly in the 1950s, the period that Brownjohn was working in New York, there was a general fascination with art constructed from ready-mades, especially of the decaying, weather-beaten kind. It was an interest that represented the antithesis of the slick modernist consumer aesthetic that was sweeping America at the time. Perhaps it was a means of commemorating the destruction of the war years: of exploring a shared sense of trauma, rather than papering over it. Marking the culmination of this interest, in 1961 the curator William Seitz staged the exhibition 'The Art of Assemblage' at the Museum of Modern Art in New York. Devoted to works

made from 'preformed natural or manufactured materials, objects, or fragments not intended as art materials', it included pieces by Joseph Cornell, Marcel Duchamp and Kurt Schwitters. Also included was the younger American artist Bruce Conner, who was known at the time for his fragile three-dimensional collages. Leading Seitz on a tour of his home town of San Francisco in the months leading up to the exhibition, Conner suggested that the shop front of a junk store on McAllister Street would make as worthy an addition as anything that could be more conventionally defined as art.

Conner showed at the Robert Fraser Gallery in London in 1966, and chances are he encountered Brownjohn during his visit (Brownjohn made leaflets and posters for Fraser and the pair ran in the same circles). If the two of them did meet, they would have had much in common: Brownjohn never lost his love of chance beauty or absurdity. Towards the end of his life Brownjohn revisited the idea behind The Composing Room poster to create a piece of print marketing for his final partnership Nagata & Brownjohn. The mistakes made on this second edition have a familiar ring – Negata, Negato, Nagata John Brown – but sadly, many of the qualities of the original are lost. In particular, the styles of the envelopes are much more consistent and the arrangement of the fragments on the page is less elegant. It is something of a paradox that the first poster is as fresh now as it was in the late 1950s, but that Brownjohn's attempt to repeat himself only a decade later fell flat. The 1959 version is a truly singular piece, managing the extraordinary trick of being both very much of its time and utterly transcendent.

1. Moholy-Nagy, quoted in Louis Kaplan, *László Moholy-Nagy: Biographical Writings*, Duke University Press 1995, p.59.

2. Kaplan's phrase, ibid., p.62.

That New York

Experimental
Typography Booklet
1959, The Composing Room
24.5 x 17.5 cm (9 $^3/_4$ x 7 in)
Brownjohn, Chermayeff
& Geismar Associates

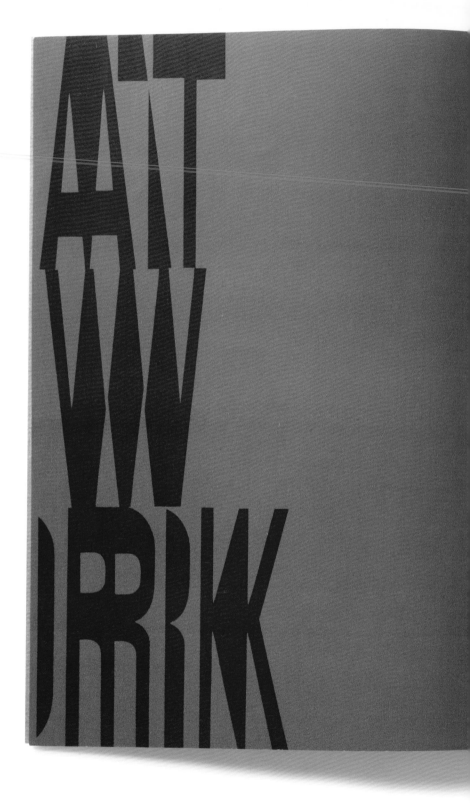

Visit **New York** for the first time;

walk in any direction

until you're thirsty.

Drop anchor at any *Bar and Grill;*

talk to the bartender; tell him you're **a stranger,**

never saw the city before.

What will he say?

You should have seen it in the old days.

Take this neighborhood.

 None of these big apartment houses then.

Or take the Bronx.

It was a wilderness;

walk a mile to the el.

Mouquin's, Villepegue's, Shanley's, the old Claremont Inn and Broadway—

Give my regards to Broadway.

They don't come like that any more.

I was a kid selling papers outside of **Luchow's** on Fourteenth Street.

Every night,

this guy with a fur collar on his coat

gives me a dollar for the **Globe**

and lets me keep the change.

They don't come like that any more.

There was a time when I would detour to avoid walking anywhere on **Seven**th Avenue south of 40th to 34th. I ne**ver liked**

Avenue, either, and still don't. I have developed an affection for **Macy's now** that The Great Department Store **is giving w**

he Shopping Center. Wanamaker's was at its best during the years w**hich car**ried it gradually downhill to its end. **I do not un**

nd those who failed to notice this long descent and had to be surp**rised w**hen the end came. They are children **who ar**

to being protected against the facts of the slaughterhouse. What g**reat perc**eption is needed to know that a de**partmen**

office building or theatre is like a tree or shrub? Yet, many do not **know this.** I can understand the young not kno**wing be**

to them, a tree seems to have existed and promises to exist forev**er. But t**he middle-aged and the old? I am bo**red, too,**

e conceit that depicts hero**i**c edifices such as the Brooklyn Bridge o**r the Wo**olworth Building as challenging natu**re. They**

ture. In art, though, as in th**e** forest, certain forms are destined for **longer lif**e than others. Fortunately, man has **permitted**

nuing life to the violin, the Jensen letter and the bicycle, despite th**e fact th**at the points of their full development **have l**

ce been reached. Not so with New York. New York cuts down both **its trees** and its buildings, not only long befo**re they ha**

d, but long before they have been able to demonstrate their ability **to live. I**n the beginning of the love affair with **New Yo**

orance of the ways of the beloved is bliss. At this stage, it's simply t**he view** of her face that matters. You ask no q**uestions**

purplish airbrush tones bey**o**nd the lower Manhattan skyline, seen **from the** deck of the bridge's first gothic tow**er; no d**

ntation is required for yell**o**w skyscraper lights or wooden-car rattl**e of Bro**oklyn-bound el trains. Later, with its **necessitie**

es knowledge of the doings of newspaper barons, political bosses, p**rosecut**ing attorneys, architects and city plan**ners, refe**

s, peddlers, pickpockets and public relations men. In the end, thoug**h, you** go back to the bridge at twilight, ba**ck to the b**

•gy has recorded the view that the real estate business—a floating crapgame in which is invested

tive, judicial and executive powers—is in the background of New York's contemporary history of

fathers vanishing into old people's homes and young wives putting off having babies for another

A horseplayer might end up his day at Belmont with winnings enough for hamburgers and a pad

mes Square hotel for the night; or, he might lose and have to borrow a fin from another horse-

to get him out to the track the next day. But a real estate gambler's day might bring about a

jam that could endanger the health and welfare of millions, lead to the narrowing of miles of

lk and cause the Air Pollution Control Commission to petition the Board of Estimate for an in-

in its annual appropriation. Who ever heard of a testimonial dinner being given to a horseplayer?

uyvil Sheepshead Bay Tavern-on-the-Green Yeshiva John Wanamaker McSorley's Old Ale House Park Row MacDougal Alley Lüchows Knickerbock
e Square Abraham Cahan Floradora Wallabout Market Fraunces Tavern Carl Van Vechten Jacob Schiff Horace Mann Van Cortlandt Onderdonck
ippodrome Mercer Street Rhinelander Patchin Place Ozone Park Eugene O'Neill Murray Hill Paddy's Market Corlears Hook Gravesend Minett
eat Kill Muhlenberg Horn & Hardart Florenz Ziegfeld Kingsbridge Alfred E. Smith Hudson Dusters Rivington Street Clason Point Washington
eapple Street Guggenheim Sandy Hook Flatiron Henry Ward Beecher Broadway Yorkville Williamsburg Vanderbilt Maiden Lane Tiffany's Har
Triborough Nathan Straus Strunsky's Love Stables Washington Square Alfred Stieglitz Boris Thomashevsky Sands Street John A. Roebling Fla
lston Jacob Riis Joseph Pulitzer Pitkin Avenue Isaac M. Singer Moshulu Parkway Gouverneur Morris J. Pierpont Morgan George Gershwin Petipas
lworth Morningside Heights Reginald Marsh Harlem R. H. Macy & Co. Otto H. Kahn High Bridge Harrigan and Hart Fort Tryon Robert Goelet
Street Hell Gate Gansevoort Jay Gould Fort Clinton Flushing Coogan's Bluff Greeley Herald Square Gowanus Fort Totten Dyckman Stuyvesant
Delancey Coney Island Cherry Lane Chatham Square Trinity Yard Cavanagh's Bowery Canarsie Delmonico Bryant Chelsea Greenpoint Fulton
Brooklyn Bronx de Peyster Carnegie Triborough Arthur Kill Bellevue Algonquin Abingdon Cooper Beekman Amsterdam Far Rockaway Altman
d Aspinwall Brevoort Bowling Green Cartier's Fort Greene Sailors Snug Harbor Astor Brownsville Belmont Bleecker Biltmore Spuyten Duyvil
Bay Tavern-on-the-Green Yeshiva John Wanamaker McSorley's Old Ale House Park Row MacDougal Alley Lüchows Knickerbocker Longacre
raham Cahan Floradora Wallabout Market Fraunces Tavern Carl Van Vechten Jacob Schiff Horace Mann Van Cortlandt Onderdonck Lefferts Hip
ercer Street Rhinelander Patchin Place Ozone Park Eugene O'Neill Murray Hill Paddy's Market Corlears Hook Gravesend Minetta Lane Great
enberg Horn & Hardart Florenz Ziegfeld Kingsbridge Alfred E. Smith Hudson Dusters Rivington Street Clason Point Washington Irving Pine
t Guggenheim Sandy Hook Flatiron Henry Ward Beecher Broadway Yorkville Williamsburg Vanderbilt Maiden Lane Tiffany's Harry K. Thaw
Nathan Straus Strunsky's Love Stables Washington Square Alfred Stieglitz Boris Thomashevsky Sands Street John A. Roebling Flatbush Field
Riis Joseph Pulitzer Pitkin Avenue Isaac M. Singer Moshulu Parkway Gouverneur Morris J. Pierpont Morgan George Gershwin Petipas F. W.
Morningside Heights Reginald Marsh Harlem R. H. Macy & Co. Otto H. Kahn High Bridge Harrigan and Hart Fort Tryon Robert Goelet Des
et Hell Gate Gansevoort Jay Gould Fort Clinton Flushing Coogan's Bluff Greeley Herald Square Gowanus Fort Totten Dyckman Stuyvesant Dut
elancey Coney Island Cherry Lane Chatham Square Trinity Yard Cavanagh's Bowery Canarsie Delmonico Bryant Chelsea Greenpoint Fulton Bu
ooklyn Bronx de Peyster Carnegie Triborough Arthur Kill Bellevue Algonquin Abingdon Cooper Beekman Amsterdam Far Rockaway Altman
d Aspinwall Brevoort Bowling Green Cartier's Fort Greene Sailors Snug Harbor Astor Brownsville Belmont Bleecker Biltmore Spuyten Duyvil
Bay Tavern-on-the-Green Yeshiva John Wanamaker McSorley's Old Ale House Park Row MacDougal Alley Lüchows Knickerbocker Longacre
raham Cahan Floradora Wallabout Market Fraunces Tavern Carl Van Vechten Jacob Schiff Horace Mann Van Cortlandt Onderdonck Lefferts Hip
ercer Street Rhinelander Patchin Place Ozone Park Eugene O'Neill Murray Hill Paddy's Market Corlears Hook Gravesend Minetta Lane Great
enberg Horn & Hardart Florenz Ziegfeld Kingsbridge Alfred E. Smith Hudson Dusters Rivington Street Clason Point Washington Irving Pine
t Guggenheim Sandy Hook Flatiron Henry Ward Beecher Broadway Yorkville Williamsburg Vanderbilt Maiden Lane Tiffany's Harry K. Thaw
Nathan Straus Strunsky's Love Stables Washington Square Alfred Stieglitz Boris Thomashevsky Sands Street John A. Roebling Flatbush Field
Riis Joseph Pulitzer Pitkin Avenue Isaac M. Singer Moshulu Parkway Gouverneur Morris J. Pierpont Morgan George Gershwin Petipas F. W.
Morningside Heights Reginald Marsh Harlem R. H. Macy & Co. Otto H. Kahn High Bridge Harrigan and Hart Fort Tryon Robert Goelet
Street Hell Gate Gansevoort Jay Gould Fort Clinton Flushing Coogan's Bluff Greeley Herald Square Gowanus Fort Totten Dyckman Stuyvesant
Delancey Coney Island Cherry Lane Chatham Square Trinity Yard Cavanagh's Bowery Canarsie Delmonico Bryant Chelsea Greenpoint Fulton
Brooklyn Bronx de Peyster Carnegie Triborough Arthur Kill Bellevue Algonquin Abingdon Cooper Beekman Amsterdam Far Rockaway Altman
d Aspinwall Brevoort Bowling Green Cartier's Fort Greene Sailors Snug Harbor Astor Brownsville Belmont Bleecker Biltmore Spuyten Duyvil
Bay Tavern-on-the-Green Yeshiva John Wanamaker McSorley's Old Ale House Park Row MacDougal Alley Lüchows Knickerbocker Longacre
raham Cahan Floradora Wallabout Market Fraunces Tavern Carl Van Vechten Jacob Schiff Horace Mann Van Cortlandt Onderdonck Lefferts Hip
enberg Horn & Hardart Florenz Ziegfeld Kingsbridge Alfred E. Smith Hudson Dusters Rivington Street Clason Point Washington Irving Pine
t Guggenheim Sandy Hook Flatiron Henry Ward Beecher Broadway Yorkville Williamsburg Vanderbilt Maiden Lane Tiffany's Harry K. Thaw
Nathan Straus Strunsky's Love Stables Washington Square Alfred Stieglitz Boris Thomashevsky Sands Street John A. Roebling Flatbush Field
Riis Joseph Pulitzer Pitkin Avenue Isaac M. Singer Moshulu Parkway Gouverneur Morris J. Pierpont Morgan George Gershwin Petipas F. W.
Morningside Heights Reginald Marsh Harlem R. H. Macy & Co. Otto H. Kahn High Bridge Harrigan and Hart Fort Tryon Robert Goelet Des
et Hell Gate Gansevoort Jay Gould Fort Clinton Flushing Coogan's Bluff Greeley Herald Square Gowanus Fort Totten Dyckman Stuyvesant Du
elancey Coney Island Cherry Lane Chatham Square Trinity Yard Cavanagh's Bowery Canarsie Delmonico Bryant Chelsea Greenpoint Fulton
Brooklyn Bronx de Peyster Carnegie Triborough Arthur Kill Bellevue Algonquin Abingdon Cooper Beekman Amsterdam Far Rockaway Altman
d Aspinwall Brevoort Bowling Green Cartier's Fort Greene Sailors Snug Harbor Astor Brownsville Belmont Bleecker Biltmore Spuyten Duyvil
Bay Tavern-on-the-Green Yeshiva John Wanamaker McSorley's Old Ale House Park Row MacDougal Alley Lüchows Knickerbocker Longacre
raham Cahan Floradora Wallabout Market Fraunces Tavern Carl Van Vechten Jacob Schiff Horace Mann Van Cortlandt Onderdonck Lefferts Hip
enberg Horn & Hardart Florenz Ziegfeld Kingsbridge Alfred E. Smith Hudson Dusters Rivington Street Clason Point Washington Irving Pine

Beneath the chimney pots

of The Village,

They lived for a while,

or tried to.

o
ree
ur
e

en
ht
e

ven

For a while, the capital of everything had become the world's number one bomb target and the odds in favor of a hero's death were good. But the script was overlong

13

144

directors, stars and backers argued among themselves, it began to seem that the end might come, as our poet foretold, not with a bang but with a whimper

Watching Words Move
and Midland Bank Series

We produced a little booklet called Watching Words Move. *It was done in The Composing Room in one day, the whole thing. It was so fun and all sorts of people picked up on those ideas – that kind of mixture of languages, not just the sound, but the spelling, and the pluses and minuses, and the figures and the alphabets. We were putting all these things together in a new way that was pretty lively.*
Ivan Chermayeff

Watching Words Move was an exercise in youthful graphic brio put together by Robert Brownjohn, Ivan Chermayeff and Tom Geismar in 1959. It is easy to imagine the three designers throwing ideas back and forth: 'addding!' says the first, 'subtrcting!' replies the second, 'multimultiplying!' chips in the third. Originally produced as a handmade typographic notebook of pasted-up letters and words, the booklet was distributed three years later as an insert in the December 1962 edition of *Typographica*. The magazine's editor Herbert Spencer had a strong interest in concrete poetry and BCG's booklet served as a playful prelude to a feature published a year later on the typographic work of artist Ian Hamilton Finlay. Spencer's guiding mission was to liberate letters from the mere delivery of information and allow them to become a means of expression in their own right.[1]

After a gap of another three years or so, *Watching Words Move* was picked up again, but this time for the straightforward commercial purpose of advertising. The genesis of Brownjohn's Midland Bank films is somewhat uncertain (producer Jean Wadlow and writer David Cammell both lay claim to the original idea), but what is absolutely clear is that they were derived from BCG's earlier typographic experiments. Between 1965 and 1970 a series of nine cinema advertisements were made for the bank, each one using animated typography to promote a certain aspect of its services. Aimed at younger audiences and screened before the popular films of the day, they were greeted with appreciative laughter and sometimes applause.

Although gloriously original in their respective fields, the *Watching Words Move* booklet and the Midland Bank advertisements have shared typographic roots that reach back to the early decades of the twentieth century. A particular influence on both projects is the work of French poet Guillaume Apollinaire. When BCG drop the 'g' of 'hang' or lift the 'o' of 'balloon', they are creating a mood that is akin to, if somewhat less gloomy than, that of Apollinaire's meticulously arranged alphabetic shower 'Il pleut' (1914). Other important sources include the designs of the Futurists and the Dadaists. Brownjohn,

above all, owed much to the manner in which artists such as Filippo Marinetti and Tristan Tzara had used typographic proportion and scale as a means of communicating tone and volume. These ideas came to the fore in his matching of sound and visuals for the Midland Bank films.

Early in 1959 Brownjohn took part in a discussion organized by the Advertising Typographers Association of America. Sitting around a table with five other typographers (including Ladislav Sutnar and Bob Gill), he repeatedly emphasized a single proposition:

I think the revolution in typography has been in terms of image. The picture and the word have become one thing.

The only real advance [...] in advertising typography has been in the use of type not as an adjunct to an illustration or the image but in its use as the image itself.

You have found that the old image, the old word, doesn't mean enough any more to say what you want it to say. It's too familiar ...

I think perhaps our modern poets have created the modern typography.

These assertions suggest that, far from being a frivolous pastime, the typographic play of *Watching Words Move* was Brownjohn's bid to make 'a new statement'. The invitation to 'watch' words is deceptively casual. In beckoning us to look rather than read, he was signalling the way towards his vision of modernity.

Brownjohn's attitude towards type and image was shared by the other members of the mid-century American graphic elite. The influence of designers such as the *Harper's Bazaar* art director Alexey Brodovitch or the master of corporate modernism Paul Rand had generated a common belief that words and pictures should be orchestrated to the greatest possible effect. In Britain, however, graphic design was at a very different stage of evolution. When Brownjohn arrived in London in 1960, most indigenous advertising still relied on reams of copy appended to an isolated image. Brownjohn's colleagues at J. Walter Thompson and McCann Erickson were struck by his preference for image above word, but in general they failed to understand that his aim was to treat them as one and the same. Art director Angela Landels remembers how he used to drive the copywriters at JWT to distraction by asking them to edit their text – four columns into two, two columns into a paragraph, a paragraph into a sentence – and then opting to use an uncaptioned image. The unfortunate writers treated Brownjohn's claim that this process helped him arrive at a solution with scepticism – and of course he did love to goad – but his need for copy was probably genuine.

Watching Words Move

Experimental
Typography Booklet
1962, *Typographica*,
New Series No.6
14 x 11.5 cm (5 1/2 x 4 1/2 in)
Brownjohn, Chermayeff
& Geismar Associates

In buying the idea of animated typographic advertisements, Midland Bank was behaving with significant daring. Brownjohn might have been a little taken aback: he told a journalist from *Tatler* in May 1965, 'The change in the past five years has been fantastic ... I could show you some 200 rejected slides that were once considered too far out.' A large part of the credit for the bank's boldness is due to Jean Wadlow, the producer at the advertising agency Charles Barker (the agency responsible for making the commercials). The idea of using Brownjohn may or may not have been hers, but she was certainly the person who sold the concept to the bankers. As a young woman working in the relatively new industry of film and TV advertising, she was uninhibited by convention or expectation. Both her bosses at Charles Barker and the Midland Bank board were won over by her enthusiasm and immediacy.

Conceived by Brownjohn, the advertisements were written by David Cammell and animated by Trevor Bond. Cammell remembers Brownjohn's most significant input to the scripts being a drawled but approving 'Yeah', but for Bond the process was much more fraught. Brownjohn was not hands-on, but he paid meticulous attention to detail. Working on the first ad in 1965, Bond telephoned Brownjohn from the studio at 3 am to ask if the dots emerging from the railway engine – dots that were posing as steam – really need be pink. In spite of Bond's forlorn tone, the request to go for the less labour-intensive route of 'just having ordinary white dots' was met with a sharp refusal. That said, however harsh Brownjohn's stickling might have seemed in the wee small hours, in general Bond derived enormous satisfaction from making the commercials. 'We even used the U certificate!' he remembers. 'We played with it, moving it about, creating the effect with black holes and underlit colour shining through.'

Bond worked on the series for the full five years, a period he considers to be his typographic education. Cammell also contributed to all nine Midland Bank ads, but for him the returns were decidedly diminishing. 'We had all got fed up with it,' he recalls. 'I kept on saying let's have another idea, but Charles Barker refused because they were such a success.' The commercials had become formulaic – 'absolutely rigid, no fancy stuff' – but were still being warmly received by audiences and awards juries.

Piers Jessop, an editor at CHB and a close associate of Brownjohn, believes that, towards the end of his life, the designer was consumed by a fear of losing the ability to have original ideas. From the mid-1960s on, Brownjohn often claimed that all he was doing was regurgitating concepts he had generated more than a decade earlier. Chances are, the relentless repetition of the Midland Bank series contributed to that anxiety. The tragedy of Brownjohn recasting the product of his youthful confidence as evidence of fading talent is emblematic of the restlessness that beset his career. Gold medals from the Cannes Film Festival did little to offset the bite of self-abnegation.

1. For a comprehensive account of the magazine *Typographica*, see Rick Poynor, *Typographica*, Laurence King 2001.

sexxx

secret

?uestion

!xclamation

sawww

ero
1ne
2wo
3hree
4our
5ive

6ix
7even
8ight
9ine
10en

+dd
−tract
xultiply
div÷de

nipped

addding

subtrcting

multimultiplying

cl o wn

div id ing

ty x pewriter

M

deao

TElephone

2uo

3rio

4tet

advertisiNg

blo⊥⊥o

o
ver

togetherness ″nch

ЯO

inflatioⁿ

tophalf

telesoapvisbeerion

TⴖNNEL aut$_o$m$_o$biles

missiles

han
ᵍ

o

nO!se exi

ballo n ¢ents

 s-s-t-u-t-t-e-r
er

&in&ndag&in rreeppeeaat

upsideumop

f1rst

mamMoth

spe-cif'i-cal-ly

s t op! e

fallin

/eaning

g

backward

f_oor

nothing

con⊥used

incomplet

per.od

com,ma

thimk

c:l:n

breaking cutting *splitting* bending

clim

Money Walks

Cinema Advertising
Late 1960s, Midland Bank
Art Director:
Robert Brownjohn
Copywriter:
David Cammell
Lighting Cameraman:
Trevor Bond
Cammell, Hudson and
Brownjohn Associates

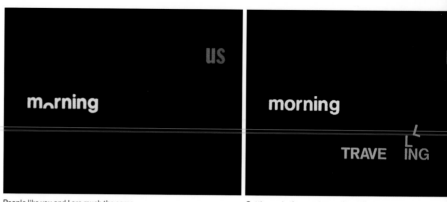

People like you and I are much the same.
Tweet tweet, cock-a-doodle-doo

Getting up in the morning, and travelling ...
Footsteps

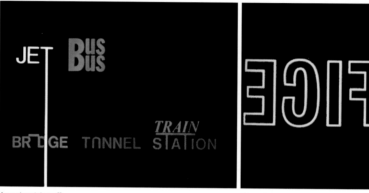

Aeroplane takes off

Door slams

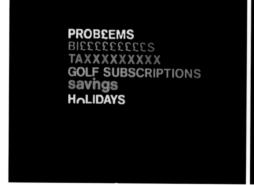

Hawaiian hula music

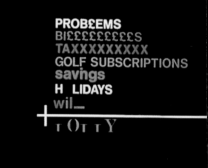

Funereal organ music

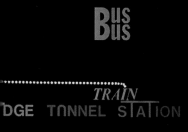

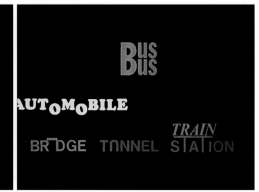

Car starts

train engine

much the same problems.
rching

They all add up to much the same thing.
Hole in one

Go to the people who understand the language of money.
er

Open an account at The Midland.
The Bank that keeps ahead on your account.

The Winner

Cinema Advertising
Late 1960s, Midland Bank
Art Director:
Robert Brownjohn
Copywriter:
David Cammell
Lighting Cameraman:
Trevor Bond
Cammell, Hudson and
Brownjohn Associates

Come in please.
Knock knock

Good morning Mr Midland Bank Manager.
Door swings open and slams shut, footsteps

Oh, buy a new car, and a new record player.
Rock 'n' Roll record

A new telly.
TV Western

You know, live it up a little ...
Roulette wheel

... tip lavishly ...
Coin spin

n. No need to be nervous, sir.
eats

You've won the pools. What are you going to do with all that money?
Fruit-machine jackpot

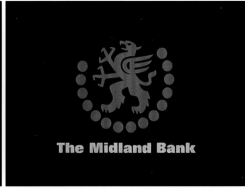

ener to mow the lawn.
r

And the new house I want to build.
Tap, tap, saw, saw – owww!

e.

And have nothing left. Why don't you put some in a deposit account, some in a current account and let us advise on investing the rest. That way your cheques won't bounce up and down so much. And you can protect yourself from the unforeseeable, and still have a bit of fun.

Thank you Mr Friendly Bank Manager.

By the way, how much did you win?

Forty-seven pounds, eighty-nine and a half new pence.

Kerching, kerching

Magazine Cover (detail)

1960, Architectural and
Engineering News
Brownjohn, Chermayeff
& Geismar Associates

London Street Photography

On his first day in London in 1960, Brownjohn is said to have caught a taxi and spent several hours being driven around the city taking pictures of its signage, shop fascias and other more casual outcrops of street graphics with his 1957 Pentax camera. This story has an element of myth to it. The collection of photographs that emerged seems too coherent and methodical to be the product of a travel-addled mind, and the details of the outing are hazy. No-one is sure whether this exercise in graphic anthropology took place on a short job-seeking trip to London, or if it occurred after Brownjohn had emigrated with his family. But, whether the pictures were taken on his first day or not (or even over the course of several days), they do provide an extraordinary record of the typographic environment of London as it rested on the cusp between the dreary 1950s and the swinging '60s.

Brownjohn made good use of these photographs in the early years of the decade. They became the basis for articles and lectures, and also inspired much of his design work. The most expansive record of the project is the thirty-one-page picture story 'Street Level', published in the fourth issue of the second series of Herbert Spencer's magazine *Typographica*, an occasional publication that was a labour of love rather than a commercial enterprise. In the short introduction to this piece, Brownjohn sets out the legend of the images and offers an explanation of their relevance to graphic design:

The photographs on the following thirty-one pages were harvested on one trip around London. The things they show have very little to do with Design, apart from achieving its object. They show what weather, wit, accident, lack of judgement, bad taste, bad spelling, necessity and good loud repetition can do to put a sort of music into the streets where we walk.

On the subsequent pages, he showed his pictures of street graphics alongside examples of design with which they seemed to have something in common (examples taken mostly from the work of his erstwhile American colleagues). The immediate emphasis of the article is on practical application, although I suspect that Brownjohn's engagement with the images was, in fact, more abstract and aesthetically driven.

Typographica's second series was published between June 1960 and December 1967, and all its sixteen issues were united by their enquiry into the use of the camera as a device for communicating specific information, or as a means of telling stories by evoking emotion and nuance. Although Spencer had never

met Brownjohn's mentor László Moholy-Nagy, his view of photography owed much to that artist's vision. He had a passion for what he called 'chance art' [1] and, as such, the 'beachcomber' nature of Moholy-Nagy's and subsequently Brownjohn's photographic eye coincided with his ambitions for the medium. A love of detail, particularly detail of the kind that is the outcome of long-term, unplanned accretion, is a theme that runs through the photographic work of all three men.

As well as the 'Street Level' article, Brownjohn showed these images in a lecture that, apparently, was billed as a 'collection of 2,000 slides of unused ideas'. The designer Brian Tattersfield recalls seeing one of these presentations at the Graphic Workshop, a forum set up by Bob Gill in the basement of an agency in Conduit Street: 'Needless to say we were all absolutely staggered by it – so much so that one friend was moved to tears knowing he would never be able to equal it. That's how involved we were in those days.' Bobby Gill, Bob Gill's then wife, also saw the pictures and was lent them by Brownjohn as a basis for a lecture of her own. 'He gave me his prints in a great big wodge and all his slides to show the students. They were amazed, because they hadn't seen anything like that,' she recalls. Bobby Gill continued to use these slides as a basis for lectures for the rest of her teaching career, finding that the pictures continued to enthral thirty years after they were taken.

Brownjohn's graphic-gathering trip around London was not unprecedented. While still in New York, every now and then he and a group of like-minded designers would trawl an area for engaging vernacular design. There is a record of one of these outings, a day trip to Coney Island, in the form of a charcoal sketch by an anonymous street artist of the profiles of Tony Palladino, George Tscherny, Brownjohn, Tom Geismar, Ivan Chermayeff and Bob Gill. Palladino remembers the trip well: 'We would ... check out interesting elements that we could use in our communications. Coney Island was full of picturesque images and design motifs. On one of those trips I found a sign that said "OPEN", it was on a shoemaker's shop. It was ripped and I noticed that, in spite of saying "OP" "EN", it could be read. I said, "Some day I am going to do that." And I used the memory of that image when I designed the book cover for *Psycho*.'

There are, however, apparent differences between Brownjohn's New York and London ramblings. In New York he would hunt in a pack, seeking out cheery seaside resorts, while in London he dwelt on the city's most dilapidated, melancholic areas – on his own. Homesick – having just bid farewell to his closest associates – he plunged into what was virtually a nineteenth-century city, still suffering from its bombardments during the blitz and from fifteen years of post-war austerity. Brownjohn's friend the designer Alan Fletcher describes London in 1960 as 'indescribably dreary', painting a vivid picture of English gloom: 'The average light bulb was 40 watts, with Lyons Corner Houses and ABC teashops, a half-pint bottle of brown the ticket to a party.' It remains a

Street Level

Picture Essay
1961, *Typographica*,
New Series No.4
27.5 x 21 cm (10 $\frac{3}{4}$ x 8 $\frac{1}{4}$)
Robert Brownjohn

painful memory to him, and it must have been even worse for Brownjohn, who arrived from the relative bustle of New York. Thus, one way of reading his street photographs is as an extremely elegant expression of culture shock.

On a more positive note, Brownjohn was particularly sensitive to the qualities that distinguished London's architectural and typographic environment. He was struck by the heavy ornamental detail of the city's Victorian building stock and its juxtaposition with the London shopkeeper's paradoxically casual use of authoritative typography. He documented the odd junction between the British desire for structure and uniformity and their non-conformist urge to make do and mend. Much more than a simple record of their times, taken together these pictures amount to a case study of an urban state of mind. In the introduction to 'Street Level', Brownjohn suggested that each cityscape has a 'unique colour'. Now Fletcher insists that, in the case of London in 1960, this colour was an unremitting 'grey', but Brownjohn seems to be offering a shade that, if admittedly still dingy, is much more nuanced.

To return to the notion of homesickness and culture shock, Brownjohn's feelings on arrival in Britain in 1960, still a relatively young man facing the task of building a new life for himself and his family, are perhaps the emotions that best characterize the twentieth century. It was an era marked by emigration, and also a time when travel was becoming easier, but the cultures of various countries remained highly distinct. The journey Brownjohn made from America to England had been travelled in reverse by both his mentors, László Moholy-Nagy and Serge Chermayeff (and his colleague Ivan Chermayeff too, while he was still a child). It had also been made by his father, who had probably emigrated just after the First World War, and by his wife Donna, who had married an American GI during the Second World War and followed him to the States, only to get divorced soon after her arrival. Obviously the motives for all of these trips are different, but they are united by a sense of upheaval. The child of immigrants in every sense, both biological and cultural, perhaps Brownjohn never felt thoroughly assimilated, either in the United States or in England. But, if this is the case, it is a feeling he would have shared with many of his peers.

Brownjohn's photographs were processed by Robert Horner on Palace Gate, London's foremost photographic printer, whose other clients included Helmut Newton and the Victoria & Albert Museum. Many of the prints were lent to Bobby Gill by Brownjohn, and she used these for her own teaching purposes. A little damaged because of repeated reference, they nonetheless portray a series of beautiful and engaging photographic surfaces. Being a Londoner, I pore over them for specific information. The images generate a paradox: although the nature of Brownjohn's interest in the ordinary graphic environment was very much before its time, the pictures he took are thoroughly rooted in a particular era. Looking through them now generates contradictory sensations of both nostalgia and the reverberations of the shock of the new.

1. Spencer in interview with Rick Poynor quoted in Poynor's book, *Typographica*, Laurence King 2001.

Street Level by Robert Brownjohn

A visitor to New York taking his first morning's walk down Fifth Avenue stopped to
inspect a bit of architectural detail that appealed to him, stepped back, looked up,
and was pole-axed with the full force of one hundred and two floors of Empire State
Building. The bit of detail that got his eyes above his head was a big, fat, curly
letter F.

The fact is that we begin to see our cityscape not so much as architecture as three-
dimensional typography. Fifth Avenue has its own unique colour – gold, bronze,
aluminium, stainless steel, marble, all the loud, aggressive, dollar-type materials in
God's Own Country. Sixth Avenue is different. So is Coney Island, Times Square,
Bangkok, and London. But, nine storeys or ninety, it doesn't really matter to the
pedestrian. Until he is knocked down and stares up from the stretcher, his streetscape
is road, pavement, and the first two floors. He remembers buildings by name,
number, and any other graphic statement within his vision.

For city areas are a mess of architectorialism, engineering, planning, and tycoonery.
Down around street level designers, typographers, scribblers, shopkeepers, and
even advertising men are welcome if they can keep the citizen's eye well away from
discovering how much worse everything gets above his head, up there with the
Builders of Our Time.

Until now, however, everything of any interest in this wide-open area of social uplift
has been done by dead men or by amateurs or vandals or politicians or accident or
neglect or dirty old men or the makers of big, busy neon signs. Architects and their
clients spend their bit of culture-money on bad sculpture or crazy screens. They
should be spending it on some happy way of showing how to get out again after you
have managed to get in.

Altogether, the more we can read our buildings, the less we will twitch at the sight
of them. The photographs on the following thirty-one pages were harvested on one
trip round London. The things they show have very little to do with Design, apart
from achieving its object. They show what weather, wit, accident, lack of judgement,
bad taste, bad spelling, necessity, and good loud repetition can do to put a sort of
music into the streets where we walk.

PENETRA

Underarm releases muscular pain. The esters it contains penetra...

PENETRA

...cause a subdermal erythema. This induces vasodilatation in...

PENETRAT

...ncreases the analgesic and anaesthetic effect and promotes the...

PENETRAT

The photographs and designs
on these and the following pa...
the similarity that exists betwe...
primitive and accidental street
and purposeful typography pr...
contemporary designers.

Top left and left: Disintegrati...
disintegration slow. A graphi...
road-laying adds impact to th...
command. Marks and Co. get...
business at street level. And...
experimental advertisement u...
same technique to illustrate a...
salve that penetrates muscle...
Opposite: Ribbed glass make...
symbol of a straight sign. An...
designer again takes his tech...
his streetscape.
A wrap-around notice becom...
mother of invention in packag...
where the word wraps around...
like the product round the fac...
Bad word spacing can happe...
can be designed.

PEN
PENETI
PENETRATI
NETRATION

TAKE YOUR
RETURN
TICKET
NOW

WASH
UP!
WASH

A MOIST TOWELETTE

FORD & C
s, Auctioneers & Estat
S, LINCO LN'S
HOLBORN 3177

me trotyp o graphersinco rporated2 7west2 4thstr eetnewyor k10telep honewat kins9- 6 290
metrot ypograph ersinc orpo rated27w est24t hstre etnewy ork1 0telephone watk ins9-62 90
metroty pograp hersincor po rated2 7we st24thstr eet newyor k10t elep honewatkin s9-6290
metrot ypog raphersincorpora ted2 7west24ths treet newy ork10te lephon ewat kins9 - 6290
m et rotypographersinc orpor ated27 west24t hstreetne wyork1 0tele phone watk ins9-62 90
metrotypog raphersinc orporat ed2 7west2 4thstree tnewyork10te lepho ne watk in s 9-6290
met rotypog raphe rsincor porated27 w est24t hstreetn ewyork10tel ephonew atkins 9-6 290
me trotyp ographersinc orpor ated27west2 4 thstr eetnewyor k 10tele phonewatkin s9 -6290
metrotypograp hersinc orpora ted27we st24ths treet n ew york10t elepho ne watkins9-629 0
met roty pograph ersin corpora t ed27west 24thstreetnewyo rk10tele phonewat kins 9- 6290
metroty pogr aphersincor pora ted27w est24t hst reet newyo rk 1 0telephonewatkins 9-6290
m et rotypog raph ersincorporated2 7wes t24th streetne wyork10t elephon ew atkins9-629 0
metrot ypogr aphersinc orpora ted2 7west2 4ths treetn ewy ork10tel ephonewat kin s9-6290
me trotyp o graphersincorpora ted 2 7west24thst reetnew york1 0 telephonewa tkins9 - 6290
metr otypo graphersinco rpora ted27wes t24t hstreetn ewy ork10tele phonew atkin s 9-6290
me troty pographersi ncorpora ted 2 7west 24t hstreetnewyo rk1 0telepho ne watkins9-6290
metro typographers incorporated 27 west 24th street new york 10 telephone watkins 9-6290
metrotypographer sincor p orated2 7 west2 4thstreetnewy or k1 0 tel ephonew atkins9-6290
met rotypog raphersinc orpor a ted27 west24 thst reetnewyork one teleph one watkins9-6290
metrot ypogr aphersincorpo rated2 7west 24thstreetn ewyork 10t eleph onewat kins9 - 6290
me trotyp o graphersinco rporated2 7west2 4thstr eetnewyor k10telep honewat kins9- 62 90

31

32

cond-hand fencing on a building
eves a fragmentation of letter
Photo by Don Foster), and the
her does the same thing with a
s-card. Then Colin Forbes goes
ther on a dust-jacket.
resh paint draws a sharp line
 neighbours. And a designer
e same line through history.

Originally publish

The Age of Reform

Richa

Hofsta

33

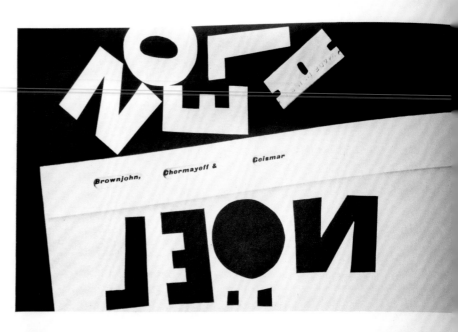

Brownjohn, Chermayeff & Geismar

WILLIAMS
WILLIAMS & C°L
TAILORS

CLOSED

LET
LET
LET
LET

38

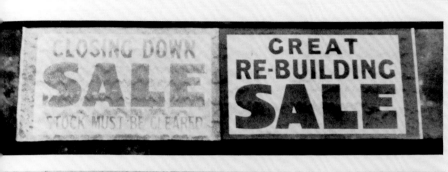

: the hardest, simplest way
st say it again and again and
again and again.

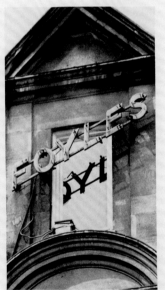

39

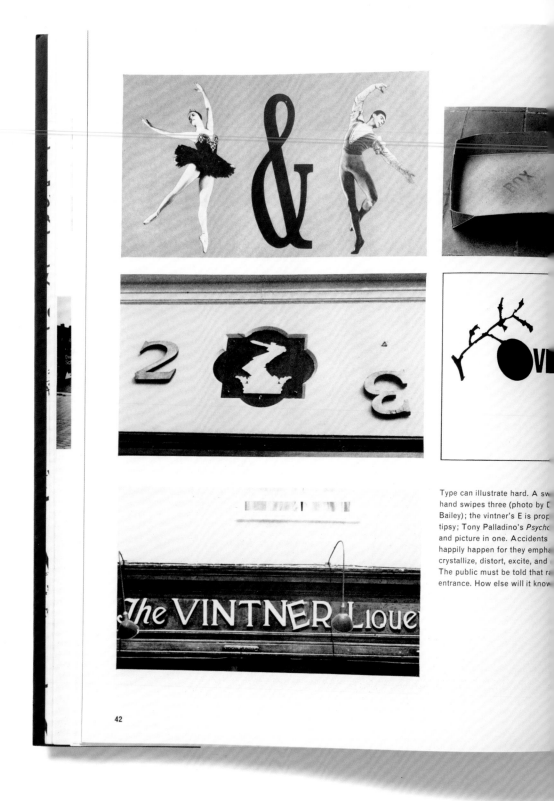

Type can illustrate hard. A sw[...]
hand swipes three (photo by D[...]
Bailey); the vintner's E is prop[...]
tipsy; Tony Palladino's *Psycho*[...]
and picture in one. Accidents [...]
happily happen for they empha[...]
crystallize, distort, excite, and [...]
The public must be told that ra[...]
entrance. How else will it know[...]

42

PSYCHO

Robert Bloch
An Inner Sanctum Mystery

RADESMEN
NTRANCE

INMENT

ENTERTA

CLOSED

OPEN
FOR

Brooke Bond
P.G. Tips

The TEA you can
really TASTE

PREMISES CLOSING DOWN
FOR REBUILDING

X1V

43

Brownjohn, Chermayeff & Geismar
An Exhibition of Graphic Design
The Composing Room: Galery 303
130 West 46th St., New York City
Showing: July 15th to July 31st

The exhibition notice only c
itself after folding unrelated
more of the same, printed o
Lost property, like charity, b
home, Rock's neighbour co
Rolls, and it's very casual m
that wants staff as casual a
The Pollo alla Cacciatore w
prethreequarterpared by Bo
private secretary. Transvasi
penetrating typographically,
removal men who may be ha
thoughts about the quality c
work are emphatic about the
effectiveness of their remov
removes itself almost compl
The hairdresser is so difficu
he just has to be good.

Pollo alla Cacciatora 12/6

Chicken deliciuosly prepared with wine, tomato, mushrooms & peppers....

~~print~~

private

secreatary

....

CBS televitsiokn

GOOD QUALITY

FURNITURE
& LUGGAGE
REMOVALS

HAIRDRESSING

NFTRATION

...wn muscular pain. It contains esters that are chosen for
...e of skin penetration, and satisfy the essential condition
...age. Transvasin penetrates the skin, and causes a sub-
...s. This induces vasodilatation in the underlying muscles,
...ntity of analgesic and anaesthetic components in these mus-
...es the local repair of tissue damaged in the initial strain.
...ost of Transvasin is 2.9d (. PTx and it is available on EC10.
...is muscular pain—prescribe **TRANSVASIN.**

47

David Enock makes impact f[...]
Bob Gill makes a noise for C[...]
destitute shopkeepers make [...]
London. All the same trick b[...]
do it better than others.
David Enock uses alphabet o[...]
make a name for sculptor W[...]
Colin Forbes has good hones[...]
blockmaker's fun. Mr Gottlieb[...]
same thing long, long ago.

50

51

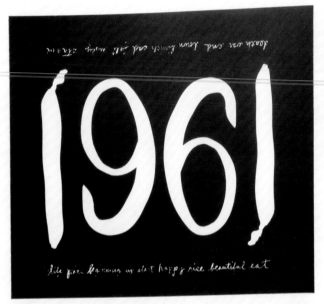

doesn war end learn breath end fell way start

like give beginning us start happy rise beautiful eat

PORT S

GRIL

Letters drip to explain or ob
meaning. And letters weath
sporting types or to attract
(Grillo by David Enock for a
Right: People are people. A
can't leave well alone.

PAQUE FLAT TRANSPARENT REFLECTIVE ENAMEL HALF-
ONE & FLUORESCENT SILK SCREENING ON ANY SURFACE
NE CREATIONS INC 13 E 19TH ST NYC 3 SP 7-8756

Bachelor Cigarettes Packaging

Seldom straying far from a smoker's hand, a cigarette packet is a de facto personal accessory. As such, it must be stylish and, from the tobacco company's point of view, it should advertise their product as explicitly as possible. Brownjohn's design for Bachelor cigarettes achieved these two aims with perfect conceptual economy. In terms of stripped-down chic, the Bachelor packet is unbeatable. Moreover, there is no better way of identifying a product by its package than simply illustrating it on the surface of the box. Why this design never went further than maquette stage is something of a mystery.

Player's Cigarettes, the manufacturer of the Bachelor brand, was founded in Nottingham in the late nineteenth century. Although by the 1960s members of the Player family were no longer involved, it remained a highly conservative concern. The name of the product is revealing: Bachelor is a raffish title, but it signals the kind of disreputable behaviour that is acceptable only as a prelude to extreme conservatism. Casting around for reasons that the design did not reach production, it is easy to imagine that Brownjohn's lack of inhibition did not endear him to the traditionalists on the Player's board.

According to Alan Fletcher, Player's Cigarettes reneged on the design because Brownjohn bragged about his idea around town, effectively pre-empting the product launch. Willie Landels remembers Brownjohn filling his maquette with tampons and handing it around to the clients. This gesture is unlikely to have gone over well. In addition to straightforward provocation, it was a brilliant subversion of the box's pretence of transparency. Brownjohn was exposing his own collusion with the social norms that govern which items are fit for public display and which must remain hidden. (It is tempting to view it as a proto-feminist act.)

Brownjohn is largely associated with print graphics and film, and the Bachelor cigarette pack is one of the few forays he made into three-dimensional design. He had, however, spent time studying product design and architecture at the Institute of Design in Chicago and was familiar with the thought processes involved in the design of packaging. A star pupil of Lászlo Moholy-Nagy's Product Design Workshop, Brownjohn had worked for the Parker Pen Company in the 1940s under the auspices of his mentor. Also, many of his earlier jobs in New York, particularly freelance work for Bob Cato and Edgar Bartolucci, involved designing graphics for display and point of sale. As a result, he was highly skilled in making two-dimensional information function in a three-dimensional context.

Among the designs in BCG's portfolio was a package for 'Wash-up' cubes: square boxes of detergent with a quirky typographic wrapping. Individually they are hard to read, but stacked one of top of another, the message is clear. Likewise the Bachelor cigarette packages would have made the strongest impact on the retailer's shelves, where the image of massed ranks of cigarettes would have outshone anything offered by the competition. This emphasis on point of sale was very much of its time and it connects to the notion of the self-service store as a place to enjoy a modern and glamorous experience. Shopping was becoming increasingly associated with leisure, and designers were charged with attracting the attention of browsing customers.

When loose goods were first packaged to be sold in fixed amounts under the aegis of brands, the effect was to create a conceptual distance between the product and its raw ingredients. The first such goods were medicines, and the purpose of branding was to inspire consumer trust that was based not on the nature of the formula, but on the associations of the name. By the late nineteenth century this strategy had extended across a whole range of goods. Once packaged, mundane products such as oat flakes became associated with extravagant promises of wholesomeness. Brands derive their power from assurances of quality, but in time these brands become stand-ins for the very qualities they advertise.

At first glance, Brownjohn's Bachelor cigarette packet appears to complete a circle: where branding once separated image and product, now they are united. A closer look, however, reveals that this is not the case. Even reproduced at actual size on the outside of a packet, an image of a cigarette is far from identical to the product. The photograph has inescapable associations with other cigarette advertising, most of it highly glamorized. As a result, it is able to communicate properties that are lacking in the real thing. That Brownjohn was able to bring the reified image of the cigarette so close to its mundane reality, without diminishing any of that image's power, is, however perverse it might seem, a demonstration of the extent to which the brand image had become independent of the product. Those sceptical of this theory should imagine how the packet would have appeared had it actually been transparent. Far from being an appealing object, it would have looked like a pub ashtray on a Friday night, minus the alluring plumes of smoke.

Brownjohn's Bachelor cigarette packet has not dated. It still looks like an ingenious and innovative piece of design and, were smoking not such a demonstrably bad idea, it would be tempting to say that it ought to be put into production today. Sadly, however, the job has been consigned to Brownjohn's hefty portfolio of work that never saw the light of day. Brownjohn's contemporary Bob Gill has vivid memories of several other unrealized jobs: the anti-smoking campaign with an eight-year-old girl puffing smoke rings, and the film protesting against deforestation, with a model shaving her long, blonde hair. Brownjohn's

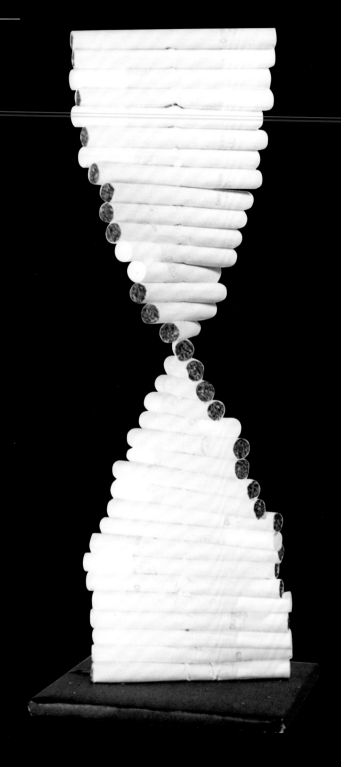

ideas did win wider acceptance towards the end of his life and, discussing the advertisements he made for Midland Bank in the late 1960s, he remarked in *Tatler* in May 1965, 'The change in the past five years has been fantastic ... I could show you some 200 rejected slides that were once considered too far out.' Nevertheless, rejection was a dominant motif of the London chapter of Brownjohn's career.

Shortly after the Bachelor debacle, Brownjohn was poached by the rival firm McCann Erickson. Like JWT, they were based in America, and hired Brownjohn to Americanize their London office. Apparently he was assured that more of his ideas would be put into production after the move, but his archive does not bear this out. Instead he seems to have been viewed as something like a court jester. According to David Bernstein, the Creative Director at McCann Erickson: 'You need a maverick, someone who speaks his mind and comes up with things from the leftfield, because you can always have a fall back. You can always say, "Let's do the safe one."'

It appears that Brownjohn's work fell victim to the safe option far too often.

Vitamin Tablet Packaging

Early 1960s, Genatosan
Robert Brownjohn

sanatogen
selected
multivitamins

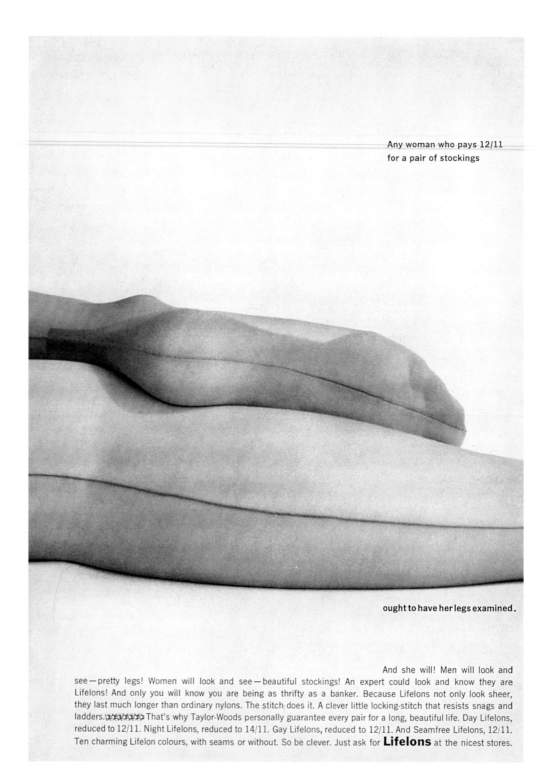

Any woman who pays 12/11
for a pair of stockings

ought to have her legs examined.

And she will! Men will look and see — pretty legs! Women will look and see — beautiful stockings! An expert could look and know they are Lifelons! And only you will know you are being as thrifty as a banker. Because Lifelons not only look sheer, they last much longer than ordinary nylons. The stitch does it. A clever little locking-stitch that resists snags and ladders. That's why Taylor-Woods personally guarantee every pair for a long, beautiful life. Day Lifelons, reduced to 12/11. Night Lifelons, reduced to 14/11. Gay Lifelons, reduced to 12/11. And Seamfree Lifelons, 12/11. Ten charming Lifelon colours, with seams or without. So be clever. Just ask for **Lifelons** at the nicest stores.

Lifelons Advertising

Advertisement Series
1963, Lifelons
Robert Brownjohn

The iterations of Brownjohn's advertisements for Lifelons stockings were shown in the display panels that line the escalators of the London Underground. The restraint of the individual images and the nature of their repetition was unlike anything else at the time.

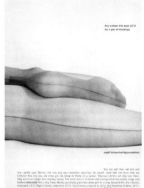

189

Obsession and Fantasy Poster

*For some reason (probably clear to a psychiatrist) four design projects in which
I have recently been involved have all had a strong emphasis on sex in the form
of the female anatomy.*
Robert Brownjohn, 'Sex and Typography', *Typographica*, December 1964

Brownjohn's run of sex-related designs comprised the Lifelons campaign
('a series of advertisements for nylon stockings, using photographs of a girl's
legs, closely cropped almost to the point of abstraction'), the *From Russia with
Love* and *Goldfinger* title sequences, and a poster for the exhibition 'Obsession
and Fantasy'. The first three of these projects were high-budget professional
commissions, but the last was, in essence, a domestic affair. This possibly
explains, while the sexual content of the Lifelons ads and the Bond titles has
been subsumed by the subsequent tide of graphic explicitness (it is hard to
imagine, for example, a time when the *Goldfinger* titles would have raised the
eyebrows of the censors), why the 'Obsession and Fantasy' poster still has the
power to shock. In begging you to imagine where and how it was created, the
photograph communicates an intimacy that crackles with erotic vulnerability.

The design of the poster is simple. Split in two, the upper half is devoted to
an image of a woman's naked breasts. Photographed straight on, with her
arms visible at either side, she reveals the word 'obsession' written directly
on her skin. The letters are positioned on her body so that her nipples stand
in for the 'O's. The hand-lettering is assured, yet hastily executed. The model
for the photograph was Brownjohn's girlfriend Kiki Milne, then called Kiki
Byrne. She remembers Brownjohn writing swiftly on her chest, with 'no
corrections or rubbings out'. The image makes no attempt to disguise Milne's
gaunt frame. Her upper arms are reed-like and the dent of her ribs is visible
under her skin. Her breasts are small and one is slightly larger than the other,
but this striking departure from the standard public image of a woman's body
– derived from soft pornography – only serves to heighten the sexual charge.
In the article 'Sex and Typography', Brownjohn described the composition as
an 'integration of sex, typography and meaning'.

The exhibition advertised by the poster was held at Robert Fraser's gallery
on Duke Street in London's West End during June and July 1963. It was a group
show of ten male artists, including Francis Bacon, Hans Bellmer, Jean Dubuffet
and Alberto Giacometti. Although Brownjohn described it as an exhibition of
'Pop' artists, the list of participants suggests that its emphasis veered towards
the surreal. His poster is certainly more akin to surrealism than pop, with its

Obsession and Fantasy

Exhibition Poster
1963, Robert Fraser Gallery
Robert Brownjohn

OBSESSION

AND FANTASY

obsession and fantasy June 12-July 10.
Robert Fraser Gallery 69 Duke-Street
Grosvenor Square London W1
Bacon Bauhus Blake Bellmer
Bettencourt Dado Dubuffet
Giacometti Lindner Stevenson

unmistakably hand-drawn lettering hinting at kinds of behaviour associated with psychosexual disorder. There is no record of the installation of the show, but its various exhibits would probably have dwelled on the body and, in all likelihood, Brownjohn's poster sat among them with ease. An all-male show, dwelling on sexuality and promoted with a pair of breasts: nothing could be more emblematic of the 'liberation' enjoyed during the swinging but decidedly sexist early 1960s.

In the article 'Sex and Typography', Brownjohn implied that the idea for the poster sprang direct from his disordered mind. Without wanting to dismiss the validity of this cursory self-analysis, it is worth adding that it also owed much to his education at the Institute of Design. Having taken a number of literature courses, he would have come across the works of modern poets such as Guillaume Apollinaire and Christian Morgenstern, and he would have absorbed László Moholy-Nagy's view that 'literature can be defined as the verbalised form of communication generated by psychological and biological forces'. The belief that words carry emotional as well as intellectual connotations was central to Brownjohn's approach to advertising typography. The 'Obsession and Fantasy' poster is a perfect encapsulation of an experience Moholy-Nagy described as 'simultaneity', in other words seeing and reading both at once.[1]

Other likely influences on the poster carry less intellectual weight. According to Milne, Brownjohn had a cheerful enthusiasm for *Playboy* magazine, a publication that had yet to acquire its tawdry connotations. More than merely being viewed as raffishly respectable, in the early 1960s soft porn even had associations of social radicalism. The climate was one in which Brownjohn could express his wonder at the Amazonian proportions of the *Goldfinger* model Margaret Nolan without inhibition. Milne designed the gold leather bikini that Nolan wears in the title sequence and remembers adjusting the top, her nose coming level with the high-heeled model's nipples. The difference between Milne and Nolan's physiques could not have been more striking, but nonetheless Brownjohn chose to explore them as part of the same landscape of female flesh.

Milne remembers the 'Obsession and Fantasy' poster fitting comfortably with the mores of the crowd that frequented Fraser's gallery: 'You couldn't shock anyone in that circle, believe me.' This view is borne out by Harold Stevenson, one of the gallery artists, who, speaking in Robert Fraser's biography, remembered the 'liberation' they enjoyed being 'very exclusive'. 'We were isolated from everyone else. It was very glamorous.'[2] All the same, some of the more candid members of the clique have admitted that the poster caused a certain frisson. Also quoted in Fraser's biography, Cedric Price, the architect of the gallery and an individual with more radical credentials than most, recalled, 'There was one exhibition which had Kiki Byrne's bare breasts on the cover [...] I lived near the gallery and I could walk down and see it.'

Since its design in 1963, the poster has had an afterlife as a cult piece of print. Milne does not know how it was distributed, but she has glimpsed it every now and then in lifestyle shots, accessorizing the walls of artists or designers. Because the image remained in the closed circles for which it was created, it never became an object of scandal. But Fraser was not always so lucky. In 1966 he was fined for obscenity after showing explicit drawings by the American artist Jim Dine. Many suspected it was a set-up, the police taking the opportunity to punish Fraser, whose unconventional behaviour had scandalized them for some time. Harold Stevenson described the late 1960s as a 'parody', and the Fraser obscenity charge marks one of the steps by which what had been an exclusive adventure was transformed into a public pantomime.

Brownjohn was proud of 'Obsession and Fantasy', and gave a framed print to the singer Georgia Brown, who was then starring as Nancy in London's version of the musical *Oliver!* Unfortunately, however, Brown was not pleased. As a pioneering feminist, she found the photograph of Milne's fragile torso extremely disturbing and never allowed it near her walls. The elements that made the poster so disturbing to Brown remain undimmed after more than forty years. Details such as the small fold of flesh in Milne's armpit and the irregularities in the inked letters catch the eye and do not let go. It is an image that will never become comfortable.

1. See the section titled 'literature' in László Moholy-Nagy's *Vision in Motion*, Paul Theobald 1947.

2. Harriet Vyner, *Groovy Bob: The Life and Times of Robert Fraser*, Faber & Faber 1999.

From Russia with Love

Film Title Sequence
1963, Eon Productions
Director: Robert Brownjohn
Animation: Trevor Bond

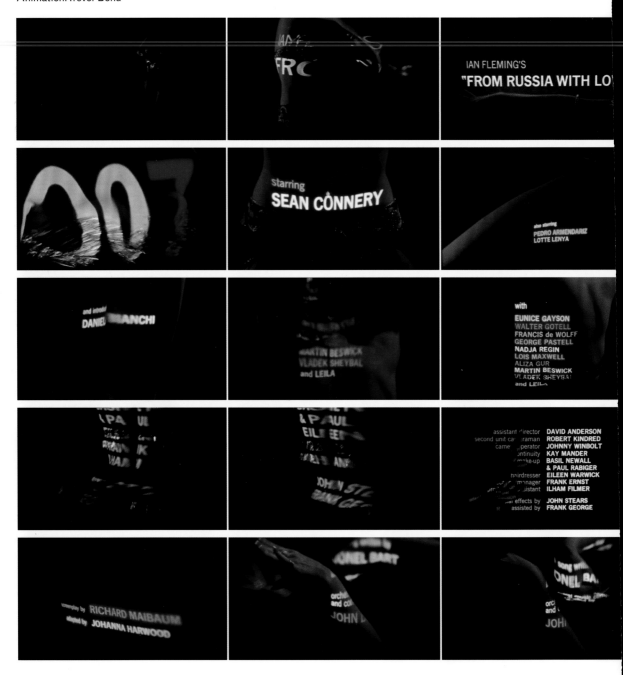

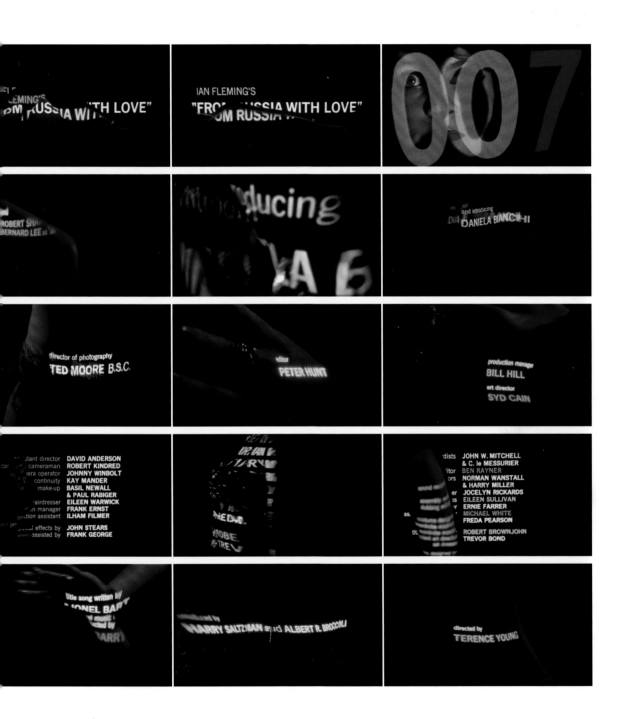

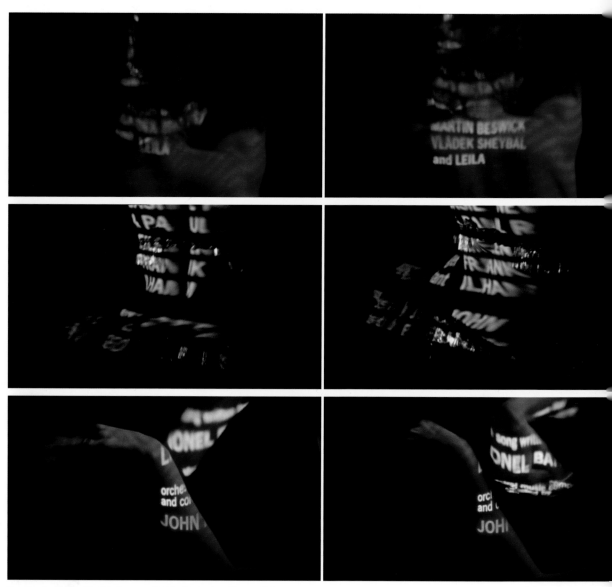

From Russia with Love, Film Title Sequence, 1963, Eon Productions *Above and following pages*

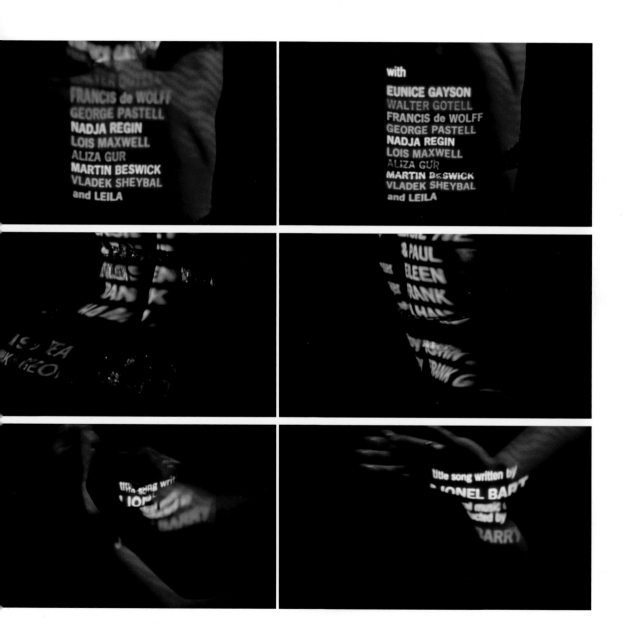

197

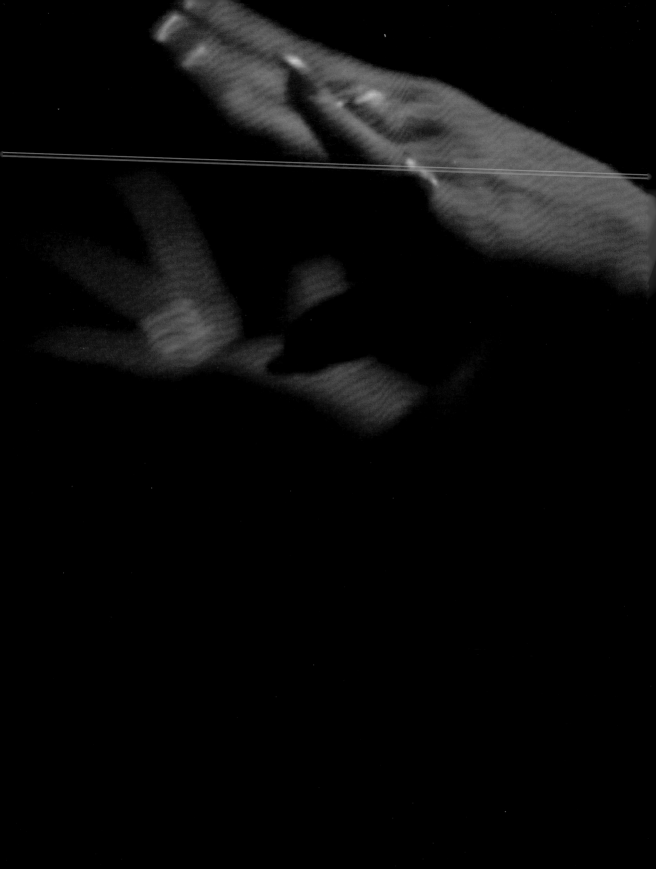

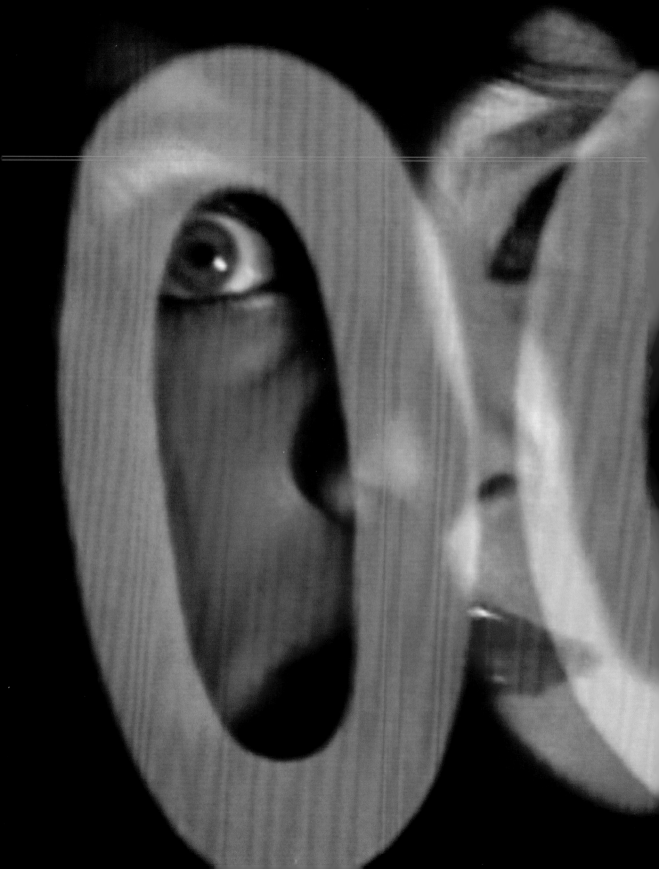

From Russia with Love and Goldfinger

The title sequences for the James Bond films *From Russia with Love* (1963) and *Goldfinger* (1964) are, without doubt, Brownjohn's best-known works. They are celebrated by graphic designers and film fans alike, with *Goldfinger* in particular being cast as the genre ideal. As well as perfect distillations of the Bond spirit, these two short pieces of cinema demonstrate a combination of conceptual neatness and visual extravagance that dazzles audiences to this day.

From Russia with Love was the second film in the ongoing Bond series. The first, *Dr. No*, had been shot a mere twelve months earlier and had premiered in England on 5 October 1962. Produced by the American business partners Harry Saltzman and Albert (Cubby) Broccoli, it had been a commercial triumph, made for little more than $1 million, but earning nearly sixty times that at box offices worldwide. When it came to making the next film in the series, Saltzman and Broccoli were coasting on the swell of success and perhaps this explains why they chose to jettison Maurice Binder, the designer of the *Dr. No* opener, in favour of Brownjohn. It is easy to imagine the evening at a Chelsea dinner party or a Soho nightclub when Brownjohn won over Broccoli and Saltzman with his personal charm and his much trumpeted status as London's hottest art director.

Brownjohn often told the tale of how he had sold the idea for *From Russia with Love*: gathering producers and executives into a darkened room, he turned on a slide projector, lifted his shirt and danced in front of the beam of light, allowing projected images to glance off his already alcohol-extended belly. 'It'll be just like this', he exclaimed, 'except we'll use a pretty girl!' And, pretty much, it was. Although the sequence works brilliantly in its context at the opening of a mainstream movie, it remains an extremely open-ended and positively experimental piece of film. Brownjohn had never worked with live action before he made the titles, and, unknown to him, nor had his animation assistant Trevor Bond. Unlike his title-design mentor Saul Bass, a man who mapped his sequences to the second, Brownjohn dived into the process without much of a plan. Interviewed a couple of years later he explained, 'It was all done in the camera, which is the way I like to do films, you know. I hate storyboards and scripts. It's nice just to have an idea and go on the floor and play around with the camera and the lights, and then shoot what you want.'

In the making of *From Russia with Love*, Brownjohn and Bond played with the camera over three different sessions. The first was in the company of a belly

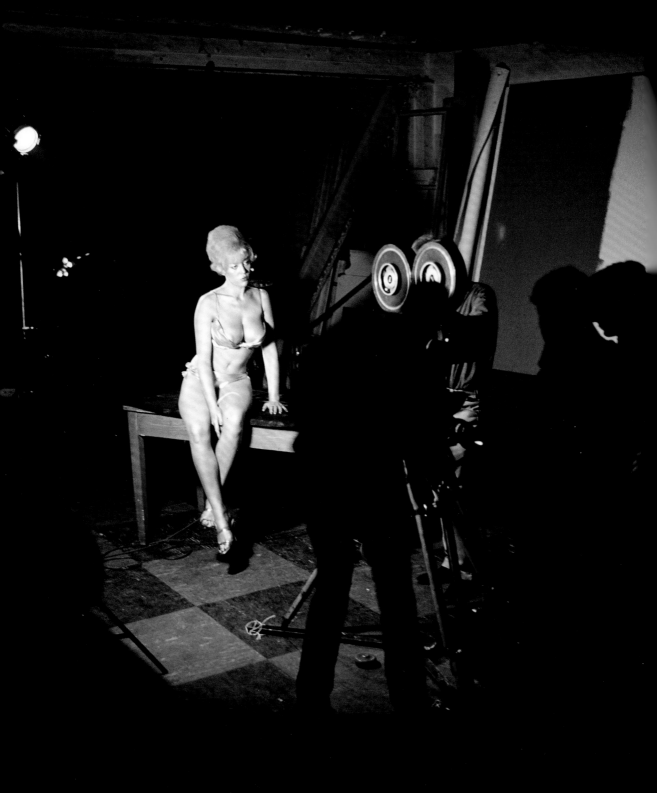

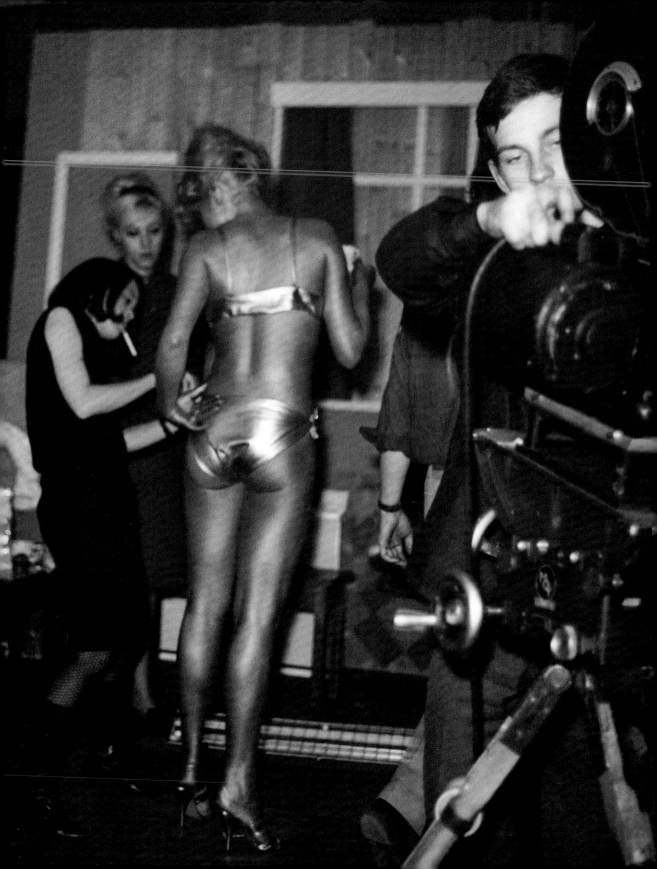

dancer, who fled when she was asked to lift her skirt. Short elements of her dance sequence survive in the final titles, demonstrating that it took Brownjohn and Bond a few tries before their idea was completely successful. As the belly dancer swings her midriff in the beam of the projector, the letterforms sweep her body in a fashion that is decorative but unreadable. Next up, on the recommendation of one of Brownjohn's louche acquaintances, was the snake dancer Julie Mendes. Having realized that the legibility problem was created by the projector's lack of focal depth, Brownjohn encouraged Mendes to move within a fixed distance of the light source, a feat she managed with considerable grace. Type has never been teased so seductively, but apparently Mendes wasn't pretty enough for the producers, so the final session involved a model looking into the camera as '007' was projected on her face.

Brownjohn told colleagues that the sequence was inspired by the sight of audiences leaving the cinema during the credits, but another important source was László Moholy-Nagy's long-term experiments with projected light. Moholy had been interested in projecting onto three-dimensional objects, creating a hybrid between sculpture and film, since the 1920s. At the Institute of Design in Chicago he encouraged students to think about casting advertisements into the night sky. Far from austere or puritanical in his approach, Moholy-Nagy's photographs often explored the way in which light caressed the human form, male and female. Bauhaus to Bond may seem like a huge leap, but that probably has more to do with the subsequent characterization of European modernism than the impulses of its protagonists.

From opening sequence to final shot, *From Russia with Love* was a huge popular success and the production of the next movie followed swiftly. The budgets of the first three Bond films rose by about £1 million each time, but Brownjohn raised his quote for the design of the titles by a much larger margin. Making the first sequence for £850, he demanded £5,000 for the second. This seemed like a huge amount at the time, but, as his long-suffering assistant Bond recalls, 'We quoted £5,000 and it cost £5,000. You never made a profit on Bj, he always used all the budget and went over the top.' Brownjohn's original idea for the *Goldfinger* sequence was to project footage of the film's characters and key props onto a gold-painted model. During the test shots, he discovered that the only way this could be done without losing the effect was by pre-shooting against a gold background. However, the producers were not keen to pay Sean Connery to run around in front of a gold sheet, so the idea was abandoned.

Casting around for a new concept, Brownjohn noticed the way in which the contours of the model distorted the images projected upon her. He decided to base the sequence on this effect, using the more-contoured-than-most 'starlet' Margaret Nolan ('41-23-37') as a three-dimensional film screen. Painted gold from top to toe and dressed in a gold leather bikini, Nolan struck seductive poses while explosions, shoot-outs and love scenes played out over her

The making of the *Goldfinger* title sequence, London 1964. Photographs: Herbert Spencer

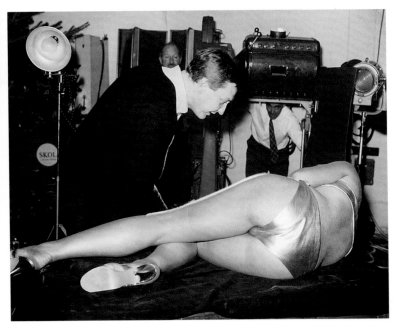

B.T. Xpenses.	100
Cam Crew.	$590 -
Dancer Ⓑ	150
Projector .	250
Slides	28
Type	150
Dancer Ⓑ	75
Studio .	60
Expenses	50
Fee	300
Brownjohn	750
Edit .	50
Rollar .	50
Model	25
Samuelson	100
Make up	45.
	£2528
	50
	75
	100
	2653

Trevor Bond's *From Russia with Love* production notebook, 1963

body. Brownjohn took particular care with details such as the golf ball that disappears between Nolan's breasts and the scene in which a pocket-sized Bond crawls over her thighs. His subsequent description of the sequence as 'architectonic' in the 1965 D&AD Awards Annual may seem improbably cool, but as he goes on to explain, the titles were made by 'building in space.'

Music has always been an important ingredient in the Bond formula and the *Goldfinger* title theme sung by Shirley Bassey is among the very best. Brownjohn's sequence is not, however, tightly synchronized to the tune and chances are the felicitous pairing of sound and visuals is the outcome of coincidence not design. This is also true of the earlier titles with their loose match between Julie Mendes's undulations and Matt Munro's crooning of the (rather feeble) *From Russia with Love* theme. Of course the jazz-loving Brownjohn would not have viewed music as an afterthought, thus the tacking together of image and song is more likely a reflection of the Bond film's hectic production schedule than anything else. Complaining in *Showtime Magazine* about the planning and financing of title sequences, Brownjohn once remarked, 'Producers always leave the titles to the last minute.'

Brownjohn was still working at the advertising agency McCann Erickson when he made the *From Russia with Love* titles, but he had left by the time he came to create the opening for *Goldfinger*. Trevor Bond remembers Saltzman and Broccoli being so delighted with the second sequence that they offered to finance an independent production studio from which Brownjohn and he could make future titles. But, much to Bond's dismay, Brownjohn turned them down flat. The dispute must have been serious, because when it came to making the fourth Bond movie, *Thunderball* (1965), the producers returned to the original designer Maurice Binder.

Subsequent to *Goldfinger*, the only feature titles designed by Brownjohn were those for the comedy drama *Where the Spies Are* (1965) and the military thriller *The Night of the Generals* (1967). Neither film was a conspicuous success, and reviewing the latter in *The Sunday Times* the critic Dilys Powell remarked: 'Nothing quite lives up to the excellence of Robert Brownjohn's title sequence.' With press such as this, it is hardly surprising that producers and directors became a little wary of Brownjohn's talents. But, while the film industry became cautious, the graphic design community was agog. The *Goldfinger* sequence won a D&AD Gold Award in 1965 and, possibly because of the happy coincidence of the colour of the prize and the titles, it came to epitomize the association's approbation. In late 1960s London, Brownjohn was widely celebrated as the designer who could turn celluloid into pure gold.

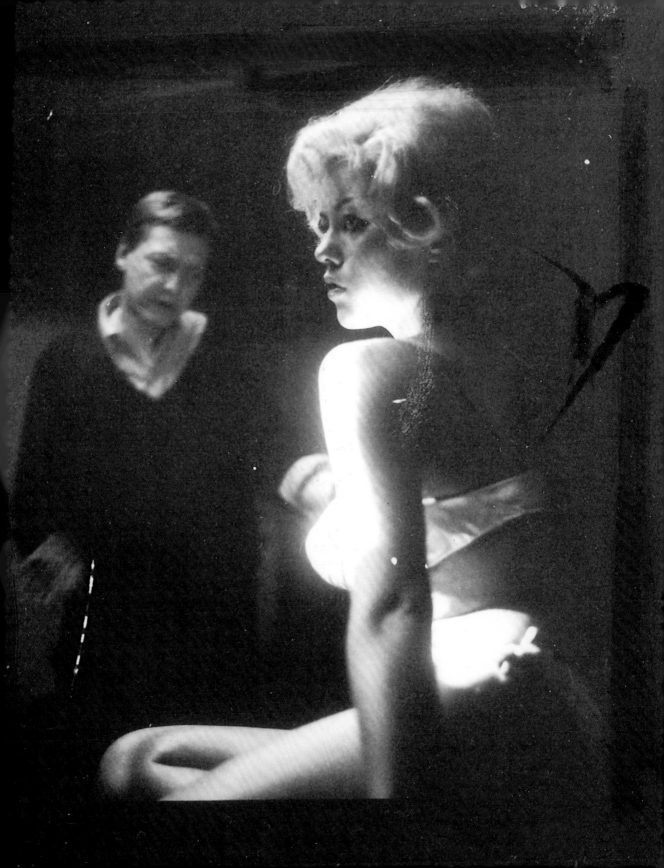

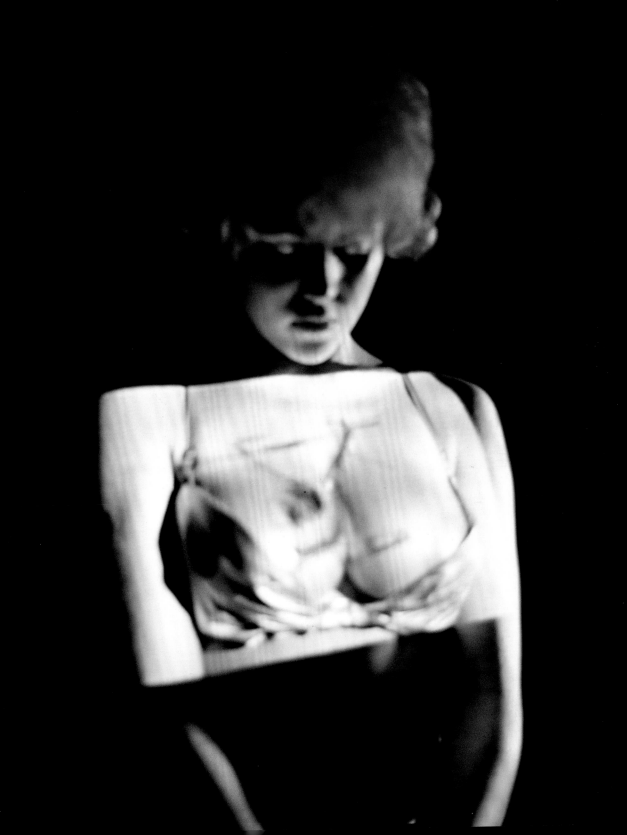

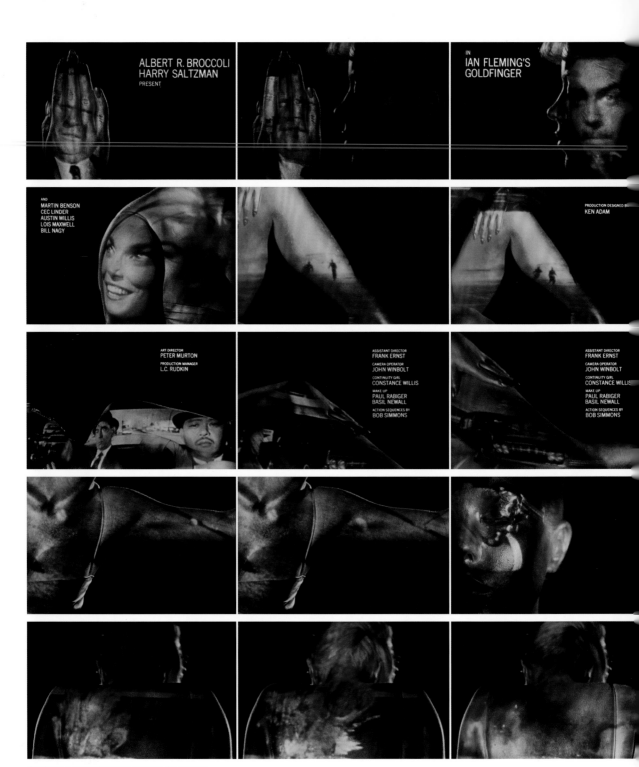

Goldfinger, Film Title Sequence, 1964, Eon Productions

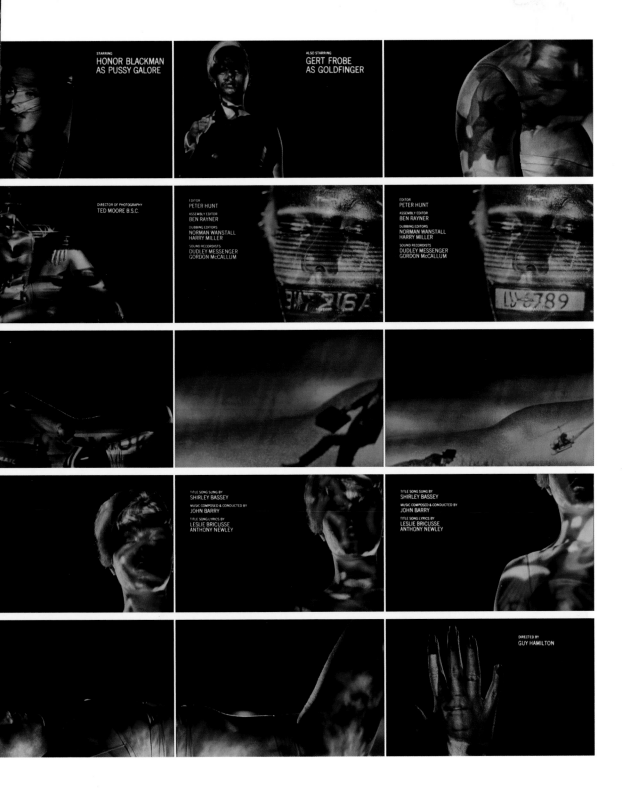

Goldfinger

FilmTitle Sequence
1964, Eon Productions
Director: Robert Brownjohn
Animation:Trevor Bond
Previous and following pages

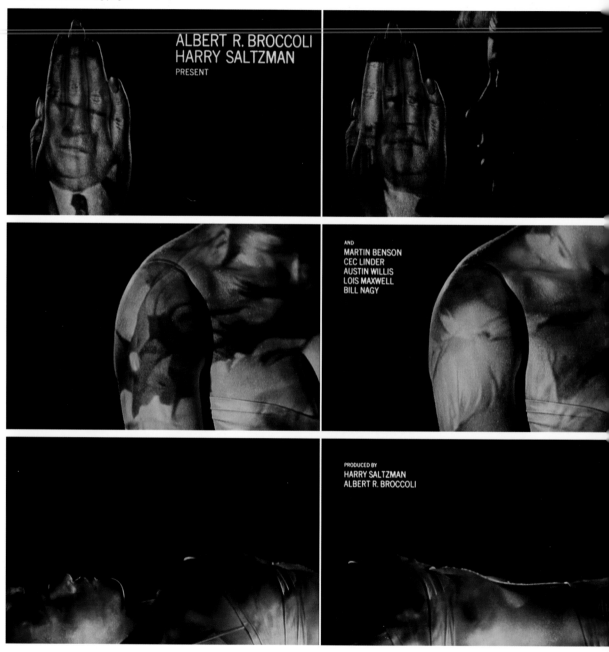

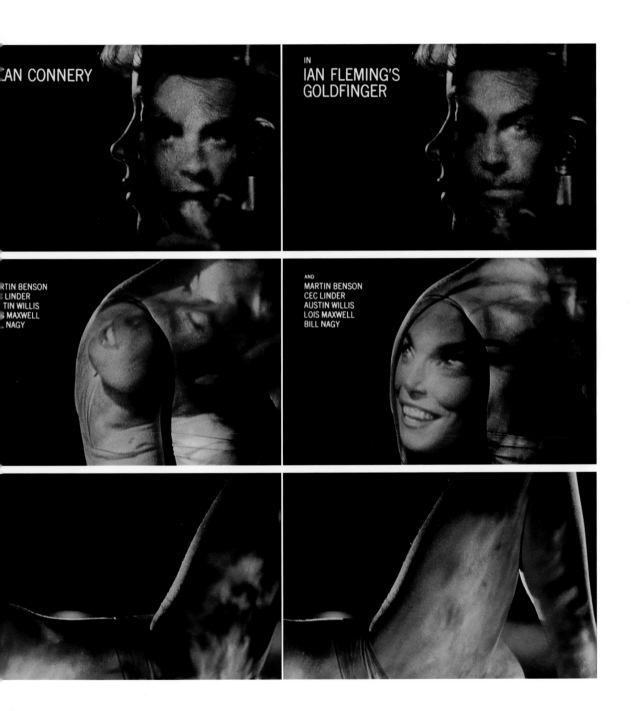

EDITOR
PETER HUNT

ASSEMBLY EDITOR
BEN RAYNER

DUBBING EDITORS
NORMAN WANSTALL
HARRY MILLER

SOUND RECORDISTS
DUDLEY MESSENGER
GORDON McCALLUM

DIRECTED BY

GUY HAMILTON

Goldfinger

Film Poster
1964, Eon Productions
Robert Brownjohn
Opposite page
Alternative design
displayed in London, 1964

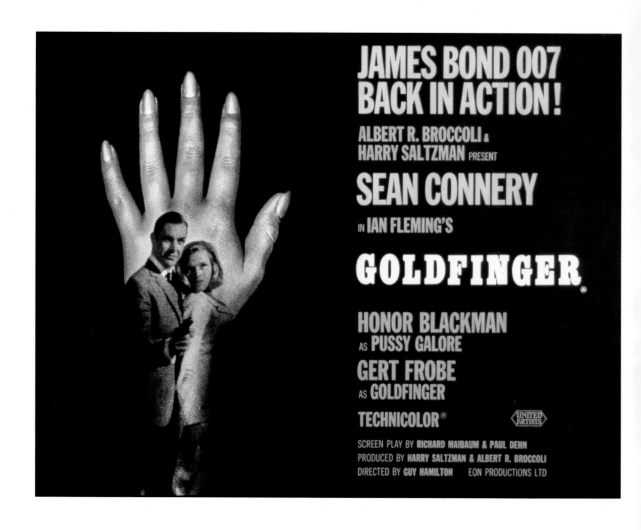

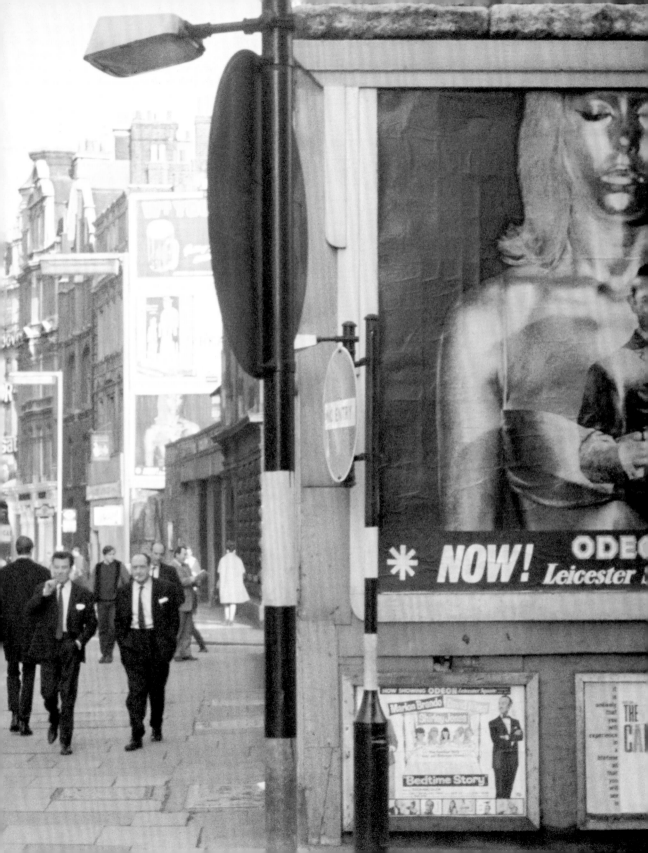

Cammell Hudson Associates Ltd
24 St Leonard's Terrace London SW3
Sloane 1358-5512
Directors D D Cammell H D Hudson

The Tortoise and the Hare

Film Title Sequence
1966, Pirelli
Robert Brownjohn

The plot of this thirty-minute
promotional film involves the
interplay of a sportscar and
a lorry as they travel through
Italy. In keeping with the
theme of the film, Brownjohn
chose to shoot the credits
on moving vehicles. The
sequence was filmed on
an airfield and involved
the complex choreography
of various cars, lorries and
industrial trucks.

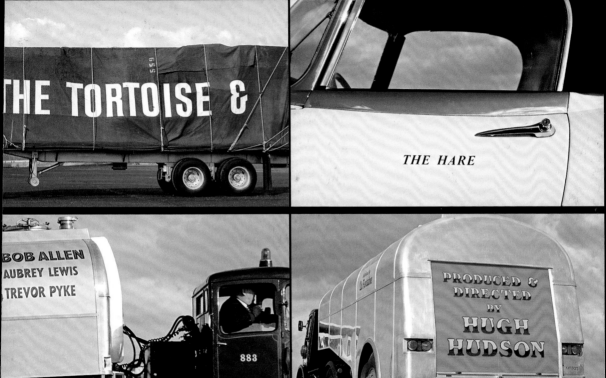

Letterhead for Michael Cooper

Brownjohn's oeuvre is characterized by standout pieces. Rather than relying on stylistic or conceptual uniformity, his best designs involve a fresh idea matched with a uniquely appropriate graphic style, creating a portfolio of showstoppers. But, even against the general brilliance of Brownjohn's norm, there remain a couple of projects that prompt a sharp intake of breath. His letterhead for Michael Cooper is one. Its twinning of typographic restraint with exaggerated scale and, more importantly, of straightforward prose with utter audacity remains a source of astonishment. That it was ever put to use seems somewhat extraordinary. As a functioning letterhead, it says a great deal about the designer, the client and the peculiarities of the 1960s London scene that buoyed them both.

Born in 1941, in London's East End, Michael Cooper was a photographer. He attended art school and, in 1964, became a friend of the Eton-educated contemporary art dealer Robert Fraser. They remained close and, in 1966, Fraser financed Cooper's photographic studio on Flood Street in Chelsea. Marianne Faithful named Fraser's Mayfair art gallery and Cooper's studio as, jointly, the places where 'all the wires were going'.[1] Cooper's subjects were rock stars (The Beatles and The Rolling Stones), artists (Francis Bacon and Andy Warhol) and writers (William Burroughs and Allen Ginsberg). Mick Jagger described him, dismissively, as a 'right-time, right-place person', but, however arguable his talent, his sense of scene was faultless.

Opened in April 1962, Fraser's Duke Street gallery was one of a handful of significant contemporary art venues in London. Brownjohn designed posters for Fraser's June 1963 exhibition 'Obsession and Fantasy' and also his show in November of the same year, 'Drawings, Collages, Gouaches'. Given his keen interest in contemporary art, Brownjohn would almost certainly have been a regular visitor. When Cooper moved into his Flood Street studio, only one street away from Cammell, Hudson and Brownjohn, the decision to ask the designer for a letterhead must have been obvious.

In formal terms, the design is strikingly severe. Its typeface, Futura Bold, was created by Paul Renner in 1928 and is a product of Constructivist experiment with basic form, being built purely from squares, circles and triangles. Set on the letterhead in six unjustified rows, it generates the look of ideologically driven graphic utilitarianism. This simplicity of form is matched with clarity of expression. There can be few more straightforward statements than 'Robert Brownjohn designed this letterheading for Michael Cooper'. But, of course, the design's appearance and tone of restraint prove misleading. They transpire to be

a means of casting Brownjohn's outrageous subversion of the function of the letterhead into even greater relief. It takes quite a nerve to convert a piece of typography intended as an advertisement for someone else into a promotion for yourself. Every communication Michael Cooper made on this paper could not help but be at least as much about Brownjohn as it was about its subject.

Bob Gill has suggested that the letterhead was designed in reaction to being cajoled into doing the job as a favour: 'This is the greatest free job ever done by a designer. What does he want to say? I did this for nothing, that's what.' Meanwhile, Gill's then wife Bobby had a somewhat different interpretation: 'Michael Cooper was somebody who used to hang around, but he didn't have any personality. Bj thought and thought of something to do for his letterhead, but the only thing this guy had done that was in any way interesting was to ask him to design it.' The truth is probably somewhere between the two. The desire to wreak revenge on exploitative 'friends' will resonate with most graphic designers, but accounts of Cooper do hint at a paper-thin personality. Among the most damning is that from Fraser's artist Jim Dine: 'Michael was pathetic, Robert's pawn ... They were close, but Mike was not a great photographer. He was on the scene in the sixties and Robert knew all these people. That's all.'

Of course, that wasn't quite all. Cooper did create iconic images of many of the era's most significant personalities and moments, the highpoint of his career being the photograph of Peter Blake's set for *Sergeant Pepper's Lonely Hearts Club Band*, a construction made in his studio. Although most of Cooper's achievements seem to be the product of energetic hanging on – the pictures of Keith Richards and Mick Jagger on the day of the infamous Redlands drug bust in 1967, for example – as far as he was concerned that might have been a talent in its own right. Moreover, Brownjohn would have been the first to admit that he too spent much of the 1960s being in the right place at the right time. It could be the case that his letterhead for Cooper was intended as a subtle swipe at the whole King's Road scene. Although Brownjohn obviously enjoyed his notoriety, his increasingly exaggerated manners and extravagant outfits imply that he had a perpetual sense of the absurd.

1. This quote from Marianne Faithful and subsequent quotes from Mick Jagger and Jim Dine were all taken from Harriet Vyner's book *Groovy Bob: The Life and Times of Robert Fraser*, Faber & Faber 1999.

Dick Fontaine has suggested that Brownjohn had a 1950s sensibility very different from that of the 'velvet-suited' brigade of Cooper and Fraser. It was a case of conceptual art and jazz versus hippy philosophy and psychedelia. A design made by Cooper himself in 1967, the same year as Brownjohn's letterhead, hints at this gulf. The three-dimensional photography and overblown yet hesitant composition of Cooper's Rolling Stones cover *Their Satanic Majesties Request* is about as far from Brownjohn's cool intellectualism as it is possible to be. But, for all the distance between the two, Brownjohn and Cooper suffered eerily similar fates. In 1973, at the age of thirty-one, Cooper died of what has variously been described as an overdose and suicide. Both of them, it seems, were victims of the less desirable side effects of being immersed in a scene.

**Robert Brownjohn
designed this letterheading
for Michael Cooper of
4 Chelsea Manor Studios
Flood Street London SW3
FLAxman 9762**

1967, Michael Cooper
Robert Brownjohn

Robert Brownjohn
designed this Business Card
for Michael Cooper of
4 Chelsea Manor Studios
Flood Street London SW3
FLAxman 9762

Robert Brownjohn
designed this Label
for Michael Cooper of
4 Chelsea Manor Studios
Flood Street London SW3
FLAxman 9762

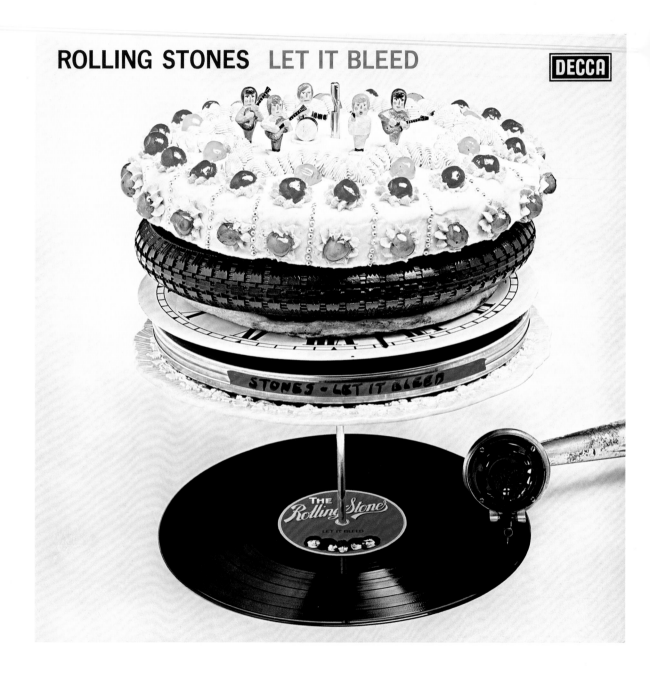

LET IT BLEED □ **LOVE IN VAIN** □ **MIDNIGHT RAMBLER** □ **GIMMIE SHELTER** □ **YOU GOT THE SILVER**
YOU CAN'T ALWAYS GET WHAT YOU WANT □ **LIVE WITH ME** □ **MONKEY MAN** □ **COUNTRY HONK**

6.21417
BL

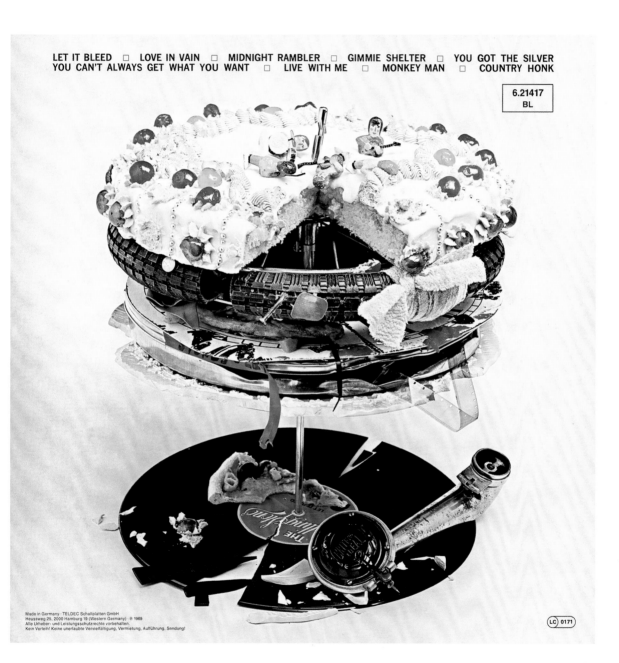

Made in Germany · TELDEC Schallplatten GmbH
Heusweg 25, 2000 Hamburg 19 (Western Germany) · ℗ 1969
Alle Urheber- und Leistungsschutzrechte vorbehalten.
Kein Verleih! Keine unerlaubte Vervielfältigung, Vermietung, Aufführung, Sendung!

LC 0171

Bj's Peace Poster

Brownjohn's Peace poster is a masterpiece of graphic restraint. Using the minimum of materials arranged in the sparest of fashions, it not only communicates a simple, direct message, but also hints at a host of alternative interpretations and subplots. The poster was one of Brownjohn's last completed jobs, indeed it may well have been *the* last. As such it acts as the perfect professional full stop, a distillation of everything that went before.

The Peace poster is built from four elements: the Ace of Spades; its hand-scrawled surround; Brownjohn's more adeptly written monogram; and an extravagant quantity of white space. Each of these ingredients is arranged in perfect proportion with all the others. The generous border framing the playing card lends drama. The similarity of scale between the letters 'PE' and the decorative Spade at the centre of the Ace promotes the instant apprehension of the word 'peace'. The small distance between the border of the card and the question mark scrawled to its right adds the perfect touch of hesitancy. And the contrast between the shaky uncertainty of the lettering on the poster and the confident designerly hand of Brownjohn's 'Love – Bj' casts an air of ambiguity over the entire composition. Many believe that the design is a reflection of Brownjohn's mental state, but, if that were the case, then it appears that it was a condition of which even he was uncertain.

The original client for the Peace poster was a New York-based peace advocacy group, and the commission was orchestrated by Brownjohn's long-time friend, the printer Dick Davison. As a supporter of the campaign, Davison asked several of the city's designers to create a flag reflecting the political consciousness of the era. Among them were Tony Palladino, David Enock and Stanley Eisenman, and, even though Brownjohn had lived in London for nearly a decade by that point, he must have been a natural figure on such a list. Davison was delighted by Brownjohn's design, believing it to be 'by far and away the best'. He entered it for several awards, and it is thought that Brownjohn may have entered the last phase of his fatal relationship with drugs during a trip to New York to pick up a prize.

The second client was Motif Editions, a London-based publisher of limited edition prints run by Edward Booth-Clibborn. As the long-term chair of the D&AD awards committee, Booth-Clibborn knew Brownjohn and his work extremely well. On the designer's death, he co-operated with Donna Brownjohn on the limited release of 'Bj's Peace Poster'. Published in 1972 in a run of 1,000, the Motif Editions version measured roughly two by three feet and was printed

on white cartridge paper. It was promoted with a postcard-sized print on which Booth-Clibborn quoted Brownjohn saying, 'I'm not a painter or a sculptor. I'm a graphic designer. I've got to have a client. I can't just sit down and work because I feel like it.' This statement almost certainly reflects Brownjohn's feelings about his work, but it nonetheless seems a slightly odd choice as a selling point for one of the designer's least applied projects.

Interpretations of the poster vary. According to Davison, Brownjohn was proposing that the most important political issue challenging the United States was that of race, but this reading is now mired by the fact that, in this context, the term 'spade' is extremely offensive. If this was Brownjohn's intention, however, he was absolutely right about the gravity of the situation. The violence surrounding the pursuit of civil rights had been spiralling since the early 1960s. In 1964 Malcolm X had announced that 'the price of freedom is death' and a year later he was assassinated. In response to his murder, Huey Newton and Bobby Seale founded the Black Panthers and issued a call for 'self-defence', urging black people to arm themselves. The Black Panthers clashed with police on several occasions and, when Martin Luther King was assassinated in 1968, the chances of the peaceful attainment of civil rights seemed very remote.

The other issue troubling the United States in 1969 was, of course, Vietnam. It was the year in which the American public first heard about the My Lai massacre, a revelation that prompted massive anti-war demonstrations in Washington. Overnight the peace movement became mainstream. Unsurprisingly, the agendas of the civil rights and peace campaigns became intertwined – in a speech made in 1967, Martin Luther King had gone as far as drawing a direct analogy between the anti-imperialist struggle of the Vietnamese and that of African-Americans. Moreover, the disproportionate number of young black American men wounded or killed in the war was highly conspicuous (a number of black veterans joined the Black Panthers on their return to the US). In 1968 Robert Kennedy was assassinated while campaigning on an anti-war ticket. Coming only two months after the murder of Martin Luther King, it seemed as if not only the US, but the entire globe was becoming enmeshed in a web of interconnected violence.

Brownjohn's Peace poster, reflecting the global nature of late 1960s anxiety, features an image of the world at the centre of the Ace. Far from being the creation of Brownjohn, however, this illustration had appeared on Universal Playing Cards since the 1920s. One of the most common brands in Britain, the cards would have featured in many a Chelsea poker game and, chances are, Brownjohn knew the design extremely well before he placed it on the poster (by coincidence the company was taken over by Waddingtons in 1970, rendering the card a rarity immediately after its starring role in Brownjohn's design). The Ace of Spades has been recognized as a symbol of death for centuries, and the connection between the world and death on the Universal-brand card has an

Poster

1969, Dick Davison/New York
Peace Campaign
90 x 60 cm (35 $\frac{3}{8}$ x 23 $\frac{5}{8}$ in)
Robert Brownjohn

unmistakably sinister contrariness. In a similar vein, there is a story, possibly apocryphal, that the American military sprinkled the Viet Cong with Aces of Spades. The brand they are supposed to have used featured the image of Liberty at the centre of the design, an association every bit as perverse as that in the Universal card.

While Davison interprets the Peace poster as a public statement, others see its meaning as purely private. They argue that Brownjohn's life had become so troubled by the late 1960s that he was looking forward to death as a peaceful escape. Pointing to the ownership of the message indicated by the signature 'Love – Bj', they insist that the poster was akin to a farewell note. Such arguments about the meaning of the design, one way or the other, imply the possibility of unravelling Brownjohn's personal and political sentiments. It seems more likely, however, that the two were inextricably linked. The coincidence between the designer's state of mind and the sense of global crises almost certainly affected him very deeply. Throughout his career Brownjohn had been sustained by the feeling of being in the right place at the right time: the jazz clubs of Chicago in the 1940s, the West Village in New York through the 1950s, and the King's Road in London during the 1960s. But, by the time he designed this poster, at the cusp of a new decade, there no longer seemed to be any right place to go. The prevailing cultural pessimism was enough to sap the strongest of wills. The Peace poster's role as a political statement needn't be seen as cancelling out its personal intent, or vice versa. Quite the contrary, the great achievement of the design is its singular expression of individual and global crisis.

PE ?

Love -Bj.

Index

Credits